POSTCARD HISTORY SERIES

Around Avondale and West Grove

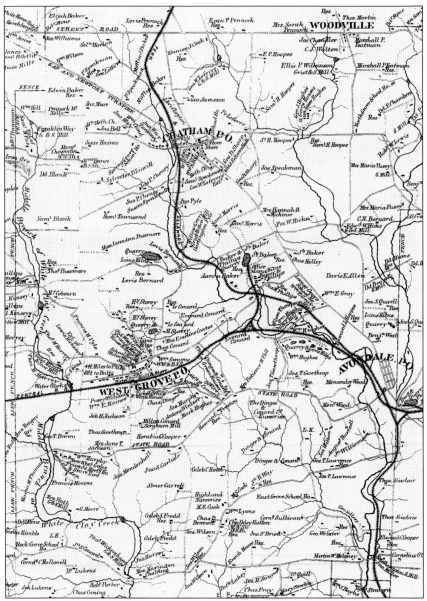

Here is an image of London Grove Township in 1873, from the *Witmer Atlas of Chester County*. (Courtesy of Thomas Macaluso.)

POSTCARD HISTORY SERIES

Around Avondale and West Grove

Dolores I. Rowe

ARCADIA
PUBLISHING

Published by Arcadia Publishing
Charleston SC, Chicago IL, Portsmouth NH, San Francisco CA

Printed in the United States of America

Library of Congress Catalog Card Number: 2006925709

For all general information contact Arcadia Publishing at:
Telephone 843-853-2070
Fax 843-853-0044
E-mail sales@arcadiapublishing.com
For customer service and orders:
Toll-Free 1-888-313-2665

Visit us on the Internet at www.arcadiapublishing.com

To my parents, Rocco and Thursa Del Nero, my brothers, Joseph and Michael Del Nero, and my sister, Theresa Del Nero March, for precious memories.

CONTENTS

ACKNOWLEDGMENTS

There are many people to thank for making this publication possible: the scholars and historians who have published previous works—Scott Steele, John Ewing, Robert Cleveland, and Paul Rodebaugh; those who have contributed information and/or lent pictures—Joseph Del Nero, Michael Del Nero, Thursa Del Nero, John Ewing, James and Kathleen Gears, Joseph Lordi, Madeline Nicotera, Thomas Macaluso, Linda Saunders (secretary of the London Grove Township Historical Commission), Mary Sproat, Louise Strode, Ruth Wright, and Judy Young. I also have to give special thanks to the following: Joseph Lordi for many hours spent editing my manuscript and guiding me through the process of laying out the book; Scott Steele for his generous spirit and careful editing of historical details; and Leon Rowe, my husband, who did my scanning and without whose encouragement and patience this book would have been impossible.

INTRODUCTION

The focus of this book will be the two boroughs of Avondale and West Grove, the village of Chatham, the settlement of Baker's Station, and the surrounding area of London Grove Township. There will also be some information on Jennersville (Penn Township) since it has close ties with the rose industry in West Grove.

The Lenni-Lenape Indians were the first inhabitants of the area encompassed by this book. An original county established by William Penn (along with Philadelphia and Bucks Counties), the area saw its first European settlers in the early 1700s, mostly English, Irish, Swedes, and Welsh, closely followed by the Scotch-Irish. Later many Italians immigrated here to work in the quarries, and in the last few decades there has been an influx of Hispanic workers mostly associated with the mushroom industry and other agricultural pursuits.

This area of southeastern Chester County is a rich agricultural area that boasted many farms, creameries, and mills. There were 16 mills in 1881, including gristmills, sawmills, and a tannery. Two areas of agriculture became world renown—the floral industry of which the most well-known worldwide is Conard-Pyle, and the mushroom industry.

A vein of granite runs through this part of Pennsylvania, so many quarries were kept busy with the production of granite, limestone, flagstone, marble, and feldspar. The Avondale and D'Amico Quarries continue to carry out this tradition today, although all the deep quarries have been flooded.

Sitting in a region traversed by two major roads, the Baltimore Pike (old U.S. Route 1) and the Gap-Newport Pike (Pennsylvania Route 41), the area saw the transport of many products to Lancaster, Philadelphia, Baltimore, and Delaware from Colonial times to the present. With the coming of the railroads to Avondale, Chatham, Baker's Station, and West Grove, this area became even more accessible and its products reached markets more easily. There were many inns and later cabins and motels established for the traveler.

With many of the first settlers being Quaker, the area was important in the Underground Railroad. Ann Preston (1813–1872), who was born in London Grove Township and became one of the first female physicians in the county, was active with her family in the Underground Railroad. Her home, as well as several others in the area, was a station on the Underground Railroad. Preston wrote antislavery poems and stories. She also wrote a collection of rhymed tales for children titled *Cousin Ann's Stories*. She became chair of physiology and hygiene at the Female College of Pennsylvania in Philadelphia and also dean of the faculty.

West Grove was first named Prestonville after Ann Preston's ancestors Joseph and Rebecca Preston. It was incorporated as a borough in 1893 and was named West Grove because it was in the western part of London Grove Township.

Joseph Pyle is considered to be the "Father of West Grove." He ran a general store, was involved in numerous early land transactions, and had many of the early buildings constructed. He was postmaster for 22 years, president and owner of the West Grove Water Works and of the West Grove Improvement Company, mayor, and a borough council member. His donations in all forms made him a much-respected citizen.

Mark Sullivan (1874–1952) was another famous citizen from the area. He started as a young newsboy for the *West Grove Independent*. As an adult, he was an editor, journalist, and historian. Among his works are *Our Times, The United States 1900–1925* (a six-volume set) and an autobiography, *The Education of an American*. As a result of his syndicated journalism, he was instrumental in the passing of the Pure Food and Drugs Act of 1906. A road on the outskirts of Avondale is named for his family, and a bridge near their home has a historical marker honoring him.

Avondale was first part of New Garden and London Grove Townships. Its earliest name was Miller's Row after John and Mary Miller, two of the earliest landholders. Later it became known as Stone Bridge after the bridge on the Baltimore Pike crossing the White Clay Creek. Then it was called Avondale from a portion of land called Avondale Farms owned by William Miller, son of John and Mary. Avondale was incorporated in 1894.

James Watson was called the "Father of Avondale." He ran a lumber, sash, and door factory and also operated a foundry and iron works. He purchased the Avondale Hotel in 1866 and made major improvements on it. He acquired many other parcels of land to make them available for the population boom brought on by the coming of the railroad.

Chatham's name dates back to the Revolutionary War era when William Pitt, the Earl of Chatham and a member of the British House of Representatives, took a stand in favor of the colonies. When word reached the colonies, a tavern was named for him, and the village that grew around it adopted the name.

George Lefever was an early supporter of Chatham, being instrumental in the coming of the railroad to town and buying the land for the Methodist church. He also ran an early store.

From the first Native Americans through early settlement, the Revolutionary War and the struggles leading to the Civil War, this area of southeastern Chester County contributed to building the country with its products and the contributions of its citizens. It was a rewarding and stimulating place in which to grow up. Its call is still heard today by many new inhabitants who are making Chester County one of the fastest growing in the state.

—Dolores I. Rowe

One

THE BUSINESS SECTION

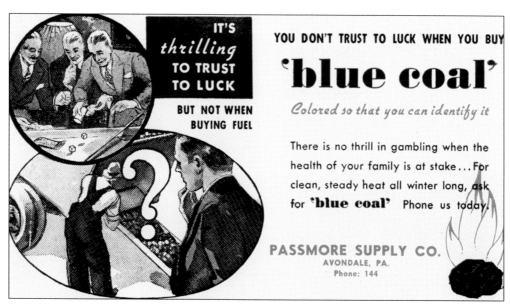

Passmore Supply Company of Avondale gave this blotter to its customers, advertising their "blue coal" for clean, steady heat. The blotter kept the name of the company in the sight of the customer when they wrote any correspondence and had to blot the excess ink left by the fountain pen.

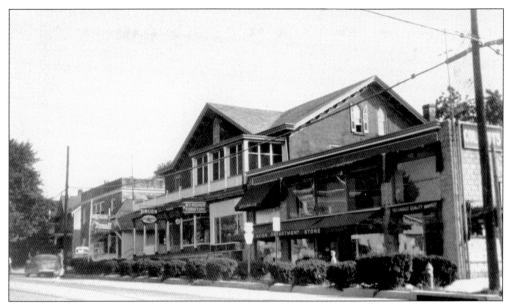

The original portion of this building (with the peaked roof) was built in 1869 as Ziba Lamborn's Store and Hall; the flat-roofed portion in the foreground was added later as Feldman's Department Store. This card from the 1950s shows Ritter's Drug Store, Keener's Furniture, the Avon Department Store (Collett's), and Fecondo's. The site, at the corner of Pennsylvania Avenue and First Street, is now a bank and parking lot.

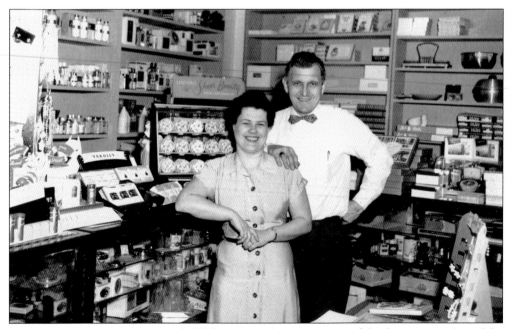

Ross and Margaret Ritter succeeded Sidney Doroshow as owners of the drugstore in Avondale. The pharmacy was in the old Ziba Lamborn store. This 1954 picture shows Margaret and Ross Ritter in the area of the store selling fragrances. Besides selling a variety of goods and dispensing prescriptions, the drugstore had a popular soda fountain.

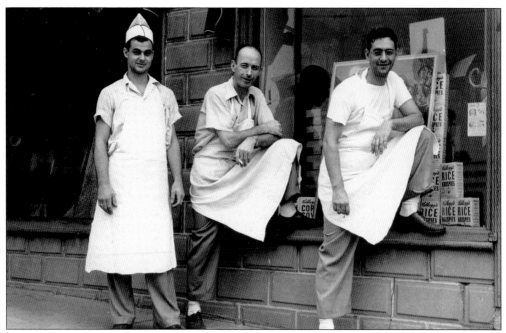

In 1951, the Fecondo Brothers Store was opened in new quarters next to the municipal building/fire company on Pennsylvania Avenue in Avondale where Medford-Dunleavy was previously in business. Children were given a free cookie from barrels inside the store. From left to right stand Guido Fecondo, Phil Rae, and Vincent Fecondo. Note the Kellogg's products in the window. This building was demolished in 1957.

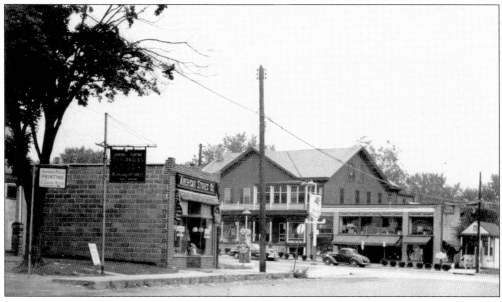

The American Store Company grocery is on the left in this view taken from State Road in Avondale. This building has been the home of Earl's Sub Shop for many years. There are also signs for Avondale Press Printing and General Electric Oil Furnaces. A Mobil station is on the corner. Across the street is Collett's Department Store; behind it is the produce stand where the Macabees sold fruit and produce from what later became Chatham Acres.

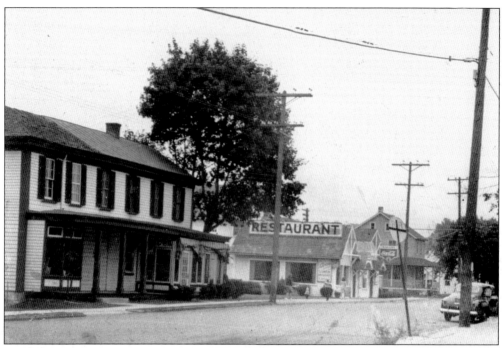

The frame building in the left foreground housed a store and the post office from 1851 to 1883. Joshua Thomas, tinsmith and plumber, had the last business before the building was demolished in 1982. The structure with the Restaurant sign was built in 1877 as Morris Watson's meat store. William Blittersdorf ran a barbershop here; his wife had a restaurant in part of the building. Later Perry's News Agency, it is now Avon News.

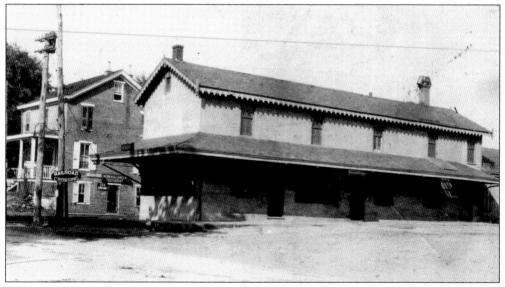

Left of the railroad station is the Ponte Building. At the time of this picture, it was the restaurant of Jacob Ageldengler, "baker of all things good to eat." Later Frank Ponte's shoemaking shop was there. Shoes in all stages of repair and construction could be seen, and the tangy smell of leather permeated the air. With a white handlebar mustache, Ponte entertained with a wooden clarinet brought from Italy.

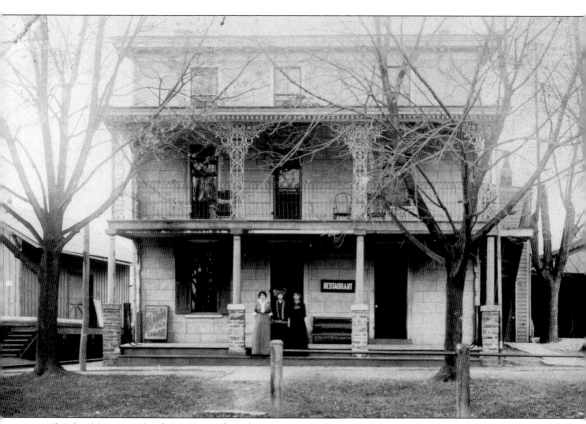

This building was built in 1775 of sandstone. It was the site of the National Bank of Avondale. In 1890, a Bachelor's Club was established and held meetings here; the Bachelor's Club was as its name implied. It was started by 12 men who "pledged their troth to single blessedness." They held hops, parties, and lectures and outfitted the hall with pool tables, a double shuffleboard, and card and reading tables. This organization disbanded in 1900. The building saw reincarnations as a store, harness shop, and dwelling, and in this view, it was the restaurant of W. C. Russell, whose establishment catered to wedding receptions and parties as well as hungry townspeople and travelers. The three ladies on the porch are, from left to right, Viola, Emma, and Reba Blittersdorf. It was later T. C. Medford's Appliance Store, and there were apartments above. Later it housed Wharry's Grocery. This building still stands next to Earl's Sub Shop on State Road and is the home of World Wide Travel. Notice the ornate ironwork on the second floor that is still on the building today.

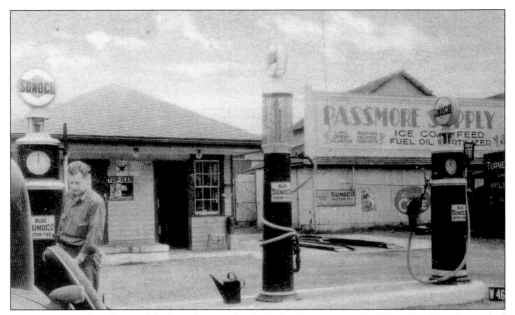

Passmore Supply of Avondale bought out the Ark Coal Company in 1926. It offered gas, fuel oil, Kopper's Coke (coal), agricultural and building supplies, and ice. It was located on South Pennsylvania Avenue where a gas station is still in business. The National Recovery Administration (NRA) sign on the building indicated that the business was a participant in the government's program to fix prices and support the recovery effort from the Depression.

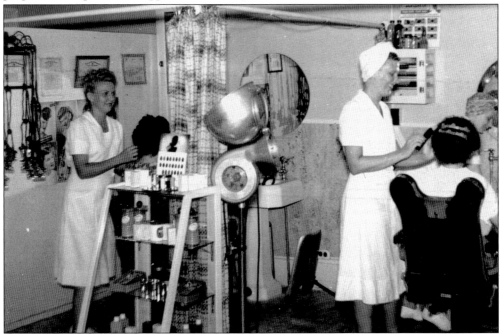

Louise's Beauty Shoppe opened in the early 1940s and was located in the Allen Block and later moved to the corner of Pennsylvania Avenue and Second Street. In this 1947 photograph, Louise Strode, the owner, can be seen on the right. Alice Mullin is on the left. Notice the early hair dryer and the tools for permanents on the far left.

14

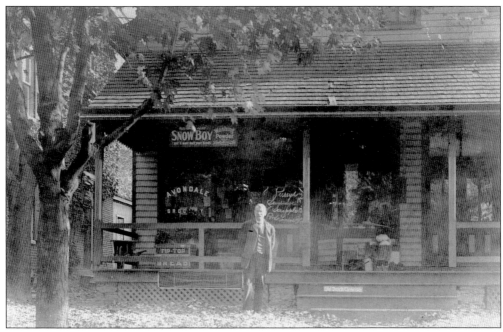

Both of these images show the Avondale Cash Grocery at 127 Pennsylvania Avenue. It was owned by Thomas H. Smith, who purchased it in 1909 from Gertrude Baker. The postcard above shows advertisements for Snow Boy Washing Powder, Tip Top Bread, and Pusey's Sausage, Scrapple, and Pork. The bottom view was taken around 1916 and shows Mrs. Thomas Smith on the right and her daughter Mary Smith (later Mrs. Gilbert Boys). Note the brooms, washboards, and cans in the window, as well as signage for Goldenblend Tea. Small signs on either side of the door read "Jell-O, the new dessert." In 1945, J. H. Cox bought the business and ran a store there.

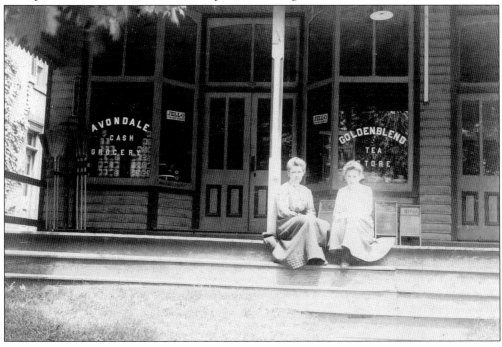

The Avondale Hotel and Store sat on property that was originally a carding mill around 1849. The hotel was built in 1857 on land that was part of Avondale Farm or Ellicott Farm, owned by the children of Thomas Ellicott and Mary Ellicott (née Miller). Aaron Baker and Josiah Phillips bought it in 1863 and hired Charles Colgan as innkeeper. In 1866, James Watson purchased it for $8,000 and hired his son-in-law Chandler Phillips as innkeeper. At that time, he made extensive repairs "to keep up its reputation as a first class hotel." During this time, Watson operated a lumberyard on the property, and later a stock auction was held at the rear of the hotel. Chandler Phillips bought the hotel from Watson in 1868 for $11,000. In the image above, the National Bank of Avondale can be seen at the right.

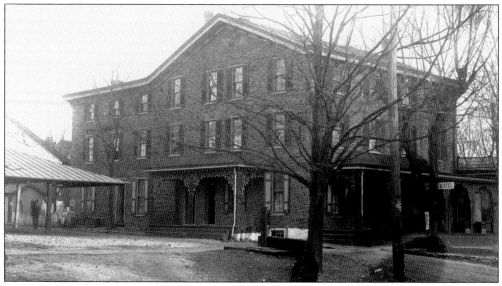

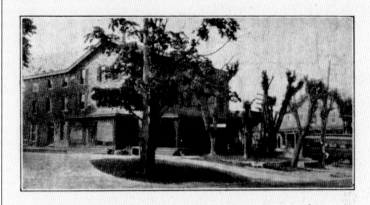
At the time of this card, C. W. Wilson was running the Avondale Hotel. The hotel was "striving to please with new furnishings, attractive rooms and tables supplied with the season's selections." Chicken and waffle dinners were a specialty, and the restaurant catered to banquet and dinner parties as well. Visitors could come in to rest in the "offices" at no charge even if they were not staying at the hotel. C. W. Wilson was known to give souvenir plates to his patrons that were stamped on the back with his name and "Avondale, PA" and with floral decoration on the front. He also ran the general merchandise store associated with the hotel. The property was sold in 1927 to H. E. Van Ness, who had bathrooms installed and the horse stables converted to automobile storage. He hired Mr. and Mrs. A. P. Rowe as managers while George Stein ran the store under the name Avondale Department Store. Once this business closed, the building was vacant for many years and was finally demolished in 1936.

17

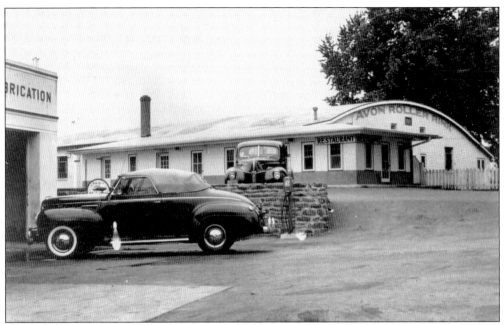

Evan B. Sharpless opened the Avon Roller Rink in 1940. George F. Gill of Cochranville designed the building and did the carpentry. It was constructed on the site of the Avondale Hotel for $25,000. The roller rink was 10,000 square feet and had room for 400 skaters. In the first six months of its existence, it had almost 15,000 patrons. It cost 20¢ for an afternoon and 35¢ for an evening of skating pleasure. Gordon Henderson was the first manager, and music was provided by "one of the latest improved models of Victorolas." The view below shows the attached Sharpless Dairy Lunch that "renders the ultimate in curb service and meals for those who enjoy the best foods, properly prepared and attractively served." Later it became Passmore Supply business and was destroyed by fire. The site now holds the Avondale Post Office.

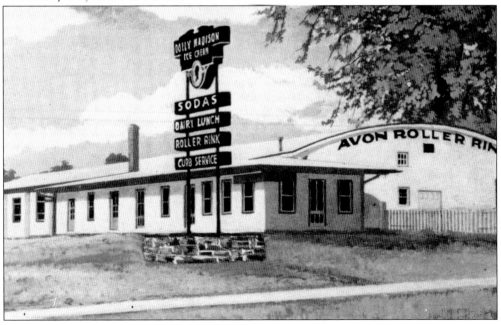

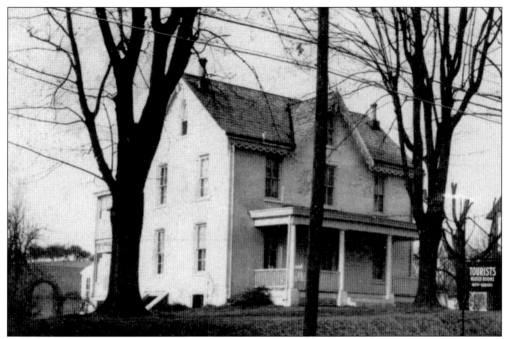

This home at 208 Pennsylvania Avenue was the home of James Watson, the "Father of Avondale." The brick used in the building was manufactured in Avondale, and Watson himself made the sashes, windows, and doors. When built, it was one of only three buildings on the west side of the road. Later it was used as the Harper Tourist Home and then the Harper Convalescent Home. It is now apartments.

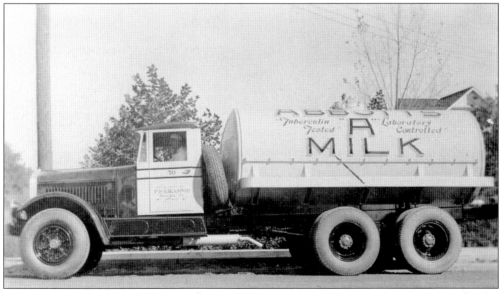

P. E. Kramme's business in Avondale was established in 1924. Kramme owned two trucks that hauled milk for Abbott's Dairies. Ralph Wickersham started as manager in 1925. By 1940, the company owned 25 trucks and served many dairy farms. All milk hauled was "tuberculin tested and laboratory controlled." P. E. Kramme is still in business today with a branch of the business in New Jersey. (Courtesy of Joseph Lordi.)

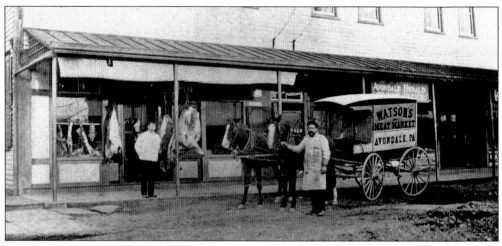

Called the Watson Building, this structure at 9 South Pennsylvania Avenue in Avondale held Watson's Meat Market, the *Avondale Herald* (a newspaper that was the successor to the *Avondale Star*), and J. Quarrl Mackey's Drug Store around 1904. Meat can be seen hanging in the large picture windows. William Watson is in front of the store. Charles Rodgers holds the reins of the horses.

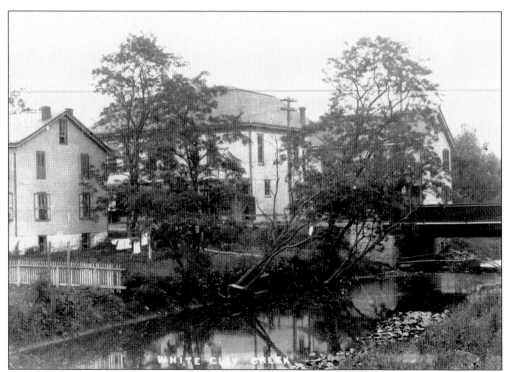

Entering Avondale from the south, this pre-1910 view shows the bridge over the White Clay Creek, the Watson Building in the center, and a residence still in use in the foreground. The building in the background has been demolished, and apartment buildings have replaced it.

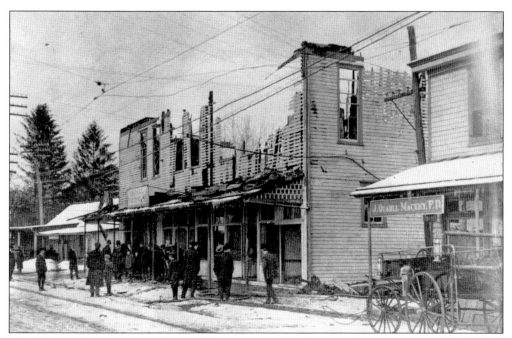

The Watson Building was destroyed by fire early Sunday morning on January 30, 1910. It housed Watson's Meat Market, the *Avondale Herald*, and United Telephone Exchange. J. Quarrl Mackey's business was then in a neighboring building. During the fire, a floor collapsed and buried three men, two of whom were injured. The building that can be seen at the left corner of Pennsylvania Avenue and First Street was a blacksmith shop.

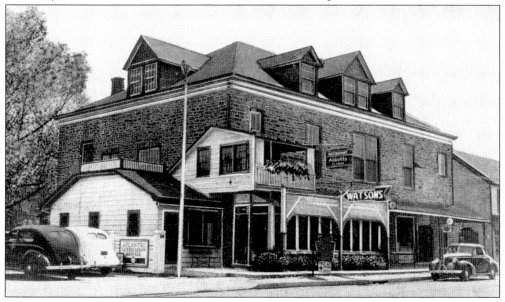

A stone building was constructed in December 1910 on the site of Watson's Hall, and a restaurant was opened there. In 1929, a Thanksgiving dinner was offered for $1.25. The view above shows the building when it housed Watson's Coffee Shop, Modesta Morris, proprietor. Mushroom and steak dinners were a specialty. The police station was housed in the small white building, and the barracks were on the second floor of Watson's.

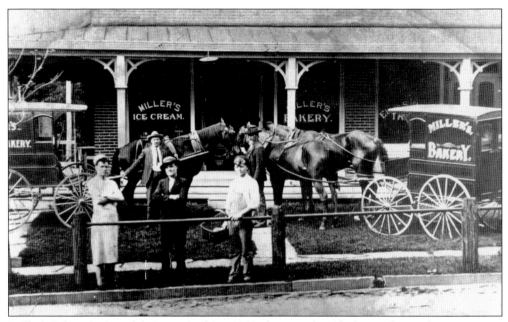

Miller's Bakery in Avondale is seen in this *c.* 1905 photograph with the two horse-drawn wagons. The men are, from left to right, Charles Miller, O. H. Miller (owner), Le Roy Miller, John Miller, and John Perry. At the time, Elmer S. Pearce had a tailor shop in the right side of the building. This business was in the Allen Block.

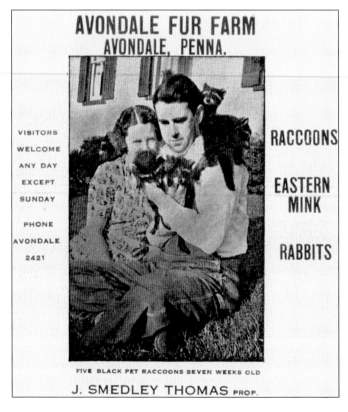

J. Smedley Thomas was a fixture around Avondale for years, being the town historian and the owner of an extensive bottle collection housed in a museum in a separate building on his property. This illustration from an envelope shows Smedley and his wife, Ruth, when they operated the Avondale Fur Farm, raising raccoons, eastern mink, and rabbits. Ruth worked at a beauty salon in Avondale for many years.

22

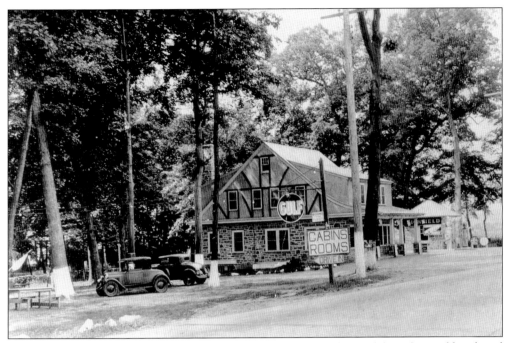

The Forest Park Inn was on old Route 1 just on the outskirts of Avondale and served lunch and refreshments. Cabins or rooms could be rented, and camping was allowed. Gulf and American Standard gas were available at the same location. Chester H. Thomas, a photographer from Kennett Square, published this view. The Tick Tock Day Care Center now occupies this building.

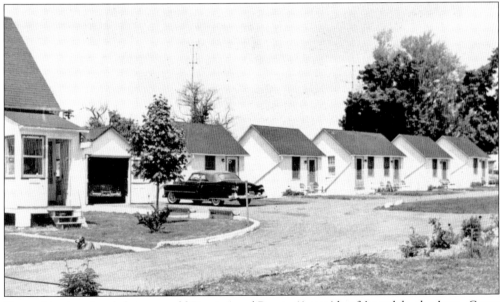

Situated in the triangle between old Route 1 and Route 41 outside of Avondale, the Avon-Grove Motel charged $6 a night for the cabins seen here; later the cabins were rented for long-term residence. A trailer park was added and remained for many years. Today a Wawa convenience store is at this location.

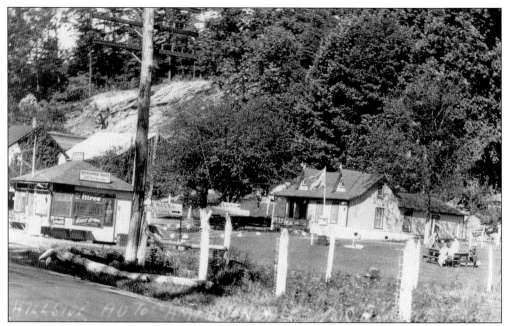

Before modern motels, many privately owned automobile camps with cabins opened on well-traveled roads, offering a limited selection of food. Hillside Auto Camp was one of these. In the image above can be seen one of the cabins that could be rented for overnight stays, a picnic table, and the refreshment stand. The rocky outcropping on the left is now part of the D'Amico Quarry next to the Rotunno Stone Yard. Many of these cottages are still standing on old Route 1 just north of Avondale and being used as dwellings. In the view below, a close-up of the refreshment stand at the camp shows signs posted that read, "Refreshment Booth . . . All Welcome," "Hires," "Coca-Cola," "Good Grape," "Quick Lunch."

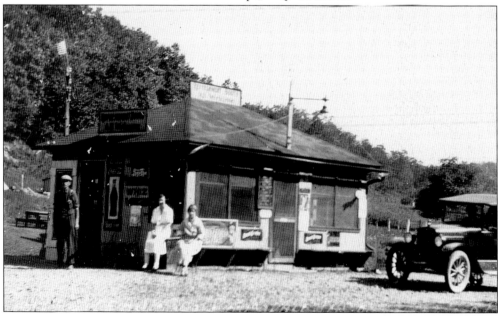

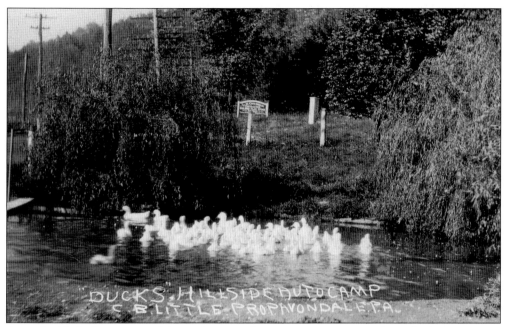

A pond with ducks was one of the enticements for motorists stopping at the Hillside Auto Camp outside of Avondale. There was plenty of open space for the children to run around and organize games. In the background is a sign for L. M. Crossan, contractor, building and flagstone.

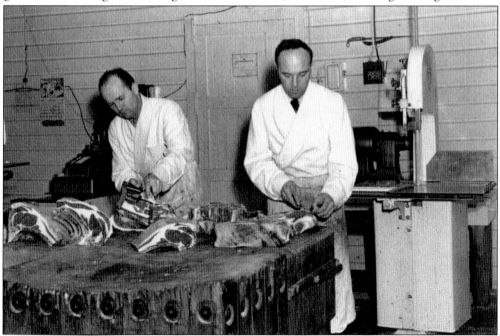

Established in 1943, the Avon Freezer Company had 300 lockers that could be rented by customers. In this 1946 photograph, owners Thomas McDowell (left) and Harold Davis can be seen preparing meats. These two later disbanded their partnership, and McDowell ran a business in West Grove while Davis stayed in Avondale. The Avon Freezer Company was later taken over by Norman Smack.

Brinton H. Chambers opened a general merchandise store in Avondale in 1892. He sold magazines, dry goods, shoes, and groceries and was also a druggist. His store was diagonally across from the Allen Block and was later the site of Eastburn's Funeral Home, now Cleveland and Gofus Funeral Home. The blotter pictured above advertised his business.

Francis Hoopes built Sunset Farm, north of Avondale, in 1786. In 1939, Mrs. D. Duer Mancill ran a business here that accommodated overnight guests and served luncheons and dinners. Later Martin Dillon operated a farm selling horses and donkeys. The Avondale Fire Company held benefit horse shows here in the late 1930s. Recently an archaeological dig on the site discovered many artifacts along with the remains of an earlier home.

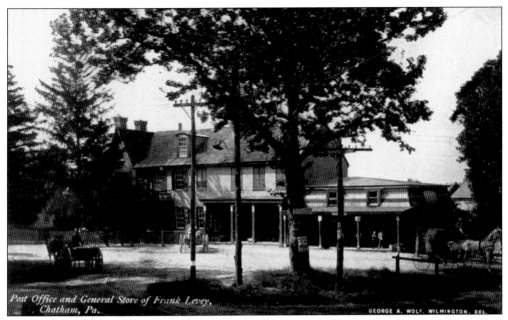

Post Office and General Store of Frank Levey, Chatham, Pa.

GEORGE A. WOLF. WILMINGTON. DEL.

This site along Route 41 near Route 841 has long been used as a general store and the Chatham Post Office. It was built in the mid-1800s; Charles Kimball was one of the early storekeepers, followed by N. Woodward. Around 1900, Frank Levy ran the general store. This *c.* 1907 view was taken around the time the store was sold to J. W. Graham. The site is now used as apartments.

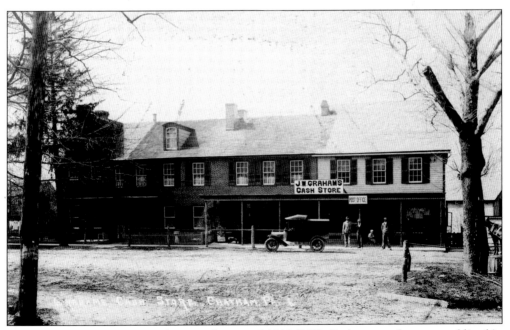

When this real-photo postcard was made around 1915, J. W. Graham ran the store and lived in part of the house. Notice the low portion of the building that is shown in the view when Levy ran the store has had a second floor added. Charles Graham sold the store in 1950. The post office has since been moved to a separate building across the street.

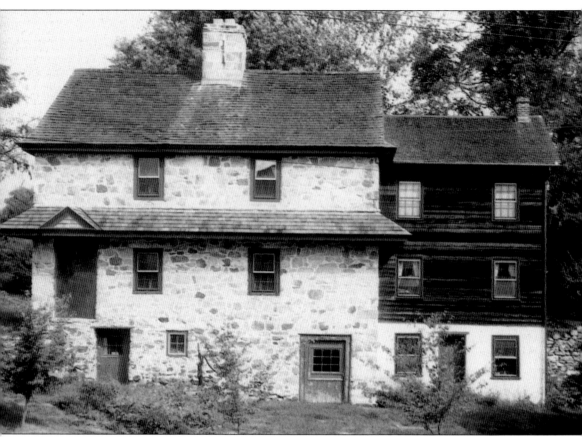

The structure pictured here was originally a tavern built in the early 1700s and named the Halfway House because it was halfway between Gap, Pennsylvania, and Newport, Delaware. When built, it was located on the Gap-Newport Pike and was operated by William McKean, the father of Thomas McKean Sr., who was a signer of the Declaration of Independence. In 1744, William McKean was forced to stop operating the tavern by the local Quakers who opposed the rowdiness of his business. In 1760, the Gap-Newport Pike (Route 41) was moved to its present location, and the William Pitt Hotel became the favored stopping place for travelers. The old inn became a residence and has recently been restored. The Halfway House is the second-oldest inn in Pennsylvania and one of the few center-chimney houses still standing. It can be found on West London Grove Road. (Courtesy of Louise Strode.)

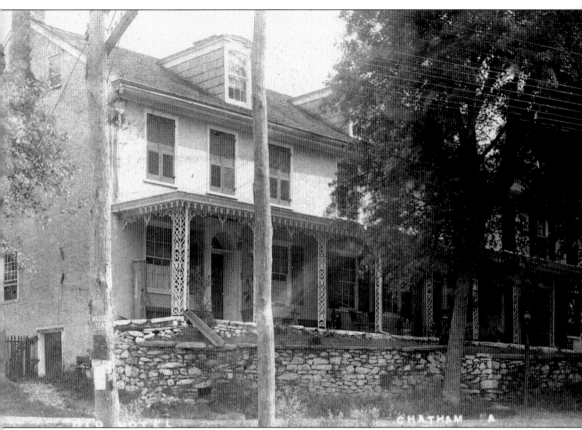

This old hotel in Chatham was built in three sections, the oldest section around 1765. Two of the three sections still stand at the juncture of Routes 41 and 841. The property included 392 acres. When the location of the Gap-Newport Pike was moved in the early 18th century, this building was established as an inn. It was originally called the William Pitt Hotel, later the Chatham Hotel. During the fight for American independence, a member of the British Parliament, William Pitt, the Earl of Chatham, opposed the repressive actions of the British government toward the colonies. When news reached the colonies, the owner of the inn, Thomas McKean Sr., changed its name to honor Pitt. Pitt later went on to negotiate with Benjamin Franklin at the end of the war. Thomas McKean Sr. was a chief justice and the second governor of Pennsylvania. His son, Thomas McKean Jr., sold the property to Joel Pennock, Jesse Pusey, Caleb Swayne, and Thomas Vandiver, who divided it into parcels to be sold. The hotel ceased operation in 1882.

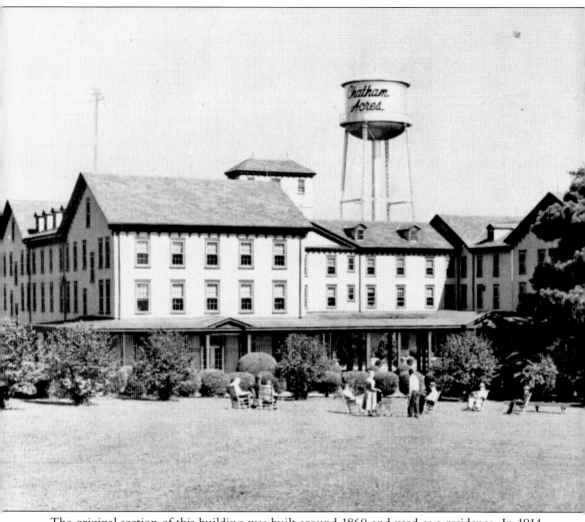

The original section of this building was built around 1860 and used as a residence. In 1914, W. E. Blaney, who was the "Great Commander of the Order of Pennsylvania Macabees" bought the property. The Macabees were a fraternal society, and Blaney wanted to provide a home for members who needed care. He bought two adjoining farms in 1920 so the home could grow its own food and be self-sustaining. Several additions were added to the 27-room original building. Eventually the home had 317 acres, 600 fruit trees, 178 head of cattle, a dairy, and over 77 bedrooms, as well as a dining room and wide porch all around. A dance pavilion was added in the woods behind the Chatham School. In 1954, Robert Kramer purchased the home and renamed it Chatham Acres Nursing Home; it was advertised in a 1963 paper as "a Hotel in the Country for the Elderly and Ill." Mrs. Kramer continued to be involved in the home after Robert's death.

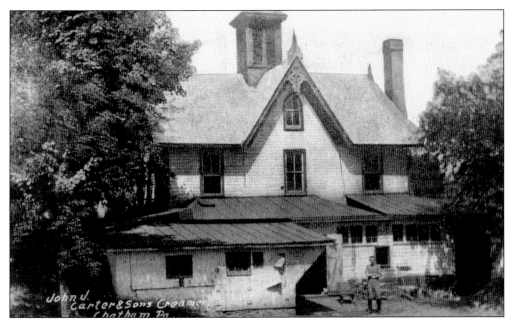

John I. Carter opened this creamery in Chatham in 1879; it was one of the first creameries in Chester County. By 1881, he was shipping over a ton of butter a week. He invented a centrifugal creamer to separate the cream from the milk. He also sold butter in unique patterns to fancy restaurants and hotels. The building, on West London Grove Road, has been restored as a residence.

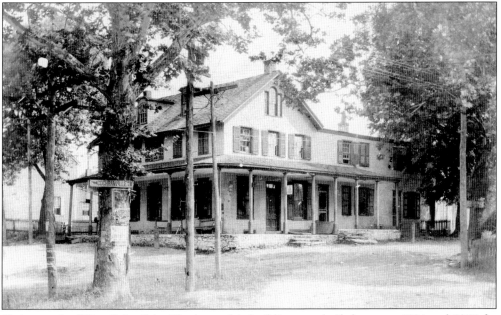

Sitting at the "Five Points" in Chatham, this building was built between 1834 and 1855 for D. Webster Chandler. It housed many commercial establishments, including a barbershop, a bakery, a hat maker, an ice-cream maker, and several general stores, the last of which was W. T. Gould's from about 1920 to the 1940s. The building was bought in 1956 and converted to a residence and apartments.

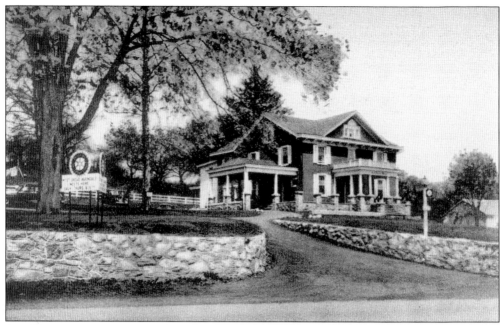

On old U. S. Route 1 outside of West Grove, the Avon Grove Manor opened on March 18, 1950, with over 100 guests in attendance. Mr. and Mrs. John Bruce, formerly of the Red Rose Inn, ran the establishment, which offered lunch, dinner, parties, and accommodations for overnight guests. The local Rotary and Lions Clubs held meetings here. Located at 349 East Baltimore Pike, the building is now used as apartments.

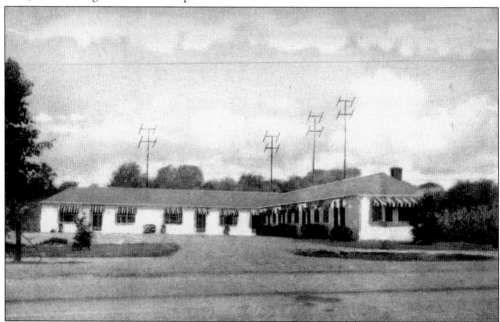

Sutton's Motel was on old U.S. Route 1 between Avondale and West Grove. It advertised baths, hot-water heat, television, and refreshments and was in business in the 1950s. After the motel closed, the building was used for a florist business and then a tax preparation service. It is now Optimum Floors.

Morton's Tourist Home was one of the homes in West Grove situated on the Baltimore Pike that were known as "bungalow row." It was in business in the 1950s and can be found at 275 West Baltimore Pike.

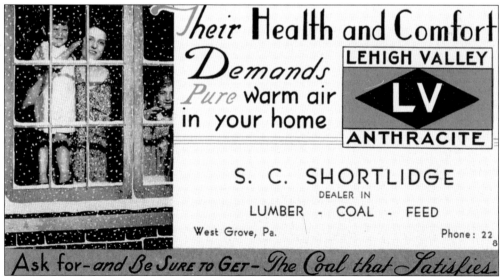

This blotter carries an advertisement for the S. C. Shortlidge Company of West Grove; Shortlidge took over the business of S. K. Chambers at 50 Railroad Avenue. It sold lumber, feed, and Lehigh Coal. Today the building houses the offices of the *Avon Grove Sun*, the Even Start Program, and Crossan-Raimato Inc., land surveyors.

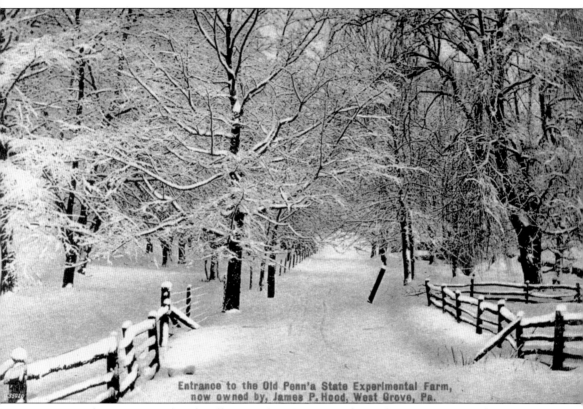

Entrance to the Old Penn'a State Experimental Farm, now owned by, James P. Hood, West Grove, Pa.

In 1868, the State Agricultural College purchased 100 acres from Thomas M. Harvey for $17,500 and established what became the Pennsylvania State Experimental Farm. Harvey was the first superintendent, followed by John I. Carter of Chatham in 1871 and Warren R. Shelmire in 1878. The farm had four to five acres of woods, 25 acres of fruit trees, and 70 acres of land under cultivation. Among the topics they studied were how to plant, the best fertilizer to use, what to feed cows and how to treat them, and the efficiency of various farm implements. They introduced Jersey and Guernsey cattle to the area. James P. Hood managed the farm at the time of this postcard. In 1965, it was operated by Elmer Young and named the Eastern Experimental Farm. Located at 300 Prang Road and now owned by members of the Young family, it is called Timberland Farms, and Ayrshire cattle are raised there.

34

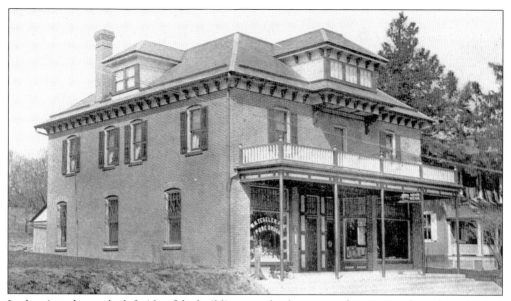

In the view above, the left side of the building was the drugstore of W. H. Tegeler, who published postcards of the area, including this one. In the right side was the business of George White, men's clothes, and Harry Rovner, tailor. In 1932, Mrs. George McCleary opened the Evergreen Tea Room in the building.

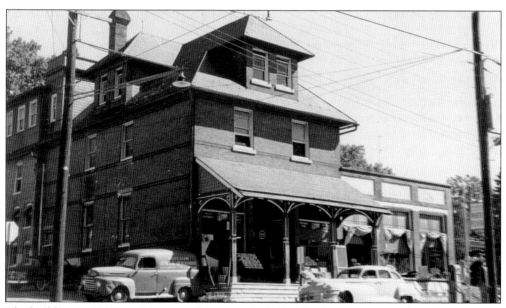

The building at 101 East Evergreen Street was built in 1867 by Francis Good. William Eachus and Edwin Swayne ran a general store here with Eachus taking sole ownership in 1869. In 1879, Robert L. Pyle bought the business for $4,534, and it was called Pyle's Store (later Haber-Pyle Bi-Lo Market). Many additions to the structure were made over the years, including the display windows seen on the right.

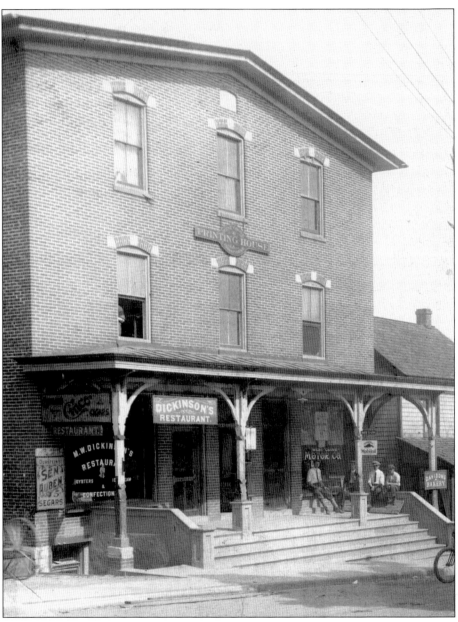

The K&P Building (now 7 and 9 Exchange Place) is shown in this real-photo postcard. The business on the left was Morris W. Dickinson's Restaurant, featuring oysters, ice cream, and elegant confections. Dickinson ran a bread wagon to New London, Chatham, and Avondale for years. On the right is West Grove Motor Company. There is also signage for Davison's Bakery and Sen Auben "Segars." On the second floor was the West Grove Printing House. Morris Lloyd established the *West Grove Independent and Chester County Mirror* in 1884 on the second floor of the bank building but moved the printing business to this building in the early 1900s. The name of the newspaper was shortened to the *West Grove Independent*. Editorship passed from Lloyd to William T. Dantz and later to Charles Webster, who held the position from 1914 to 1964. It billed itself as "spicy, newsy, truthful" and enjoyed a wide circulation. In 1928, the business moved to the Evergreen Apartments. It ceased printing with the October 8, 1964, issue.

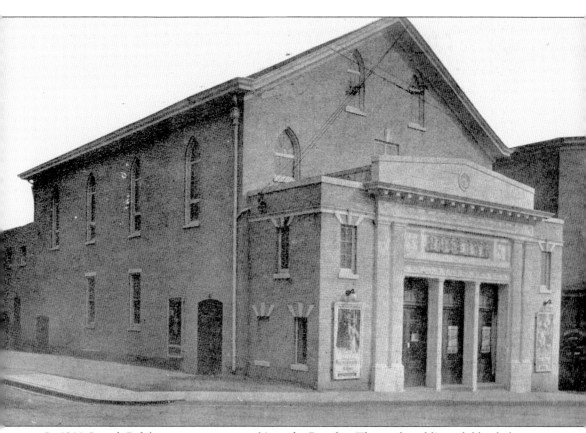

In 1914, Joseph Pyle's store was converted into the Roselyn Theatre by adding a lobby, balcony, and projection booth. It was called the Roselyn Community Center and had a theater available for "educational, religious, political and other popular assemblies, entertainments and institutes, etc." A. W. Gould was the manager. It was used for vaudeville acts and silent movies; when sound, or talkies, was added, it ran double features every Monday for the price of one. Those on the mailing list sometimes got special "novelties and features" like reduced tickets for the double feature, already a bargain! The West Grove Fire Company bought the theater in 1930. In 1935, the adult ticket cost 35¢ until 6:00 p.m. Saturday the movie ran continuously from 2:30 p.m. The programs stated, "Cool—the best cooling station in town. See the pick of the best talkies in cool comfort." Leon Ament was the projectionist from 1917 to 1976, making him a town institution. The theater closed in 1977 and was demolished in 1980. The Avon Grove Veterans' Memorial is now at the site.

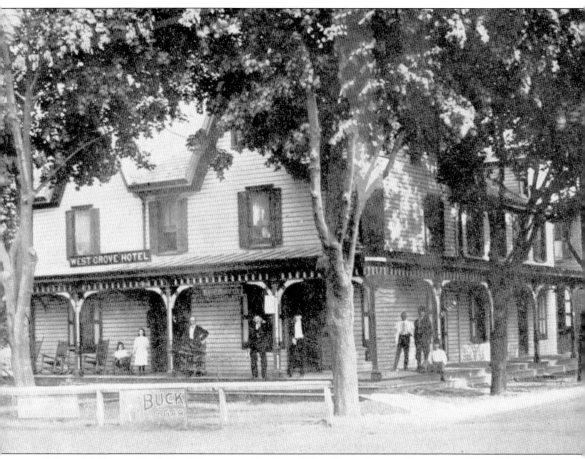

Hiram H. Bowers built the West Grove Hotel, or West Grove Inn, at the corner of Rosehill and Prospect Avenues in 1883. It offered 18 rooms for overnight guests, a parlor, a reception area, and a dining room large enough for 50 guests. Its grand opening was held on November 29, 1883, with invitations to dignitaries and leading citizens and a charge of $1 for the general public. Over 80 people enjoyed the dining experience in two seatings that first day. The inn was successful and had a good reputation, being described as "homey." General and special elections were held there. Mr. and Mrs. Thomas P. Kennedy of Oxford bought the inn in 1904 and subsequently published this card. Kennedy's tenure was marked by contention as he tried to obtain a liquor license several times with great opposition from the local citizenry. He eventually closed the inn and ran a boardinghouse for three years. Harry J. McLimans, a local builder, converted the building to apartments in 1924. The wraparound porch has been removed.

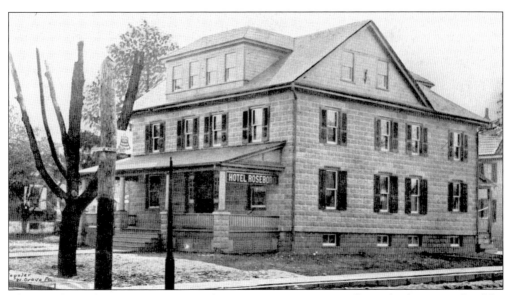

The Hotel Roseboro in West Grove (the New Temperance Hotel) was built as a result of the citizens' opposition to Thomas P. Kennedy's petition for a liquor license for his West Grove Inn. The West Grove Hotel Company was incorporated and raised almost $10,000 through stock subscriptions. Mrs. George Ortlip was hired as manager, and the grand opening was on March 3, 1909.

POST CARD

PLACE STAMP HERE

This space may be used for correspondence

THAT MAN for whom a birthday present is so hard to select would be pleased with a gift from our stock, which includes many articles specially suitable for *men:* Cigar and cigarette cases, match boxes, shaving brushes, mounted in silver and gold; cuff links and buttons, shirt studs, scarf pins, rings of every description, watch fobs and chains, and other jewelry, and *watches.* Prices right.

Fine watch repairing.

T. E. CLAYTON

1915		JULY			1915	
S	M	T	W	T	F	S
-	-	-	-	1	2	3
4	5	6	7	8	9	10
11	12	13	14	15	16	17
18	19	20	21	22	23	24
25	26	27	28	29	30	31

JEWELER AND OPTICIAN

General Repair Work

Jewelry Catalog Mailed on request,

WEST GROVE, PA

This space for the address only

The Osborne Co., Newark, N. J. No. 15.

Many local businesses sent cards to their customers with views of current topics on the front. The reverse of this card shows a German Krupp gun on motor that was being used during World War I. T. E. Clayton, jeweler and optician, sent this out in July 1915. He advertised gifts for men at the "right price." Clayton's business was on the left side of the West Grove Fire Company building.

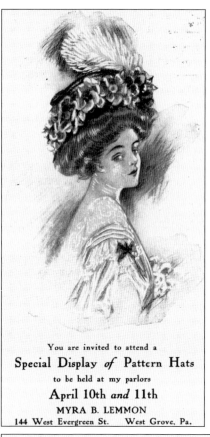

You are invited to attend a
Special Display *of* **Pattern Hats**
to be held at my parlors
April 10th *and* **11th**
MYRA B. LEMMON
144 West Evergreen St. West Grove, Pa.

Myra B. Lemmon used postcards to advertise the newest goods at her millinery store just as newspaper flyers do today. This card was sent to Coatesville to announce a special display of hats on April 10 and 11 around 1907. The store was at 144 West Evergreen Street. Lemmon previously ran a Victorian café on Exchange Place.

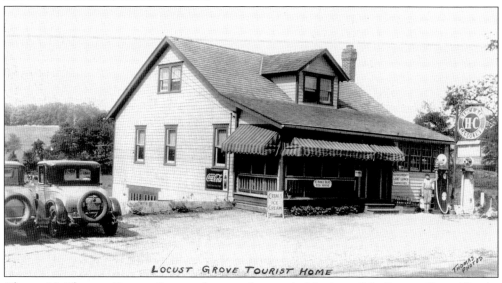

LOCUST GROVE TOURIST HOME

Chester H. Thomas, Kennett Square photographer, took this view of the Locust Grove Tourist Home that was on old Route 1 between West Grove and Jennersville. A sign on the porch reads, "E. Noble Rea's Tea House"; there are also advertisements for Coca-Cola, Crane's Ice Cream, and other refreshments, light lunches, and sandwiches. Sinclair Gasoline could also be purchased. This building has since been demolished.

40

MUSICIANS' JUBILEE FESTIVAL

SUNSET PARK
on Route 1, Between West Grove and Oxford

FRIENDS, OLD FIDDLERS, JITTERBUGS, MUSICIANS and any type of performers—you are respectfully invited to come, also bring your friends, and join our FIRST JUBILEE FESTIVAL,

SATURDAY, AUGUST 24, 1940
[Rain Date: September 7th]

The time of assembling is 10 o'clock standard time. Come early and stay late. Any musical instrument may be played on this programme. Also Singing, Dancing, etc. An amplifying system will be used.

Admission—ADULTS, 10c. CHILDREN, under six, FREE.

G. ROY WALTMAN, Owner

G. Roy Waltman started Sunset Park in Jennersville in 1939 with a stage, kitchen, concession stands, and picnic tables; a covered stage was added later. It became known as the Grand Ole Opry North. Roy's son Lawrence took over management in 1957. Many famous musicians appeared here, including Loretta Lynn, Conway Twitty, Ronnie Milsap, and Dolly Parton. The park closed after the 1995 season. The area is now a shopping mall.

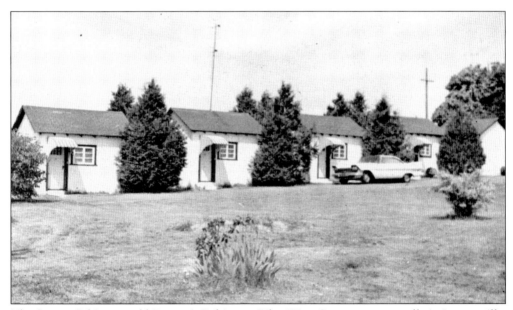

The Sunset Cabins, on old Route 1, Baltimore Pike, West Grove, were actually in Jennersville. Judging from the car in the view, they were in business in the 1950s. The cabins are no longer there.

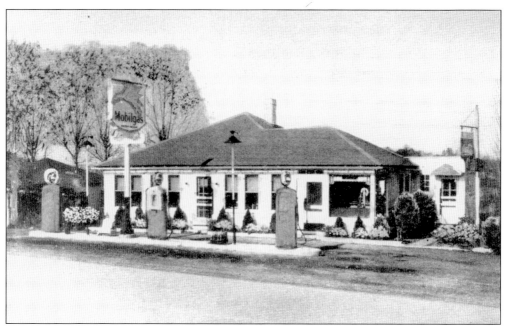

Located on old Route 1 between West Grove and Oxford (at Jennersville), the Evergreen Inn served "excellent foods—spaghetti our specialty." As with many of the early stops for travelers, food, as well as fuel, was available.

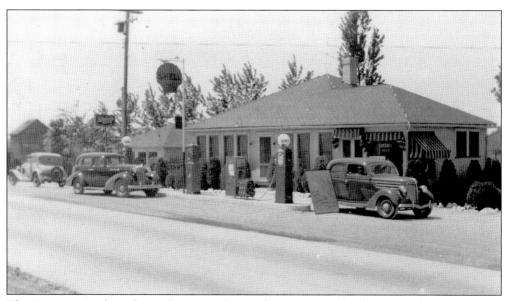

The Evergreen Inn later changed names to the Spaghetti House and still served its famous spaghetti according to area residents. Note the gas pumps changed from Mobil in the previous image to Shell. This establishment was on the site of the present Mason's Store near the Jennersville Regional Hospital.

Two

Transportation and Industry

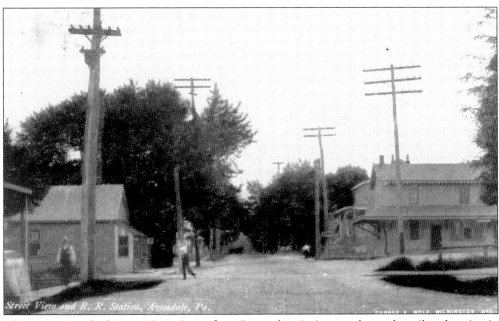

Street View and R. R. Station, Avondale, Pa.

This street view looking up State Street from Pennsylvania Avenue shows the railroad station in Avondale that had room for the station agent and his family on the second floor. The coming of the railroads spurred much growth in the area.

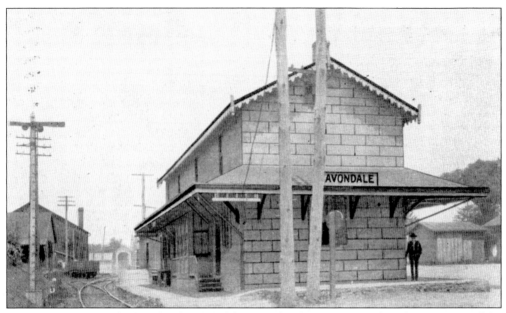

In 1854, ground was broken for the Philadelphia and Baltimore Central Railroad in Avondale. Eventually the Pomeroy and Newark Line also came through Avondale. Harvey Baker built the station, and local farmers did much of the grading for the lines using their own teams. The man standing at the station is Webster A. Nichols, a well-known auctioneer.

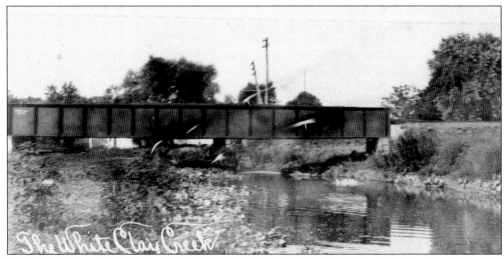

Shown in this real-photo postcard that was sent in 1914 is the railroad bridge that crosses the White Clay Creek in Avondale. This bridge is still in use and can be seen if one glances to the west while crossing the stone bridge on Baltimore Pike. To finance the railroad, stock was sold at $50. The engines were named *Brandywine, Kennett, Octoraro,* and *Port Deposit.* The last passenger service was in 1948.

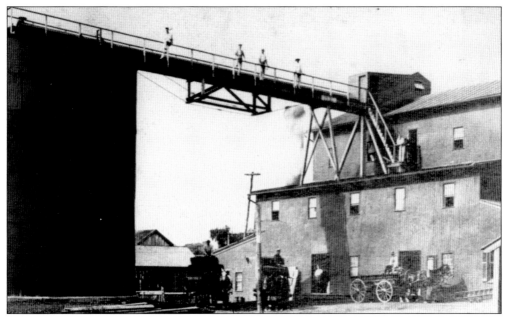

The Pennock and Brosius Mill of Avondale was originally built by William J. Pusey. This 1905 view shows, from left to right on the bridge, Robert Comblin, George Beck, Elmer E. Miller, and Chester McKim; on the steps are Chandler Logan and Clarence P. Fell; at the bottom doorway is James McDonald, bookkeeper; and with the team in front of McDonald is George Pennock of Chesterville. The others are unknown.

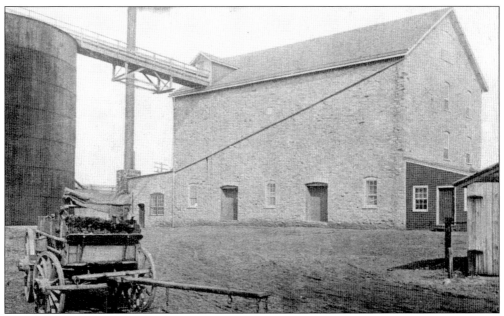

The Excelsior Rolling Mill replaced the Pennock and Brosius Mill after it was destroyed by fire on June 26, 1906. Feed and flour were ground and sold there. An early advertisement states, "Try our Superior Flour, the product of Modern Machinery." The mill had an 80-foot smokestack weighing 3.5 tons. Subsequent owners were the Chester-Delaware Farm Bureau, Chapman Industries, Carborundum, and, now, the Edlon Company.

The West Chester, Kennett and Wilmington Trolley Company began running cars to Avondale in September 1904 as far as the county (stone) bridge on Pennsylvania Avenue. It took some time to receive permission to cross the bridge. Thomas O'Connell, president of the Oxford, West Grove and Avondale Line was finally able to complete the line and settle the disputes with the county and Pomeroy and Newark Railroad and extend the line to West Grove. In both of these images, the trolley is shown on Pennsylvania Avenue. In the real-photo postcard below, the bank can be seen clearly as well as the horse and buggy coexisting with "modern" technology. Fares were 5¢ on a zone basis. A round-trip from Kennett to Avondale took 30 minutes. The trolley tracks were removed in 1937.

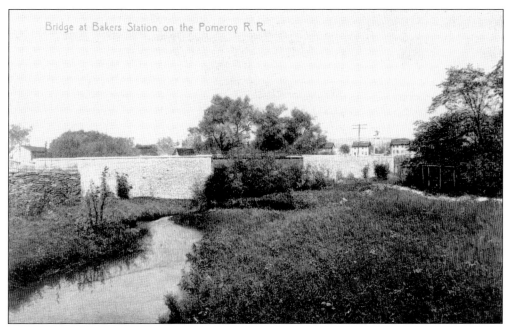

The Pomeroy Railroad served the quarry industry and residents at Baker's Station with two runs a day traveling over the bridge seen here. It also served the Pennsylvania State Experimental Farm now on Prang Road. The railroad connected with the main line of the Pennsylvania Railroad and also connected Avondale with Newark, Delaware.

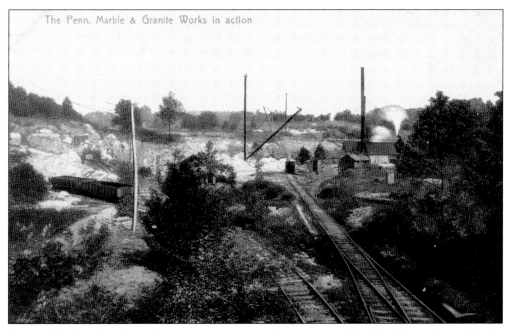

Much of the London Grove Township area sits on a large granite dike. The Pennsylvania Marble and Granite Works (or Baker's Station Quarry named for Aaron Baker) began in 1815 with limestone production. The quarry was located on Charles Halsey's farm (later the Hepburn property) and was called the "upper" quarry by local residents.

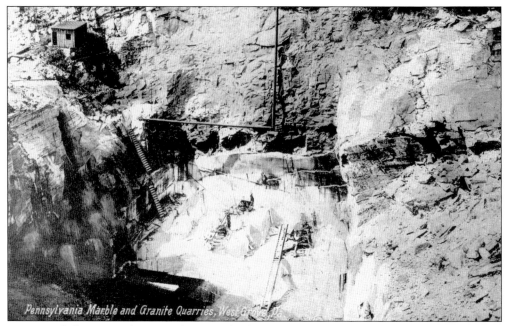

Mary E. Phillips, a teacher, sent this view looking into Baker's Station Quarry to her students on June 11, 1908, with the following message: "These derricks are very tall, one of them being third highest in the United States. They are used for hauling the blocks of marble from the quarry hole which is over 100 feet deep."

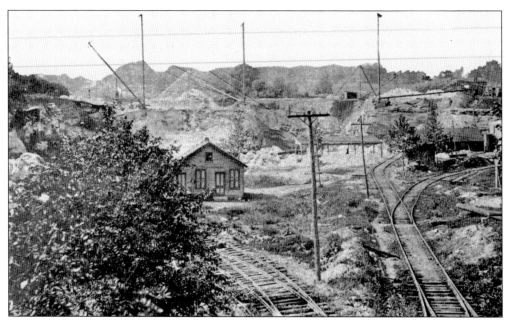

Baker's Station sits on a hill between old Route 1 going to West Grove and Route 41 going to Chatham. Some of the original buildings in the settlement were destroyed when the bypass was built. In 1855, Joshua Hunt of Avondale was responsible for one of the innovations that resulted from the quarry industry. He invented a "continuous lime kiln based on burning oil."

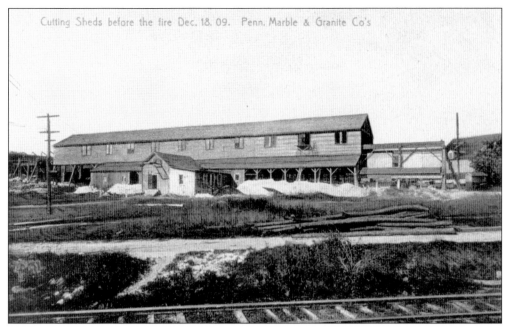

In 1893, marble was discovered under the limestone at Baker's Station, and it was determined to be equal in quality to that from Carrera, Italy. An Italian community of about 200 residents grew around the industry here. Town members organized a brass band of 37 members and had a festival and fireworks every August. The cutting sheds shown above burned on December 18, 1909.

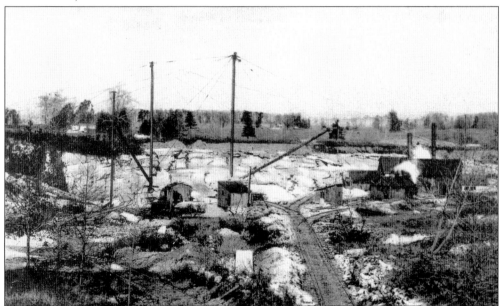

Marble quarried at the Pennsylvania Marble and Granite Works was used to build the courthouses in Media, Pennsylvania, and Patterson, New Jersey; the post offices in Hanover and York, Pennsylvania; and the pillars of the First National Bank in West Chester, as well as many other edifices. At the Columbian Exposition in 1893, the company was awarded a prize for its statuary marble. The quarry closed in 1919.

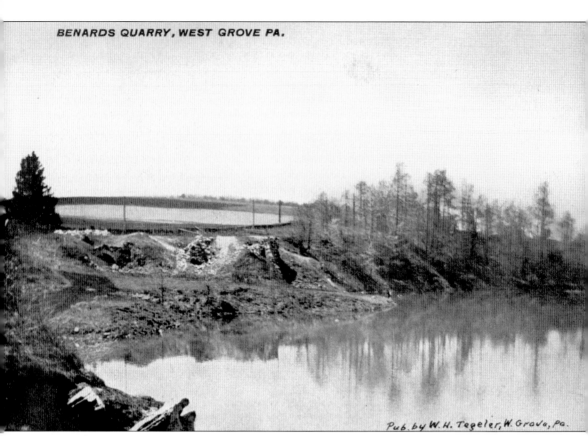

BENARDS QUARRY, WEST GROVE PA.

Pub. by W. H. Tegeler, W. Grove, Pa.

Bernard's Quarry was near the cloverleaf of the Route 1 bypass at West Grove and was filled in during construction of the bypass. Watson's Quarry operated on Indian Run Road in Avondale. On Lake Road, the Avondale Quarry, or "lower" quarry, was in business on the property of Charles Hughes. It was the site of another Italian community. This quarry, along with Baker's Station and others in the area, ended production when they were flooded by underground springs. Workers at the Charles Hughes Quarry on Lake Road reported that the flooding came on so quickly that although the men were able to escape, the mules and equipment were lost. That site was used as a swimming hole for years and later became the Avon Lake Club with swimming and a shooting range for members. It is now closed and inaccessible. Today there are surface quarries still operating in Avondale that produce Avondale Brownstone, sand, and gravel. D'Amico Quarry and the Avondale Quarry are both on old Route 1 as the road heads north to Kennett Square.

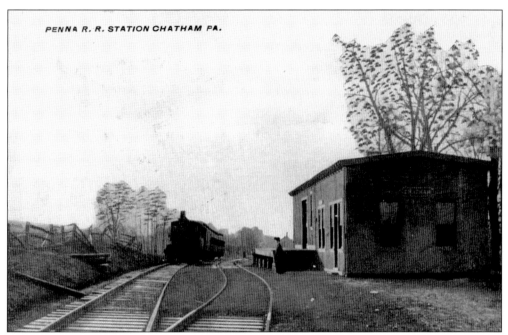

The Pennsylvania Railroad Station in Chatham was located just off Route 41 north of the village and was served by the Pomeroy and Newark branch of the Pennsylvania Railroad. George W. Lefever was one of the earliest proponents of a railroad that would connect Pennsylvania and Delaware and have a station in Chatham. He became president of the Doe Run and White Clay Creek Railroad that later changed its name to the Pennsylvania-Delaware Railroad Company. The grand opening of the station was on June 30, 1873. This venture had a huge impact on business. John Carter's Creamery and Frank's Sausage Company were two of the businesses to benefit. The station seen here was for freight and can still be seen opposite J and L Tire Service. A passenger station was on the opposite side of Route 41.

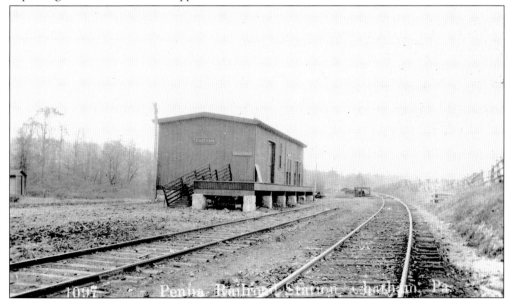

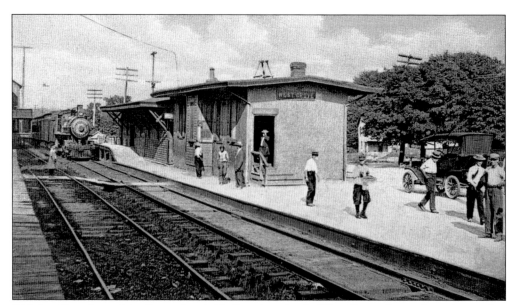

This bustling view of the Pennsylvania Railroad station in West Grove shows the train coming in and people waiting on the siding. The station was built in 1860 and renovated in 1873 to add a ticket office and waiting rooms. Train passenger service was discontinued in 1948. The view below shows the buildings across the tracks. The large frame buildings were the warehouses of S. K. Chambers and Brothers, who had a lumber, coal, grain, and seed business established in 1868. The small brick building was the Chambers freight weighing station—the first and only railroad platform scale on the Baltimore Central Railroad line. S. C. Shortlidge bought this business in 1923. The two buildings in the foreground are still standing, although the large building is now stucco. The small building is now the Station Ice Cream Store.

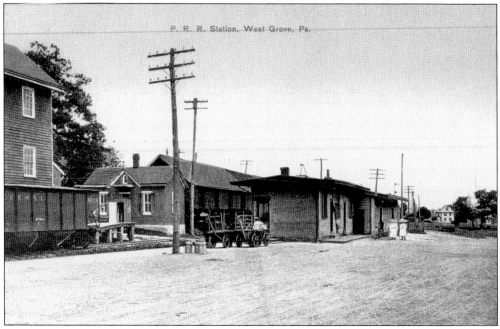

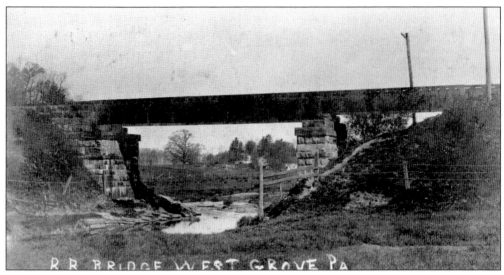

This railroad bridge can still be seen at the west end of West Grove just past Brackin's Garage on the left side leaving town.

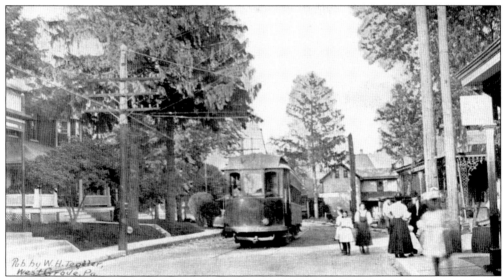

The first regular trolley from Avondale to West Grove ran on April 20, 1906. The tracks entered on Evergreen Street and ended at the intersection with Oakland Avenue. The Oxford, West Grove and Avondale Street Railway operated this line using cars from the West Chester, Kennett and Wilmington Lines. This service ended in 1923, but the West Chester Street Railway took over until 1928, after which trolley service ended in West Grove.

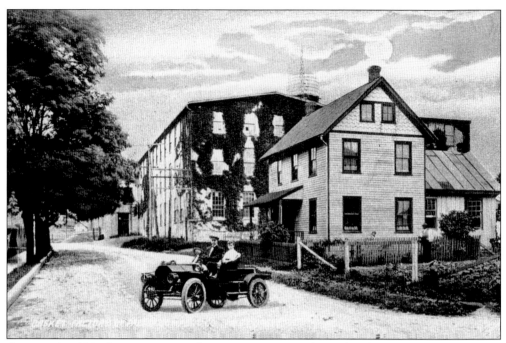

On May 1, 1885, the Paxson Comfort Company opened a casket factory in West Grove at 104 Walnut Avenue. It was three stories high and measured 50 feet by 100 feet with a 30-foot-by-40-foot attached boiler house, the largest type in the county. The building cost $11,000 and was made from local limestone. Coffins could be ordered in yellow pine, oak, chestnut, poplar, gum, walnut, birch, or maple. By 1886, 60 men were employed and 25–30 caskets were made per day. Overtime was needed as the result of the Johnstown, Pennsylvania, flood in 1889 and later for World War I and the influenza epidemic of 1918. The largest casket ever made at this factory was to accommodate a six-foot, 600-pound person. It was seven feet long, three feet wide, and two feet deep and was shipped to Frankfort in Philadelphia.

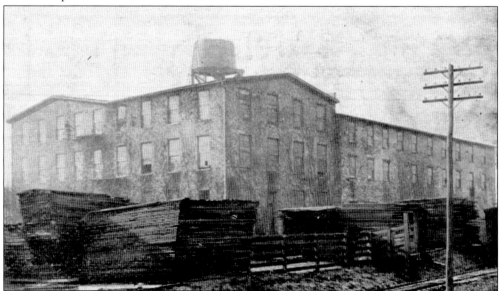

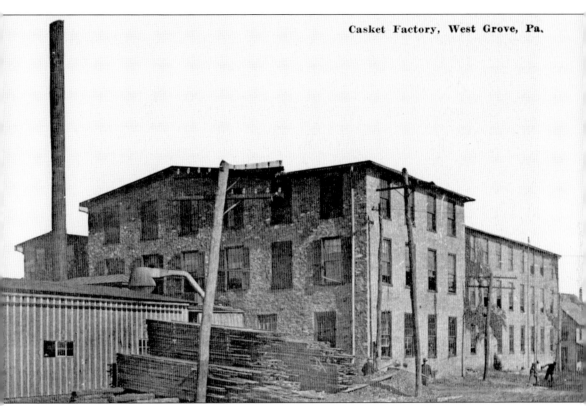

James L. Lovett was superintendent of the casket factory for years, and locals remember him going to the bank and carrying a "big bag of cash" to pay the workers every Saturday. The casket factory went through several economic fluctuations and owners over the years. In 1920, it became McCloskey Millwork Company that made door and window sashes and radio cabinets. A spectacular fire on October 11, 1928, ended this business. It burned for eight hours, and the glow from the fire was reported as far away as West Chester, Pennsylvania, and Wilmington, Delaware. A total of 23 fire companies responded, including ones from Baltimore, Maryland, Dover, Delaware, and Media, Pennsylvania. Water was obtained from creeks and the quarry as well as fireplugs. By the time the fire was under control, it had burned one million feet of lumber, the millworks, and several nearby homes, causing $500,000 worth of damage. In 1933, a knitting mill (whose name changed several times) was constructed on this site. It has since closed.

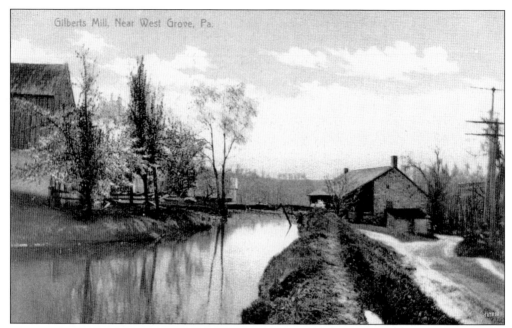

Now known as Gilbert's Mill, this structure, built around 1750, was first known as Water Corn Grist and Merchant Mill and later Willow Grove Grist and Saw Mill. Darlington Pyle operated it in the mid-1800s. From the 1880s to 1919, it was operated by Edwin Gilbert and his son, Jesse, and was a cider and feed mill.

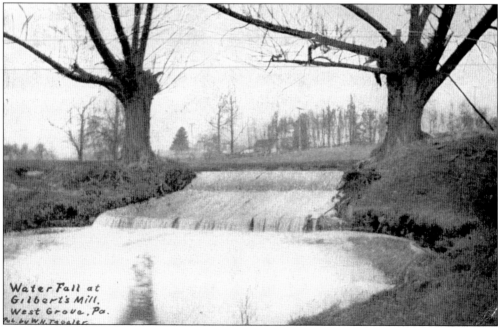

Gilbert's Mill was later turned into a residence, and there was a candle shop there for a time. It can be found on Route 841 between West Grove and Chatham at 318 Chatham Road. The waterfall shown above at Gilbert's Mill is where the millrace emptied back into the White Clay Creek. Local druggist W. H. Tegeler published this postcard.

The mill in this view has been converted into a home. It was known as Wickerton Roller Mills, owned by E. C. Chandler, who operated the mill until 1932. It had a creamery and general store and served as a post office from 1892 to 1901 with Chandler as postmaster. Wickerton is south of West Grove in the southern part of London Grove Township. The settlement underwent many name changes: Walnut Grove, Canningsville, Wickersham Mills, and finally Wickerton.

Harvey's Mill was one of many mills supported by the White Clay Creek. The mill was on Paschall Mill Road. Harvey's Dam, shown above, was near the mill, west of West Grove. Both the mill and dam have been demolished.

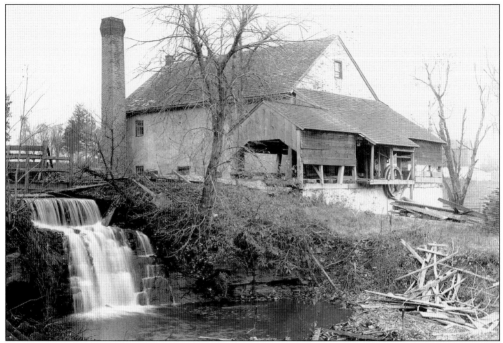

Thirteen miles of the White Clay Creek run through the middle of London Grove Township as well as near Avondale, West Grove, and other parts of Chester County before meeting with the Christiana Creek in Delaware. The scene above is the old Phillips Mill on Ewing Road near West Grove; it is no longer standing. The scene below shows the creek as it passes under a bridge on the Baltimore Pike in Avondale. Apartment buildings now sit to the left of the creek in the view below. The original photograph used for the postcard was taken by William Chambers. (Above, courtesy of John Ewing.)

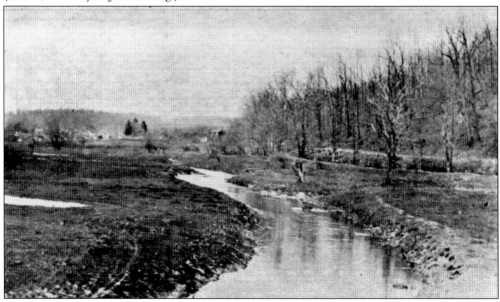

Three

THE HOME OF THE ROSES

The Conard-Pyle Company, successor to the Conard and Jones Company, sent this postcard advertising its Rouge Mallerin rose with a glowing scarlet color and rich damask fragrance—two for $1.

59

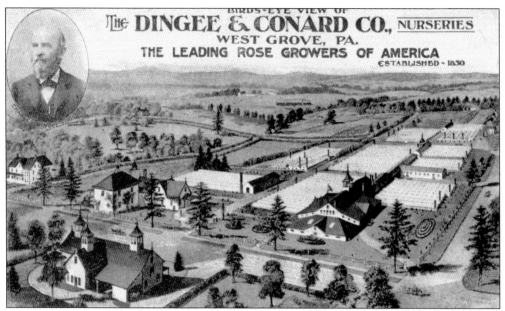

Thomas Harvey started the first nursery business in West Grove. Alfred Conard, an employee of Harvey's, joined with Charles Dingee in the mid-1800s and established the Dingee and Conard Company. In the 1890s, the Conard and Jones Company was established. Both of the cards on this page show an overview of the company's extensive greenhouses and fields, packing sheds, offices, and retail facilities. These facilities were southeast of West Grove on State Road and Rosehill Road. Charles Dingee is shown in the oval portrait on the card above. In the bottom left of the card below can be seen the intertwined *D* and *C* used as a logo during this time.

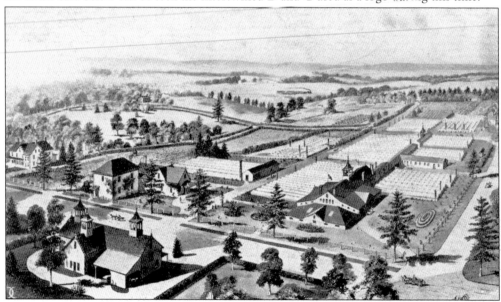

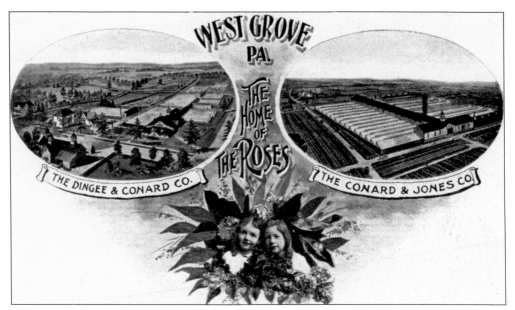

The image above titled "West Grove PA., the Home of the Roses" shows both the Dingee and Conard and Conard and Jones names; views of portions of the nursery are reproduced in the ovals. The card below shows the many greenhouses and cultivated fields. The logo in the lower right is now made up of a *C* and *J*. In 1925, Robert Pyle and his son, Robert, bought the nursery and renamed it Conard-Pyle. He registered Star Roses as the trademark for his roses, and they are still highly sought after in the nursery business today. Conard-Pyle's retail business was closed in 1978, but the wholesale business is still going strong.

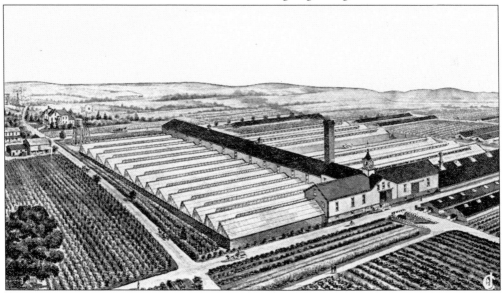

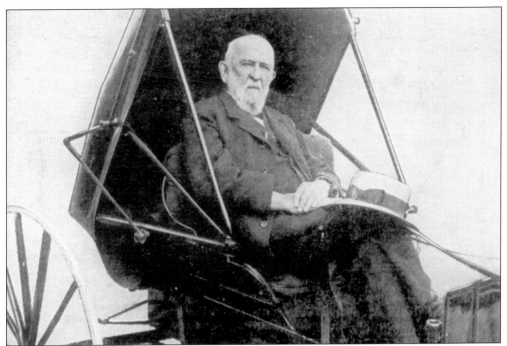

At 84 years of age when this card was produced, the founder of Dingee and Conard is shown on this advertising postcard introducing the "Peerless New Rose, Charles Dingee"; it was called "the crowning masterpiece" of the last 60 years, said to never be out of bloom and hardy everywhere. At this time, Dingee was not active in the business but still interested in the company he founded.

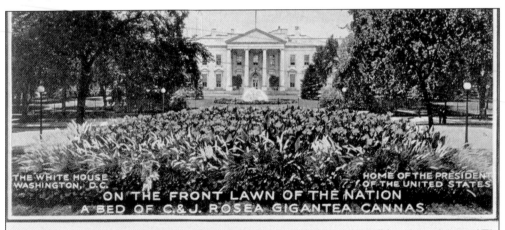

THE WHITE HOUSE
WASHINGTON, D. C.
HOME OF THE PRESIDENT
OF THE UNITED STATES
ON THE FRONT LAWN OF THE NATION
A BED OF C.&J. ROSEA GIGANTEA CANNAS

Visitors at Washington, D. C., are impressed with the wonderful beauty of the well-kept grounds around The White House, Capitol and Public Buildings. Those in charge of these grounds insist upon having "none but the best," and consequently use C. & J. Cannas almost exclusively for bedding.

You can make *your* lawn as beautiful, too, all summer long if *you insist* upon having C. & J. Cannas "Rosea Gigantea" strong plants 30 cts. each, $3.00 for 12; $22.50 per 100, prepaid. See catalog for 70 other varieties.

THE CONARD & JONES CO. *Rose and Canna Specialists* WEST GROVE, PA.

Groundskeepers in Washington, D.C., in charge of the White House, Capitol, and public buildings "insist upon having 'none but the best,' and consequently use C. & J. Cannas almost exclusively for bedding" in this *c.* 1908 view. The back lists the varieties of cannas available with the names and descriptions and how many plants would be needed for various size beds.

The new canna, William Saunders, is shown here. Antoine Wintzer is quoted, "Of the many thousands of hybridized seedlings produced by me, none approach nearer the ideal canna than this peerless variety." This card acknowledges an order from Ross, Iowa.

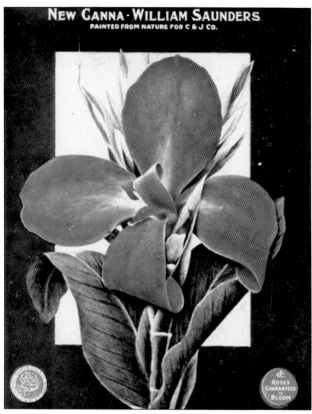

Charles Dingee employed Antoine Wintzer from Alsace, France, as his grower. In 1866, Wintzer began by growing roses from cuttings supplied by E. G. Hill of Harmony Grove Farm nearby. Wintzer also developed many species of canna lilies and was given the nickname "the Wizard of Cannas." Although a majority of their cards show roses, this one shows a field of canna lilies.

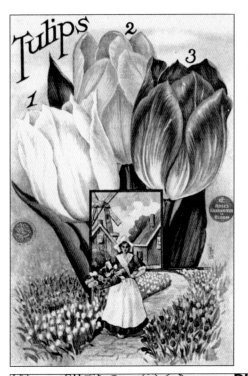

Evoking their origin in Holland, this card advertises three different tulips that could be bought from the Conard and Jones Company for 25¢ for 3 of each kind, 12 in all. The bulbs were guaranteed to bloom. The company shipped by Adams Express.

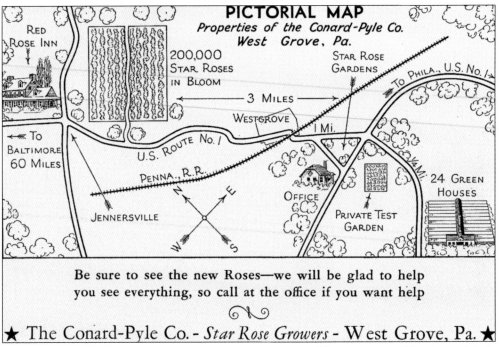

Although not in proper perspective, this gives an overview of the properties of the Conard-Pyle Company, showing both the West Grove and Jennersville sites. This is a double-fold handout in which customers could write their wish list for flowers. The back is an advertisement for the company as well as one for the Red Rose Inn where customers could "refresh themselves . . . in cool spacious rooms . . . and select surroundings."

When Robert Pyle became the head of Conard and Jones, later Conard-Pyle, he registered the name Star Rose as the trademark for their roses. He and his wife entertained many famous customers, including Helen Keller, who visited the nursery and was a guest at Rose Hill, the Pyles' home.

"*And soon we shall have thinkers in the place of fighters. What ye want is light, indeed— God's light, organized In all high souls.*"

With Christmas Greetings and Best Wishes for the New Year

ROBERT AND HANNAH C. PYLE

"Rose Hill"

WEST GROVE, PENNSYLVANIA

No stranger to famous people, the Conard and Jones Company received orders from Clara Ford, Thomas Edison, Lou Henry Hoover, Walter P. Chrysler, and Henry S. Firestone to name a few. The Star Roses that Pyle trademarked are still a standard in the industry today.

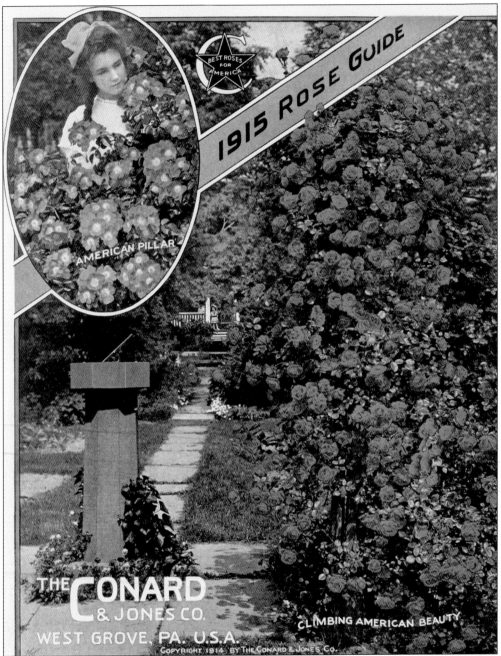

THE CONARD & JONES CO.
WEST GROVE, PA. U.S.A.

1915 ROSE GUIDE

BEST ROSES FOR AMERICA

AMERICAN PILLAR

CLIMBING AMERICAN BEAUTY

COPYRIGHT 1914 BY THE CONARD & JONES CO.

Conard and Jones catalogs were highly illustrated with much detail on the plants offered and are fascinating reading even today. Foreign orders came from King Boris of Bulgaria and Emperor Haile Selassie I of Ethiopia, among others. Although they are the most famous and prosperous of the nurseries in the area, the climate and soil supported many other such businesses: Harmony Grove owned by Isaac Jackson; Brae Mawr Farm owned by H. H. Corson and Sons; Meadowside Greenhouses owned by Odone Rosazza; Joseph T. Phillips and Sons (new and rare plants); W. R. Shelmire (carnations); and florists George J. Hughes, E. J. Cloud, C. D. Clayton, William A. Coltrain, G. W. Renard, and Myron I. Pickel.

66

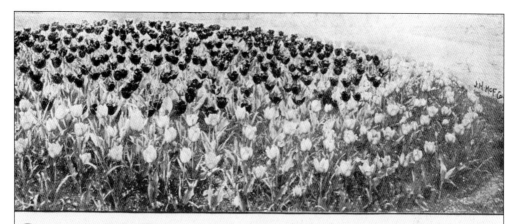

Great Values in Bulbs and Plants

REMARKABLE 50 CENT COLLECTIONS

The Collections of Bulbs and Plants for house-blooming are, without doubt,
the greatest value to be had, and any one of the collections
will give untold pleasure to the fortunate possessor

Collection 1.—10 Hyacinths, five double | 50c. Collection 9.—We will send 6 hardy Fl

This "Special Offer Mailing Card" was sent to those who had received the Dingee and Conard fall catalog and had not responded with an order. It offered a selection of bulbs and plants for 50¢ that would include the recipient as one of the many thousands of "Dingee Flower Folks" all over the country. (Courtesy of James and Kathleen Gears.)

"HOW TO GROW ROSES"

A handsome book of thirty-six pages in beautifully colored covers and sumptuously illustrated—interesting, instructive and invaluable in showing you simply what you need to know and have and do to get an abundance of handsome bloom—also a list of 101 of the Best Roses in America, telling how to prune each one; also a Rose lover's calendar.

Price, 10c., or Free on request with a $1.00 order.

The Conard & Jones Co., West Grove, Pa.

The card above shows a little girl in a field of roses. The message in the upper right corner could be changed depending on what the company wanted to advertise at the time. There were advertisements for roses, peonies, and cannas. The back of the card has a star logo with the slogan "The Best Roses in America."

"GREAT MOMENTS IN HISTORY"
The Vanderkraats leaving Holland for America

The Vanderkraats family had been in the rose business in Holland, and in the 1920s, they moved to the United States. They established Paramount Nurseries on land they purchased in Jennersville, Pennsylvania. Robert Pyle hired Arie Vanderkraats in 1927, and the Conard–Pyle Company bought all his roses for several years. Paramount built a large storage facility near Jennersville that held 500,000 plants. They sold roses at wholesale to other nurseries. The office was on the West Grove side of the old Wooden Shoe Inn on the Baltimore Pike, and a Dutch windmill, the symbol of the company, could be found on the other side of the Wooden Shoe. The blotter above shows the family's emigration as "Great Moments in History" and also shows their patriotism with the Statue of Liberty and its inscription. Paramount Nurseries was sold around 1970.

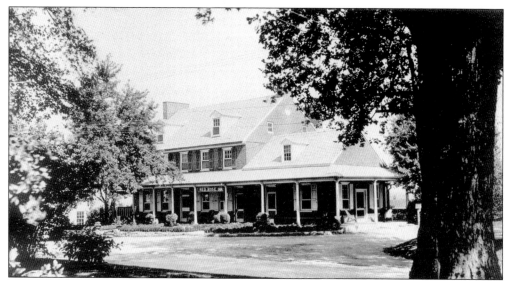

The Red Rose Inn sits on land granted to William Penn, grandson of the founder of Pennsylvania. In 1740, Samuel Cross built the inn, and a large addition was built in 1829. The deed stipulated payment of one red rose a year to Penn or one of his descendants. Robert Pyle of Conard-Pyle instituted Red Rose Rent Day in 1937 to carry on the tradition.

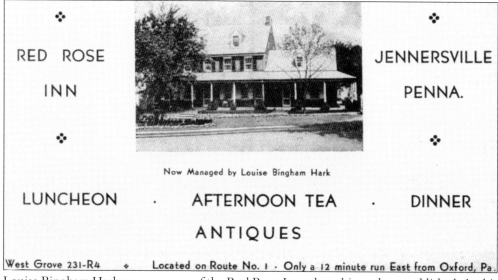

RED ROSE INN JENNERSVILLE PENNA.

Now Managed by Louise Bingham Hark

LUNCHEON · AFTERNOON TEA · DINNER

ANTIQUES

West Grove 231-R4 ❖ Located on Route No. 1 · Only a 12 minute run East from Oxford, Pa.

Louise Bingham Hark was manager of the Red Rose Inn when this card was published. At this time, besides lunch and dinner, the inn served afternoon tea and advertised its antiques shop. It was "only a 12 minute run East of Oxford, Pa." The Red Rose Inn is still in business today.

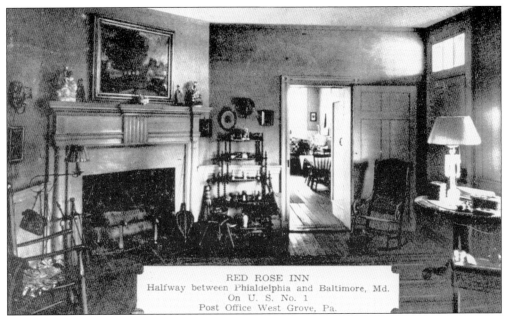

RED ROSE INN
Halfway between Phialdelphia and Baltimore, Md.
On U. S. No. 1
Post Office West Grove, Pa.

Victorian decorations and furnishings can be seen in this view of the entry and dining room at the Red Rose Inn. An antiques and gift shop was operated at the inn for many years. Carpeting now in place reflects the rose heritage with large red roses on a deep green background.

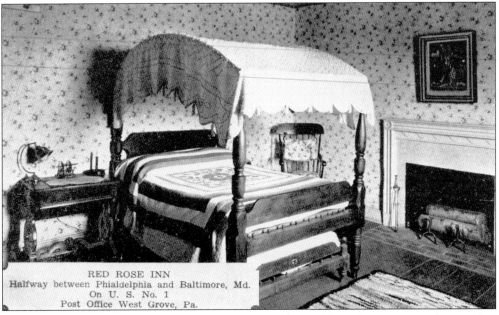

RED ROSE INN
Halfway between Phialdelphia and Baltimore, Md.
On U. S. No. 1
Post Office West Grove, Pa.

Located halfway between Philadelphia and Baltimore, the Red Rose Inn was a popular stopping place for the last two centuries. Note the antique rope bed in this picture of one of the guest rooms. In conjunction with the rose business, the inn was visited by many well-known patrons. In 1941, Grand Duchess Charlotte of Luxembourg came to see the introduction of a rose in her name.

70

Four

Community
Institutions

A Sunday Afternoon Community Meeting
Will be held in the West Grove Presbyterian Church
February 19th, 1933, at 2.30 P. M.
Hon. WILLIAM D. UPSHAW
U. S. Congressman from Atlanta, Georgia, for eight
years, will speak on
"America's Greatest Battle"
SPECIAL MUSIC
Come and Bring Your Friends

Along with the lecture hall in Avondale, the town hall in Chatham, and the Hall Building in West Grove, the local churches were the sites of cultural events, as shown on this postcard from the West Grove Presbyterian Church.

Still standing at 411 Chatham Street in Avondale, this building, constructed in 1894, replaced a frame building constructed by London Grove Township. It served first as a grammar school; the first high school courses were begun in 1900 with two years offered and later three years. Surprisingly, in a time before women's suffrage, the board of education in Avondale had three men and two women from the day of its establishment.

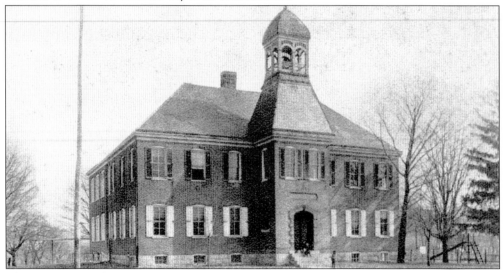

This view was made around 1916 when a four-year vocational high school was established, one of the first in this area of Pennsylvania. There were forge and dairy rooms in the basement, a homemaking department, and two agriculture teachers. In 1919, five students and their teachers were chosen by the Pennsylvania Farm Product Exhibition to receive honors at the farm show in Harrisburg. Now privately owned, the building is being restored.

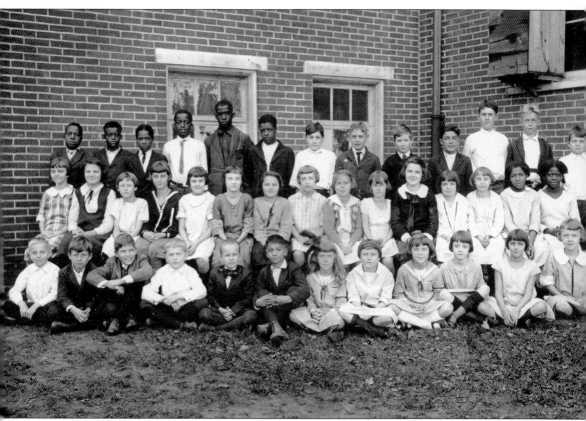

The third and fourth grades of the Avondale School are shown in this 1923 photograph. From left to right are (first row) William Elrich, Maynard Hodgson, Charles Logan, Robert Elrich, Nathaniel Watkins Jr., Nicholas Corby, Anne Marshall, Margaret McCue, Ruth Marshall, Jane Armstrong, Margaret Rosazza, and Elizabeth Pusey; (second row) Helen Miller, Esther Cleveland, Ada Jones, Mae Allison, Margaret Yeatman, Thelma Logan, Anna Cleveland, Evelyn Renard, Emily Marvel, Edith Watkins, Carol Gould, Rosalie Miller, Mary Gorman, unidentified, and unidentified; (third row) Herman Lee, Arthur White, LeRoy Boyer, unidentified, Norman Thompson, Radford Mitchell, Jesse Rakestraw, Lincoln Buckley, John Elrich, Ralph LaFrance, Smedley Thomas, Orville Jones, and Owen Miller.

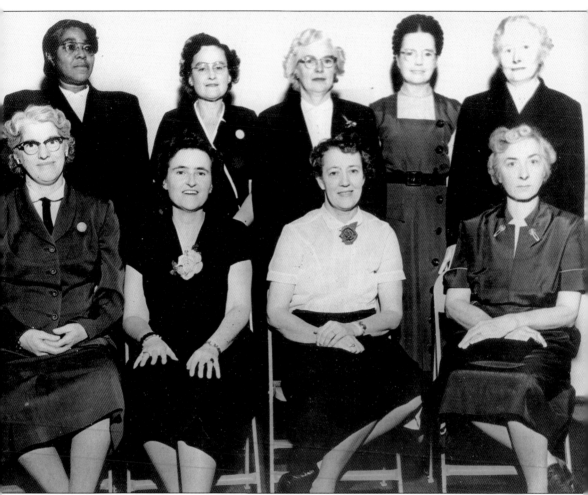

At the time of this picture, the 1940s, the Avondale School was used for the elementary grades exclusively. There were nine teachers who taught 266 students. From left to right are (front row) Helen Heald, grade 3; Helen Carlin, grade 1; Helen Carroll, grade 6; and Mae Moore, grade 4; (second row) Mabel Harmon, grade 4 Union Room; Mary Skillen, grade 4; Mary Hyde, grade 2; Doris Redmond, grade 4; and Elizabeth Reynolds, grade 6 and principal. Many of the teachers taught at other schools prior to coming here: Reynolds, Penn Township and Delaware County; Carlin, London Britain Township, West Ward, Downingtown, and Barnsley; Hyde, East Grove School; Moore, Unionville; Heald, rural schools; and Skillen, Lincoln University. The other teachers had many years at Avondale. Harmon was in her 31st year of teaching when this picture was taken. Several of these teachers moved on to the West Grove School when the Avondale School was closed.

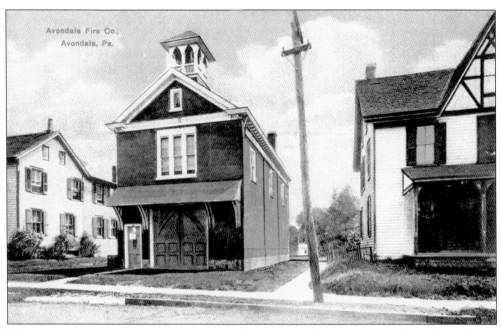

The Avondale Fire Company was organized in 1888. A hand engine and 700 feet of hose were ordered for $804. The building above was constructed in 1895, on land purchased from Herbert K. Watson. It held the Avondale Municipal Building and Fire Company. Marshall J. Russell built the structure that still stands on Chatham Street between Second and Third Streets. It is a private residence; the tower has been removed.

Shown about 1950, this building was constructed for the Avondale Fire Company and Borough Hall. It is still used today by the fire company and can be found on Pennsylvania Avenue. The Medford–Dunleavy appliance business was in the building on the right. It has been demolished, and the site is now a parking lot.

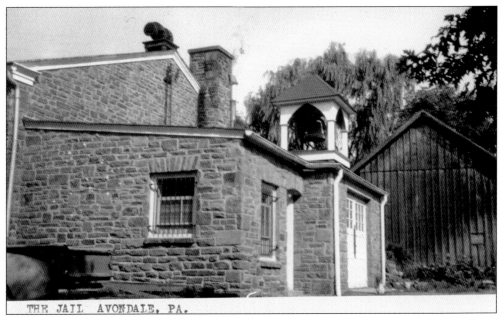

THE JAIL AVONDALE, PA.

In 1950, when the new Avondale Fire Company and Municipal Building was constructed, a jail was also included as part of the building. This structure can still be seen on Morris Street at the back of the fire company building. It is now the fire company kitchen.

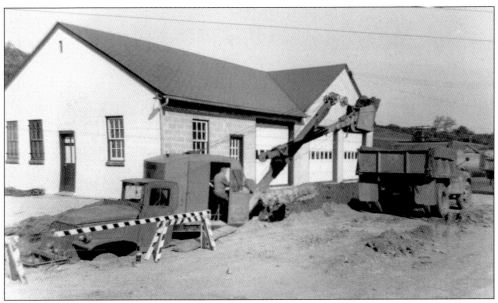

In 1953, it was decided that a new location for the jail was needed. A new borough hall was built on Pomeroy Avenue, and the jail was housed there. The building is still in use as a borough hall.

Built in 1896 by Charles S. Wilson for $4,225 excluding the heating system, this building was used as the National Bank of Avondale (first established in 1891 in the old Bachelor's Club building). The structure has been used as a bank ever since it was built, going through many mergers and name changes including National Bank of Chester County, Southeast National Bank, and Fidelity; it now houses the Sovereign Bank. The stone used in the building is Cockeysville Marble from the Baker's Station Quarry north of Avondale. The bank was saved from destruction when the Passmore Supply Company (adjacent to the bank on the site of the old roller rink) caught fire on January 30, 1966, during a blizzard.

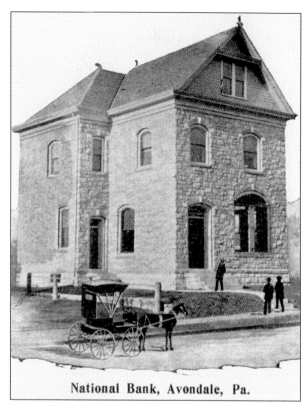

National Bank, Avondale, Pa.

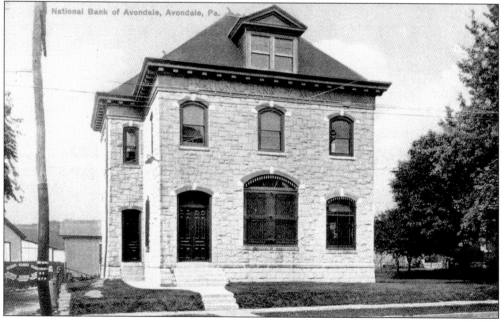

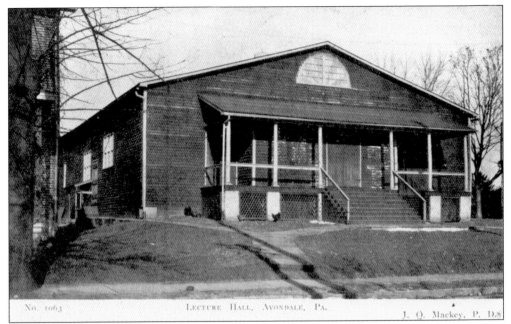

Also called the opera house, the lecture hall was built in 1904 by Harry P. Little. Among the famous speakers who came to the hall were Booker T. Washington and Champ Clark. Performances included the Mozart Symphony Club of New York City and the Boston Orchestral Company. The lecture hall was on State Road next to the Ponte Building. It was sold in 1910 and used as a feed warehouse.

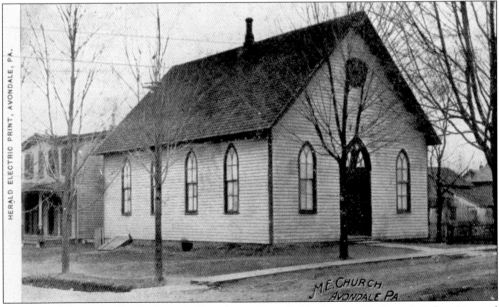

The Avondale Methodist Episcopal Church was founded in 1868 with Rev. J. Baker Steward ministering to seven people in his home. Built in 1880, the structure above became the first permanent home of the congregation. When the new church was built, London Grove Grange bought this structure for $800 and used it until 1999. It sits at the corner of Second and Chatham Streets and is now a private residence.

Land for the Avondale Methodist Episcopal Church at Second and Chatham Streets was bought from James Watson. This rare image shows the pulpit of the church decorated for Children's Day about 1902. At this time, Rev. A. A. Thompson was pastor.

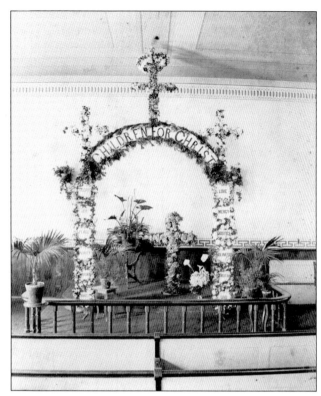

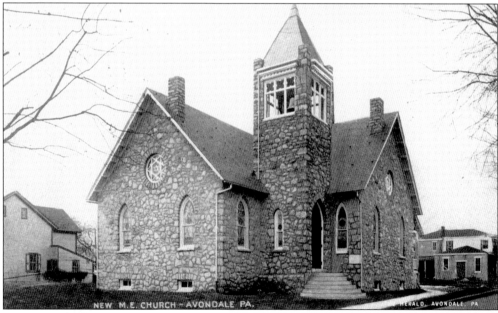

A new Methodist Episcopal church was constructed in 1907 on land where William Search had operated a greenhouse at the corner of Third and Chatham Streets. H. L. McLimans was the contractor; the church cost $9,000 to build. Members donated 20 stained-glass windows. Rev. Ken Hall is the pastor now. In the background on the right, the former Eastburn Funeral Home can be seen.

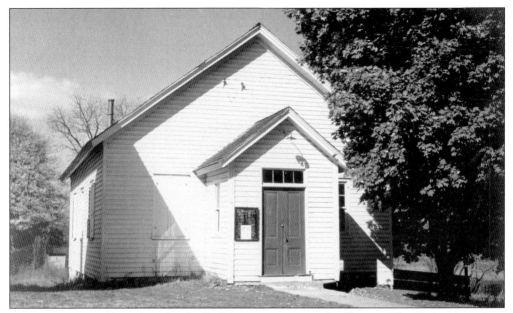

In 1878, New Garden Township built this structure as a schoolhouse. The Union American Methodist Episcopal Church of Avondale was the owner of the structure when this photograph was taken. Today members of the Galilee Union American Methodist Episcopal Church worship here. It can be found right before the bridge over the White Clay Creek on Third Street.

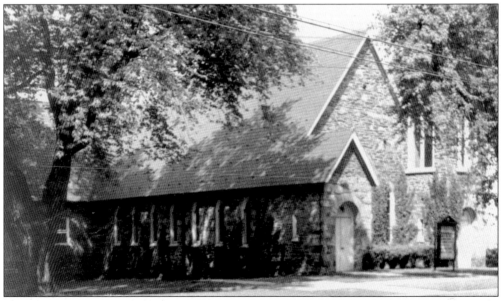

The Avondale Presbyterian membership of 12 first met in Ziba Lamborn's Hall under the direction of William C. Moore of West Chester. In 1872, land was purchased from Howard L. Hoopes, and a church was constructed of local stone for $4,300 at 410 Pennsylvania Avenue. The church was dedicated in 1874. The first minister was Rev. John S. Gilmor of Kennett Square. Serving the community today is Rev. Ray Meute.

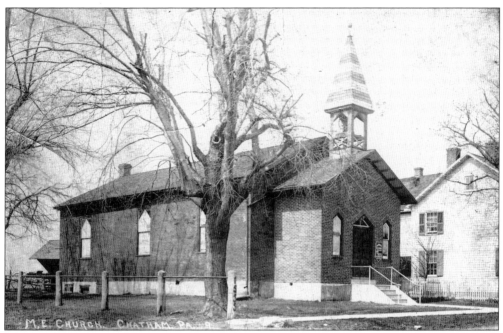

George W. LeFevre bought land for the Chatham Methodist Episcopal Church in July 1845. The church was built in 1846 and enlarged by 20 feet in 1859; later a vestibule was erected. In 1868, the Chatham and Avondale Methodist Episcopal Churches decided to share a pastor. This worked for many years, but in 1982, both churches became independent charges with a full-time pastor of their own. In the image below, the horse sheds that were built in 1890 can be seen at the rear of the building. The image above shows the house next door to the church that was purchased as a parsonage in 1965; members of the church and community renovated this building. Still a thriving part of the community, the Chatham Methodist Church is led by Rev. Robert A. Crane.

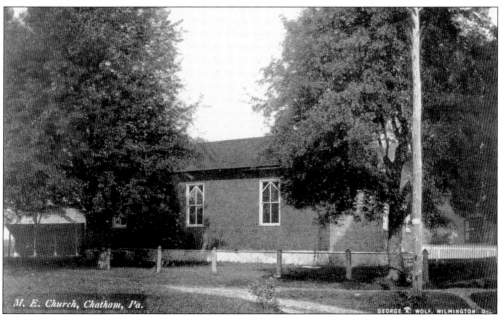

In 1865, a one-room brick school was built on East London Grove Road. Because of the expanding population, it was demolished and replaced in 1892 with the two-story building seen above. L. May Frank and Ada Nichols were two well-known teachers at the school. The two children seen in front of the school are Harold (left) and Alfred Heibeck around 1900. This building has been extensively remodeled and is now a residence. Spring Grove School was on West London Grove Road and was very similar in appearance to the Chatham School. It burned in the mid-1980s. North Grove School can still be found at the intersection of Lamborntown and East London Grove Roads and is now a residence. Because the ventilation fan at the top was painted red, white, and blue, the North Grove School was called the "red, white, and blue school" by many residents. (Courtesy of John Ewing.)

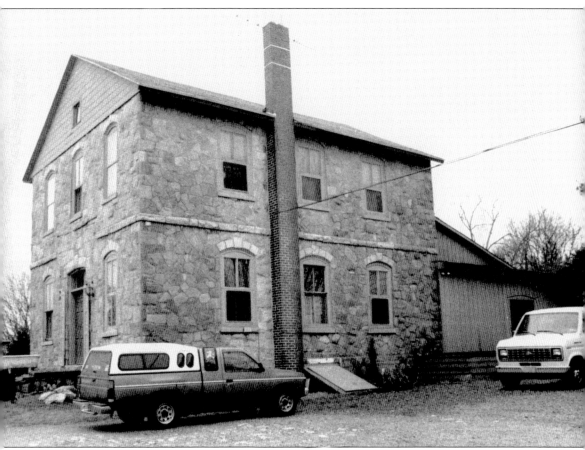

On old maps, the original Locust Grove School is shown across the road from this building that later was called Locust Grove School. It is located on Route 41 north of Avondale next to Perkin's Pancake House. The original school was brick, while this two-story school was built of gray stone. Teachers in the late 1800s were Alice Mendenhall and Anna M. Swayne. It was still being used as a school as late as 1914. Nick Del Nero, a quarry worker, bought the structure and rented it out as apartments; a fire in 1947 gutted the interior. After renovation, Rocco Del Nero moved his family into the building and had his upholstery business in the basement; his wife, Thursa, opened the Avon Grove Sub Shop in a small building also on the property. When this photograph was taken, the building had again been sold and was being made into an antiques shop with a large addition on the side and back. It is now Antiques and Images owned by Walker/Williamson.

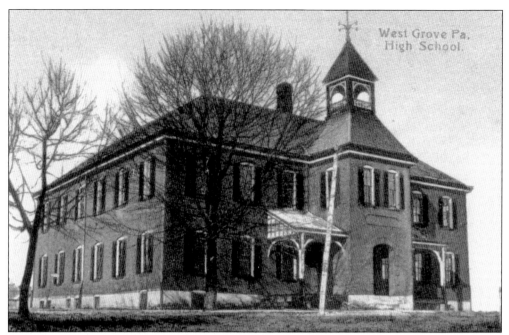

Ground for the West Grove High School at the corner of Myrtle Street and Summit Avenue was purchased from John Turner and Milton Pyle, and the building was ready for the first day of class on September 30, 1889. Several of the local school districts in the area consolidated in 1953. This building was demolished in the late 1960s, and the land has remained vacant.

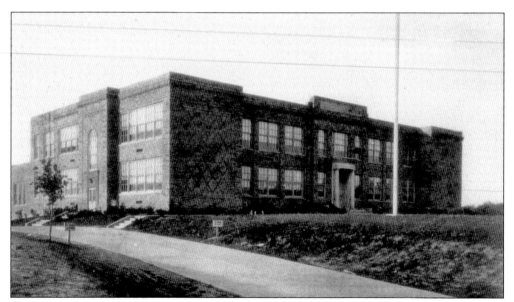

The final merger of the five townships and two boroughs that became Avon Grove School District occurred in 1965. The building in this picture was constructed in 1928 and served as the high school until the present one was opened in 1957. This building was then used as Avon Grove Elementary School for many years and now houses Avon Grove Charter School. It stands at 110 East State Road.

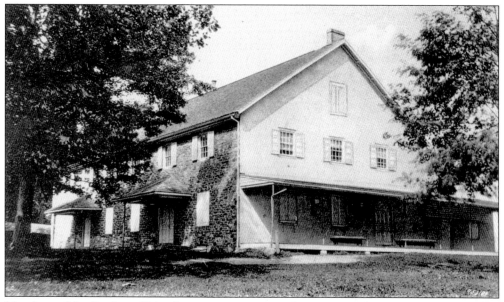

Members of the Quaker religion began meeting in London Grove at the Scarlett farm, the home of John and Anna Smith. Anna Smith was from a prominent Quaker family, the daughter of Caleb Pusey. After 10 years, the home was too small for the congregation, and land was purchased from the London Company and Henry Travilla to build a meetinghouse; it was constructed of logs with a stone foundation and was used for 19 years. In 1818, the building seen in these postcards was built for worship. A Penn oak (planted at the time of William Penn) still stands on the grounds of this active meeting. The village of London Grove is no longer in London Grove Township.

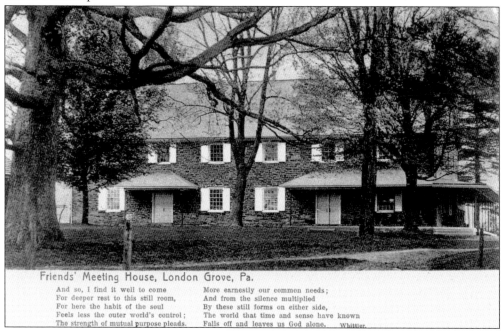

Friends' Meeting House, London Grove, Pa.

And so, I find it well to come
For deeper rest to this still room,
For here the habit of the soul
Feels less the outer world's control;
The strength of mutual purpose pleads.

More earnestly our common needs;
And from the silence multiplied
By these still forms on either side,
The world that time and sense have known
Falls off and leaves us God alone. Whittier.

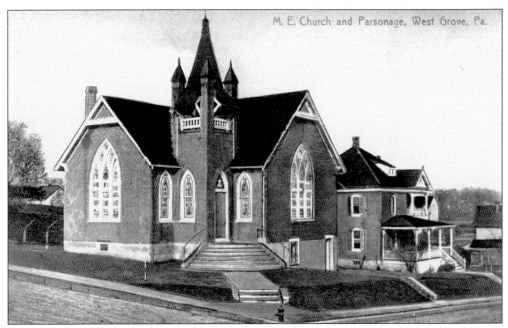

The Methodist Episcopal congregation in West Grove held its first meetings in a private residence and later met in the K&P Building. In 1886, at the corner of Prospect and Hillside Avenues, James Wilson began construction of the church. Built for $4,099 including furnishings, it was dedicated in September 1889. Eglesia Cristo Rey now meets in the building. A new Methodist Episcopal church was built at 300 North Guernsey Road.

The Star of Bethlehem African Methodist Episcopal Church was on Summit Avenue in West Grove. Built in 1892, it was dedicated on June 11, 1893. Rev. A. Smith of West Chester was responsible for the original organization of the congregation in 1889, when it held services in the Hall Building. The church is no longer standing. Rev. Fred Hicks serves at the Enon Missionary Baptist Church on Willow Street today.

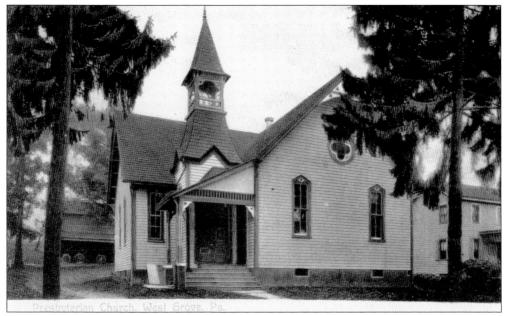

In 1866, a student of Princeton Theological Seminary, Edward P. Capp, was sent to Chester County as a Sunday school missionary. He began holding meetings near West Grove. Later meetings moved to the Hall Building with Dr. W. R. Bingham as preacher. In 1884, a church was built for $3,312. Originally called the Presbyterian Chapel at West Grove, it is now West Grove Presbyterian Church, located at 139 West Evergreen Street.

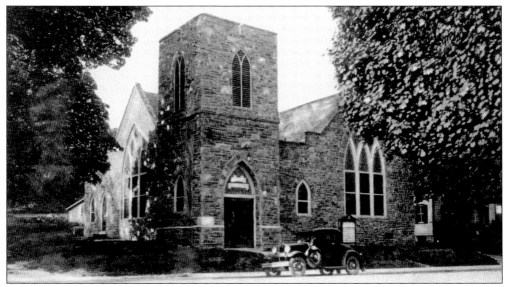

Growth of the Presbyterian congregation enabled a new house of worship to be constructed. In 1930, the wooden structure was replaced by the stone church still in use today. Ernest Foster, later an Avon Grove School District shop teacher, designed the building, and H. L. McLimans donated the stone and did the masonry work. The cost of the new building was $15,000.

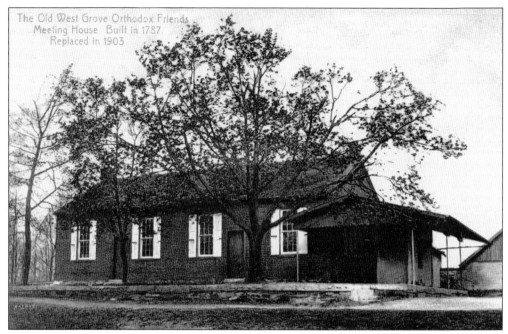

Many Quaker families moved to Chester County early in its founding. In 1787, a Friends meetinghouse was built in West Grove on land partially donated by William Jackson of Harmony Grove Farm. The image above shows that first structure. The Orthodox branch remained at this meeting while the Hicksites moved out of town. Eventually the structure needed much repair and was replaced.

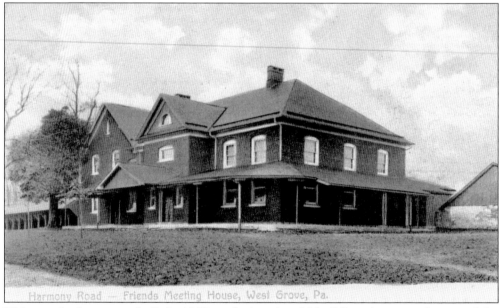

This meetinghouse was built in 1903, replacing the old building shown at the top of the page. Generous contributions and use of material from the old building made this possible. At 153 Harmony Road, the meetinghouse is still used by the reunited branches of Friends and also houses the West Grove Day Care.

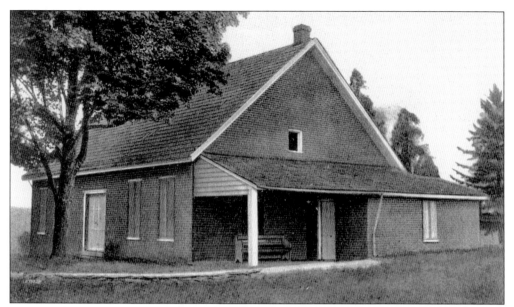

In 1827, the "Great Separation" occurred among the Quakers, creating two branches—the Hicksites and the Orthodox. In 1831, the Hicksites left the Harmony Road Meeting in West Grove and built this meetinghouse at 609 State Road. Here Benjamin and Hannah S. Kent organized the Clarkson Anti-Slavery Society. Paul Rodebaugh's local history club from Fred S. Engle Middle School helped restore some of this building. This meetinghouse is not in use, although burials are still performed.

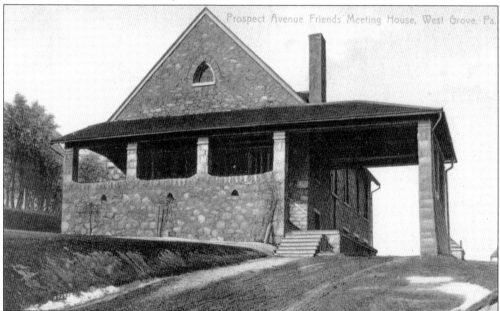

Frederick Pyle, an architect from Washington, D.C., designed the Prospect Avenue Friends Meeting House in West Grove. In 1901, the Hicksites had this structure built on land donated by Milton Jackson. H. L. McLimans did the masonry and James A. Wilson the carpentry. When the Quakers reunited, this building became the Church of the Nazarene in 1950, and later Free Will Baptist. Today it is used as a day care center.

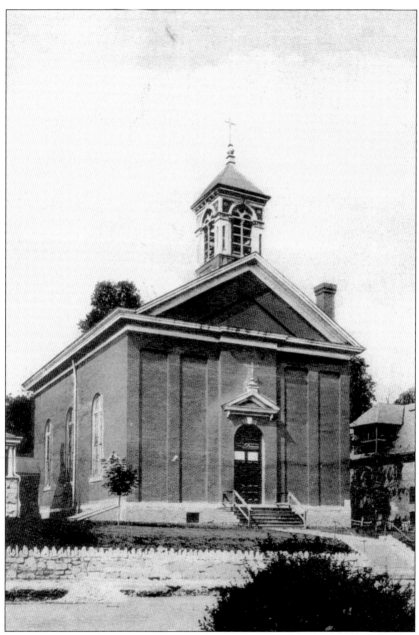

About 1860, with the advent of railroad service to West Grove and an expanding population, Rev. James Kelly was sent by the Philadelphia Archdiocese to hold services for the area Catholics who had previously worshiped at St. Malachi's Church in Doe Run. Mass was held in parishioners' homes and in the rear of the Hall Building. Land for a church was obtained from Joseph and Mira Pyle, and the cornerstone of St. Mary's Church (Assumption Blessed Virgin Mary) was laid on September 13, 1873. Benjamin Taylor did the masonry work, and David Jackson was the carpenter. Other priests oversaw further expansion of the church facilities: Father Dagget, the rectory; Father Keegan, the convent; and Father Edward Kelly, the St. Mary's School. On this postcard published by Frank P. Houston, West Grove druggist, the building to the right of the church is Pyle's Store.

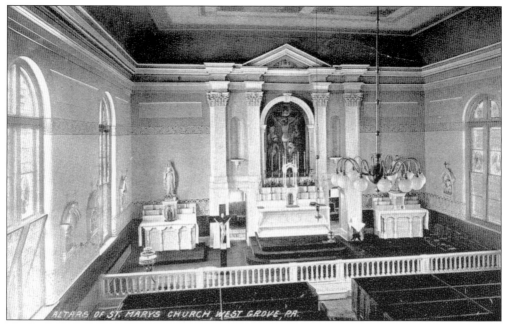

This detailed interior view at St. Mary's Church shows the beautiful chandelier, classic center altar, and stained-glass windows. The cost of construction of the church in 1873 was $14,750.

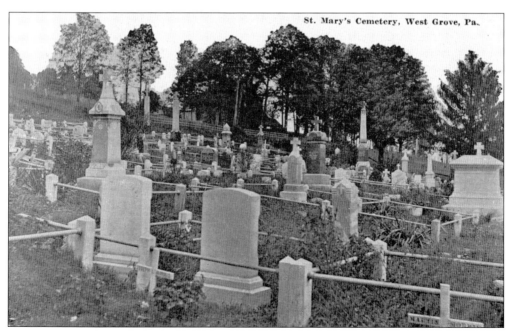

In 1880, ground was acquired for a cemetery, and St. Mary's Cemetery was established. It can be found across from the Sunoco station on the east side of town along old U. S. Route 1.

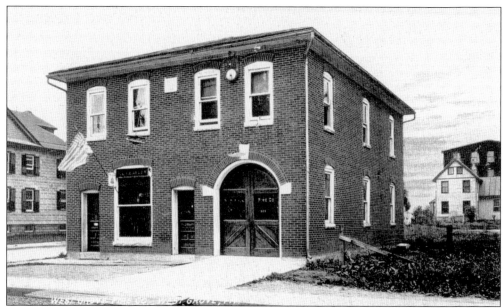

Robert Pyle was the first president of the West Grove Fire Company. The building shown here is on Prospect Avenue at the corner of Walnut Street. The new fire station is behind this building, although the fire company still uses this site for meetings and offices. A private home and the three-story casket company can be seen in the background. The Hotel Roseboro is on the left.

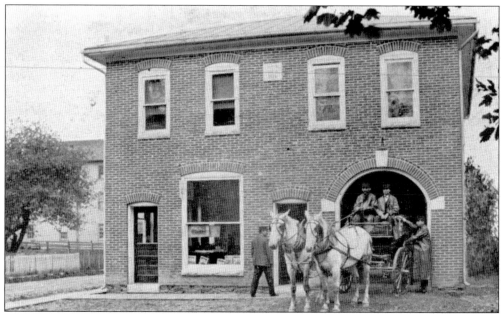

Although there were concerns and talk about organizing a fire company in West Grove as early as 1887, the actual establishment of one took place on September 2, 1904. In 1904, the first piece of equipment was bought—a four-wheeled chemical engine with two tanks costing $1,500. The Ancient Order of Hibernians, a Catholic lay organization, had the fire company building constructed, and they met in the second floor.

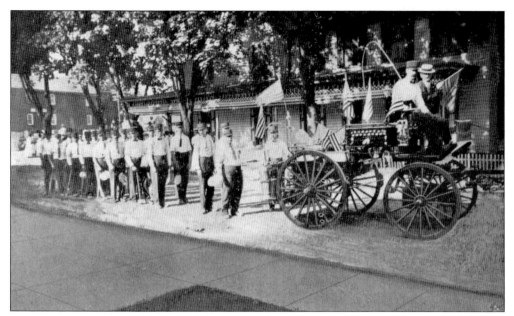

The members of the West Grove Fire Company in the view above appear to be in parade formation. The picture was taken on Prospect Avenue in front of the West Grove Inn. The message says the carnival was a great success, and the writer took in $258.15 (a large sum in 1905, the time of this postcard). Perhaps the firemen were assembled in conjunction with the carnival.

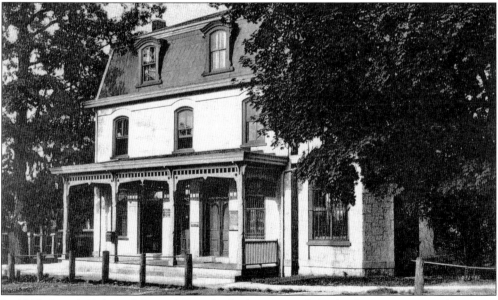

In 1883, Joseph Pyle and Samuel Kent built the National Bank of West Grove at the corner of Exchange Place and Railroad Avenue. The bank and post office shared the first floor until 1956, when the post office moved to a newly constructed building behind the bank. At various times, this building has also housed the library, borough offices, Masonic lodge, and the police station and jail.

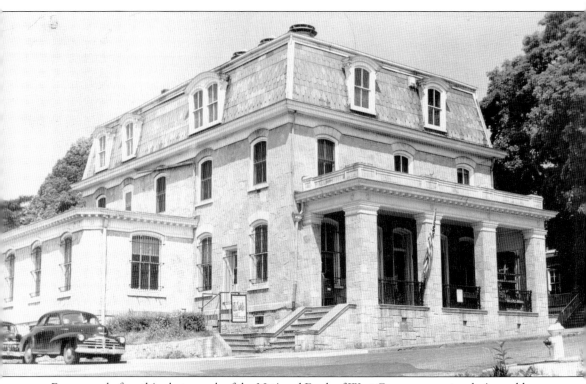

Four years before this photograph of the National Bank of West Grove was sent, a daring robbery took place on October 9, 1947. Two men carrying a sawed-off shotgun and a submachine gun, both of which were covered by newspapers, fired over the head of a cashier and ran out with $8,319. They were reported as saying, "You have no chance at all"; neither was wearing a mask. Harry Griffiths, postal clerk, ran out to confront the robbers. He was wounded but still able to hit the getaway car with five shots. Because of this, the police were able to identify the car at a home in Lewisville. The money was recovered, half of it buried in a jar at a farm in Bear, Delaware, and the rest with the other robber, who was apprehended in Arizona. After the identity of the robbers was known, it was reported that the two had been seen at a local taproom, apparently waiting for a lull in business at the bank before they hit. The Sovereign Bank is at this location today.

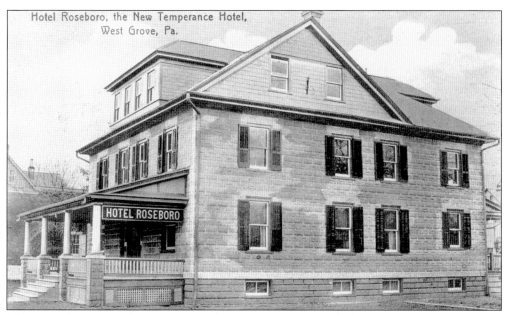

Hotel Roseboro, the New Temperance Hotel, West Grove, Pa.

HOTEL ROSEBORO

The West Grove Hotel Company, in direct competition with the West Grove Inn in close proximity, built this hotel specifically as an anti-drinking establishment in 1908. It cost $3,425 to construct from ornamental concrete block that was made in West Grove; the construction was done by H. W. Shaw and Company. The building still stands at the corner of Prospect Avenue and Walnut Street and is now used as apartments.

In 1918, Dr. William B. Ewing bought the Hotel Roseboro for $6,000. He saw a need for a hospital in the area, made especially acute by the influenza epidemic of the same year. More than 5,000 babies were delivered before 1955, including the author! During the blizzard of 1958, patients were flown in by helicopter; the hospital was so full, it overflowed to the fire hall across the street.

The Community Memorial Hospital *West Grove, Pa.*

The West Grove (Ewing) Hospital was closed when the Community Memorial Hospital opened in Jennersville to serve the needs of the area. Later called the Southern Chester County Medical Center, that facility is now the Jennersville Regional Hospital.

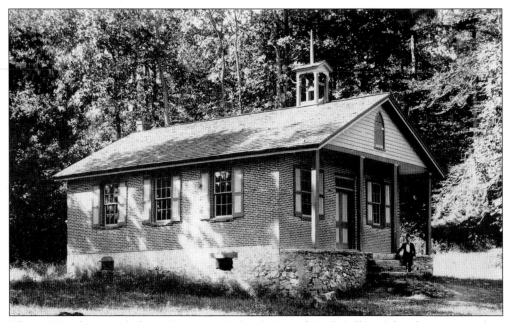

This *c.* 1891 photograph shows East Grove School. One of Mark Sullivan's brothers, pictured on the steps, was schoolmaster at the time. This is the school that Mark attended. The Sullivans lived on the hill behind the school. This structure is now a private home at 800 Clay Creek Road. Another local school, Rock Grove, can be found at the junction of Avondale–New London and South Guernsey Roads and is also a residence.

Five

HOMETOWN
STREETSCAPES

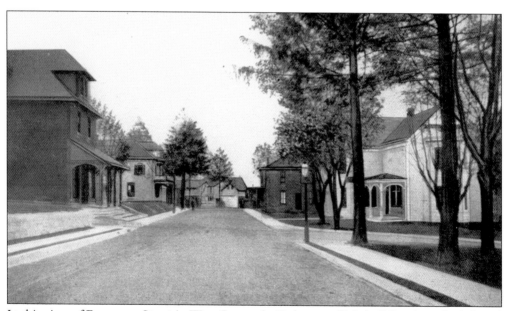

In this view of Evergreen Street in West Grove, the Rakestraw-Pyle building is on the left, and what became the office of Dr. Agnew Ross Ewing is on the right.

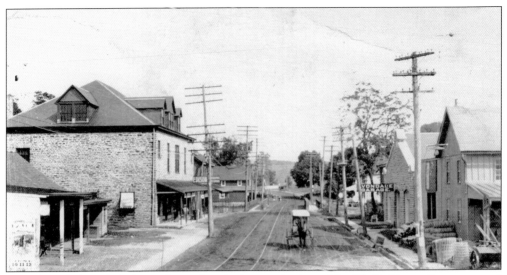

A card mailed in 1914 shows Pennsylvania Avenue in Avondale. H. R. Pusey Company and the Avondale Garage, now Lutzwood Cabinetmakers, can be seen on the right. Jesse Pusey sold Studebakers at the garage, the largest fireproof garage in Chester County. On the left are the old blacksmith shop and the Watson Block. A sign advertises Edison Phonographs that were sold by George Anderson, "the Talking Machine Man."

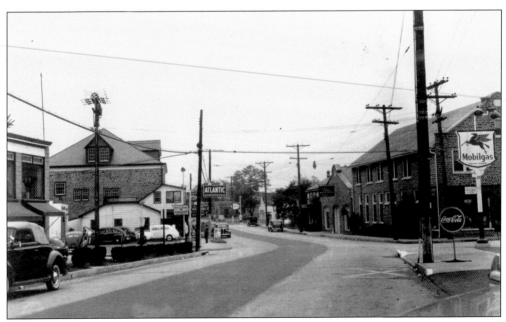

Taken from a little farther north on Baltimore Pike, a later card shows how the area had changed. The blacksmith shop is gone, and Watson's Hall became Watson's Coffee Shop. Pusey's business and automobile garage are on the left. Signs for Atlantic, Mobilgas, and Esso are visible. Today a Sunoco station sits where the Watson's Coffee Shop was.

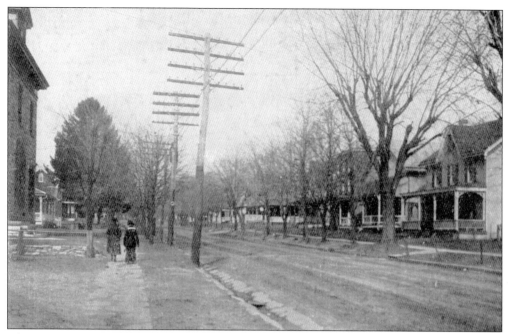

The National Bank of Avondale is shown on the far left on Pennsylvania Avenue. Across the street is the home at 131 and other homes along the 100 and 200 blocks. Pennsylvania Avenue is the main street through town. It is lined with many mature trees.

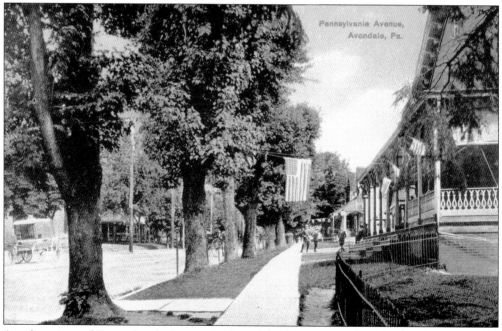

Another view of Pennsylvania Avenue in Avondale shows many flags displayed on buildings and across the sidewalk. This was probably for the July Fourth festivities but could have been for another celebration, parade, or event.

The "Square" was the term given to the important intersection of Pennsylvania Avenue and State Road. The Avondale Hotel can be seen on the right, and the building that was last used as Joshua Thomas's Plumbing business is on the left. Ed Herbener published this card; he had a studio in Strickersville, Pennsylvania, and later Newark, Delaware.

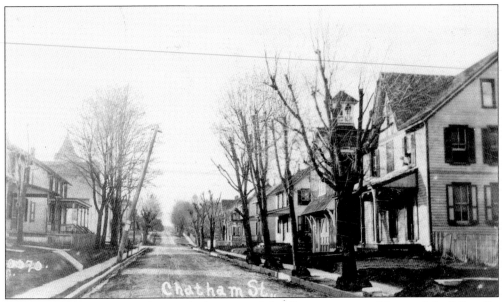

Chatham Street in Avondale was the location of the fire company and borough building for many years. It was the building with the tower seen here on the right. The land was purchased from Herbert K. Watson; Marshall J. Russell was the builder. The fire company building has been converted to a residence and the tower removed. Homes in the 200–300 blocks can also be seen in this view.

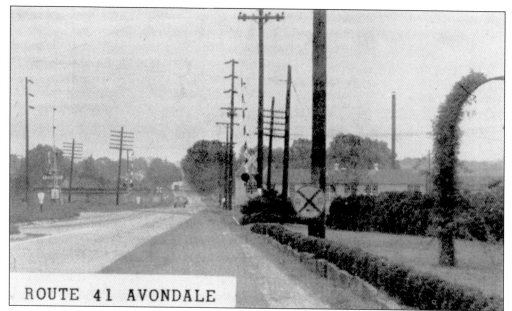

ROUTE 41 AVONDALE

Looking toward Wilmington, Delaware, on the south side of Avondale, this view shows the railroad tracks and past them on the right, the old Superior Canning Company. To the left, old Route 1 splits off and goes toward Kennett Square. That area now is the site of the IG "the Market" and Pop's Diner. This view was taken around 1945. (Courtesy of Ruth Wright.)

On the north side of Avondale, Route 41 meets old Route 1. Today on the left is Pyle's Hardware Center. Hidden by the trees is what was Sunset Farm. On the right, the barn has been demolished, and there is a Sunoco station and Avon Wheel Trailer Park. Note the sign for the West Grove-Avondale Rotary Cub that met at the Evergreen Tea Room in West Grove. (Courtesy of Ruth Wright.)

Looking north on what is now called the Gap-Newport Pike as it traverses through Chatham, this card shows the old William Pitt Hotel in the distance. This building was most recently the business of Kauffman's Furniture and Country Store and was previously a children's day care center. The home on the far left is at 3309 Gap-Newport Pike.

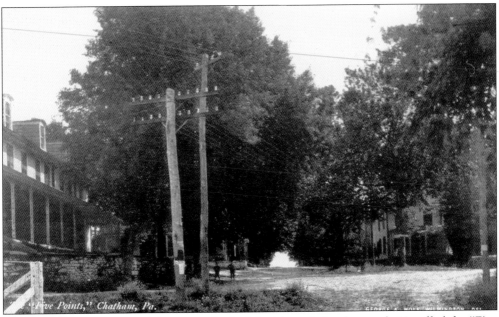

With the William Pitt Hotel shown on the far left, this card also shows what is called the "Five Points" where several roads meet. They are U. S. Route 41, State Road 841, East London Grove Road, and Chatham Road.

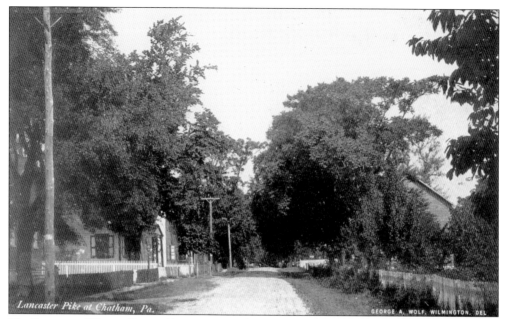

The Lancaster Pike, or Route 41, was a major highway from Wilmington and Philadelphia (via Route 1) to Lancaster. It is still a major route today with heavy truck traffic carrying commodities to their destination, which contrasts with the tranquil scene in Chatham shown above.

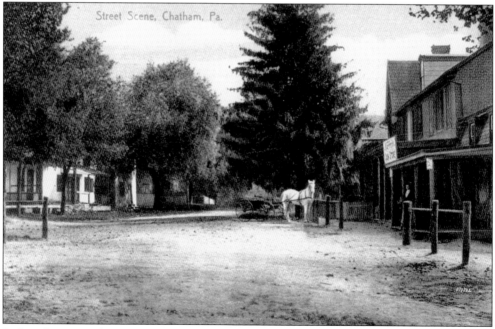

Before the automobile transformed travel, every town had hitching posts for the horses. These are evident in this scene showing the general store in Chatham on the right. The building on the left was constructed in the mid–1800s and was the mercantile store of J. S. Taylor in 1876. In 1900, it was owned by John Hayden and was known as the Blue Pig, a restaurant and reported speakeasy.

Another view of the Five Points road intersection in Chatham shows milk wagons on either side of the road. They were probably bound for Carter's Creamery or to one of the two general stores in town. The William Pitt Hotel is in the middle of this view behind the dense cluster of trees.

Although not in London Grove Township today, the village of London Grove was a busy settlement at the beginning of the 20th century. This scene shows many vehicles in the center of town. The old blacksmith shop can be seen in the distance where Pennsylvania Route 926 meets Newark Road. Today London Grove village is located in the township of West Marlborough.

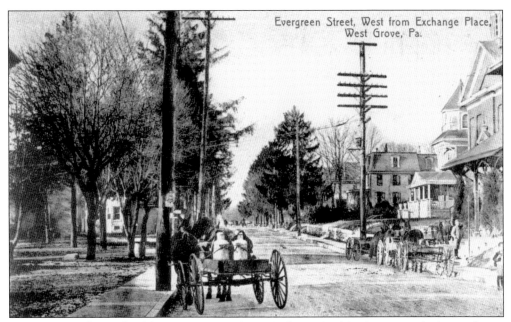

A busy day in front of Pyle's Store in West Grove is shown in this view; note the horse-drawn wagons, one with milk cans. St. Mary's Church, rectory, and some houses beyond can be seen on the right. In the trees on the left stood Dr. Agnew Ross Ewing's home. Frank P. Houston, West Grove pharmacist, published this postcard. A souvenir plate with the same view can also be found.

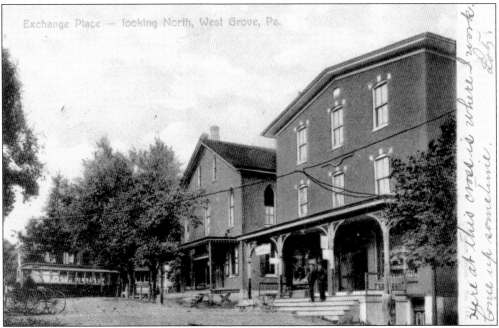

Exchange Place looking north in West Grove shows the Hall Building in the background and the K&P Building in the foreground. Joseph Pyle built the Hall Building in 1867; it was used as a general store, post office, bank, and meeting room. In 1885, the structure in the foreground was built and called the K&P Building after Pyle and Samuel Kent, who had it constructed.

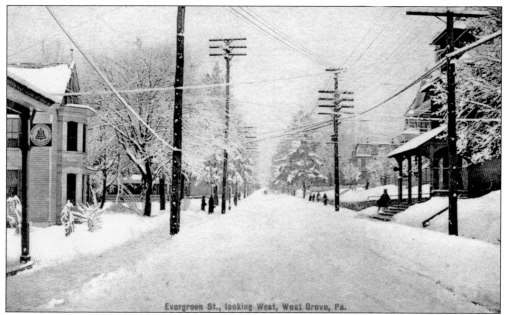

Looking west on Evergreen Street, this view shows Pyle's Store, the Catholic church, and the rectory on the right. On the left is the building that was later Dr. Agnew Ross Ewing's office. It was formerly Chambers Nursing Home and Laughlin's Millinery Store. Printed snow scenes of small towns are unusual.

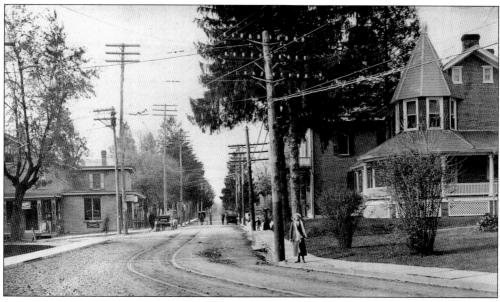

In this view of Evergreen Street, one of the oldest remaining buildings in West Grove can be seen on the left. Joseph Pyle had this structure built in 1860 as a general store and residence. It became Nellie Baker's pharmacy in 1879, Frank P. Houston's pharmacy from 1902 to 1952, and then the West Grove Pharmacy. It is now Country Station, a gift store. Dr. Charles Heald's residence is on the right.

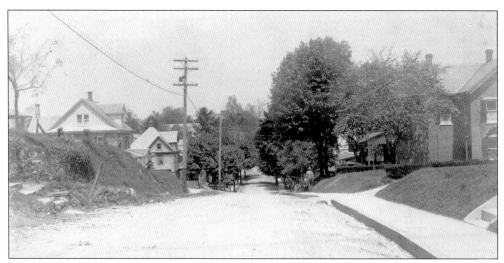

Looking north on Prospect Avenue toward the center of West Grove, one can see the home at 135 on the right and those at 124 and 120 on the left. Prospect is the main north–south road through the borough.

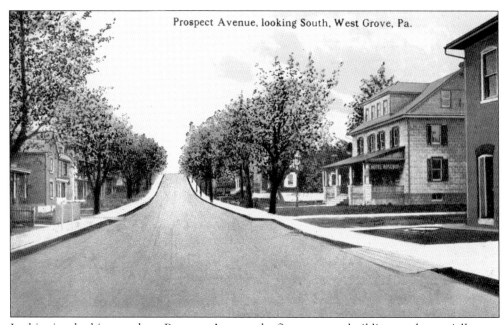

Prospect Avenue, looking South, West Grove, Pa.

In this view looking south on Prospect Avenue, the fire company building can be partially seen on the right with the Hotel Roseboro next to it. Across the street was a building that housed numerous businesses, including the Kaywood Market, Houston's Grocery Store, Cipolla's Shoe Store, and, now, Marrone's Delicatessen.

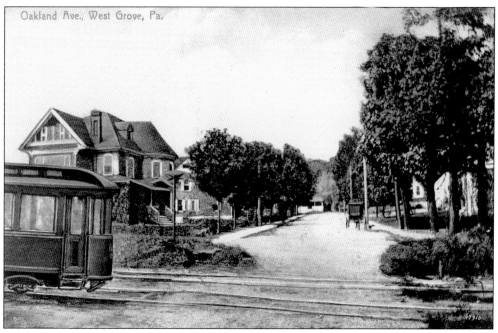

In West Grove, the trolley followed the railroad tracks along Railroad Avenue for some distance. Looking up the road toward Evergreen Street, the house on the left is 24 Oakland Avenue.

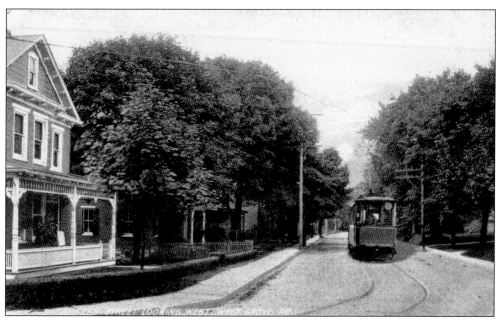

The trolley turned off Evergreen Street onto Oakland Avenue here at the corner of the two roads in West Grove. The house on the left is 160 East Evergreen Street and was owned by auctioneer Byron Cochran at the time of this image.

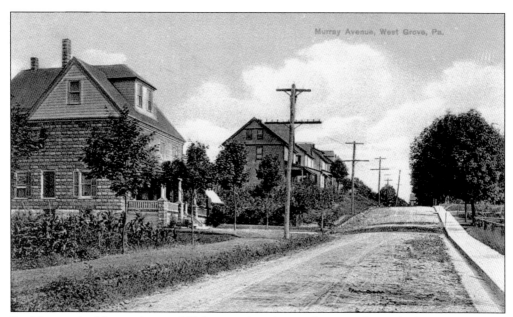

Looking up the Murray Avenue hill from Walnut Street, this view shows the homes at 113, 123 (now with enclosed porch), 127, and 129. The first house is made from the same ornamental concrete block as the Hotel Roseboro.

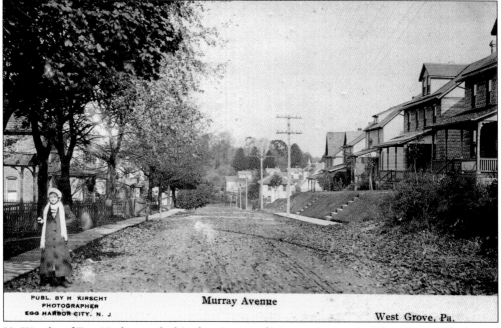

Murray Avenue

West Grove, Pa.

H. Kirscht of Egg Harbor took this clear image of Murray Avenue in West Grove. The homes on the left are 138 and 134. On the right can be seen a double house at 137 and 139 (now with an enclosed porch), a double house at 133 and 135, and then the homes at 129, 127, and 123.

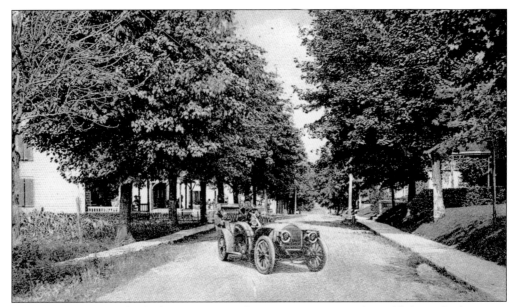

This view appears to be looking east toward Prospect Avenue and would show the homes at 151 and 148 Edgehill Avenue in West Grove.

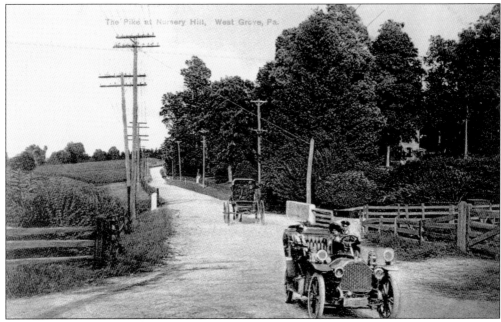

A horse-drawn carriage and early automobile are both shown on this dirt road that is now Rosehill Avenue in West Grove. In the trees on the right was the home of Charles Dingee, one of the founders of the Dingee and Conard Company. That home is now Foulk Funeral Home owned by Matthew Grieco.

Six

RESIDENCES AND MISCELLANEOUS

During the golden age of postcards (1898–1918), almost everyone exchanged cards with friends. With this craze came the advent of the generic card with cute sayings or pictures that could then be personalized with one's town name. This one recommends Chatham for a happy home.

PANORAMIC VIEW - AVONDALE, PA.

Avondale July 30-06
Dear Sister.
he bottom *See Uncle Wills old place at* *of the hill. Also the stable +* *undry ules. See his bed room window* *Mr ? H.*

This panoramic view looks down on Avondale from the top of Reservoir Hill behind the site of Inniscrone Golf Club today. The three houses on the left are still standing on State Road as 235, 233, and 231. A pond popular for ice-skating was near these homes. The road then proceeds in toward Pennsylvania Avenue past the railroad station. The hill to the right in the distance is an area where stone has been quarried for years.

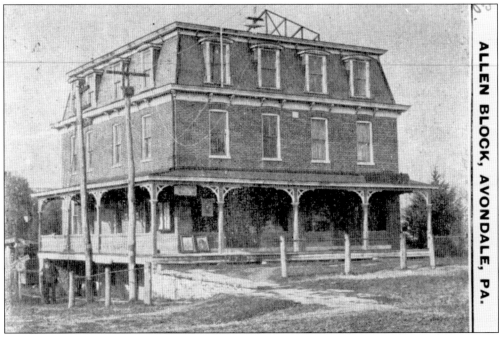

ALLEN BLOCK, AVONDALE, PA.

Called the Allen Block and Hall, this building at 300 Pennsylvania Avenue was constructed in 1884 and over the years was used by many businesses, including a milliner, pharmacist, baker, tailor, photographer, and undertaker. The Avondale Library was established on the second floor in 1885. Many community activities took place here. The building is now used for apartments.

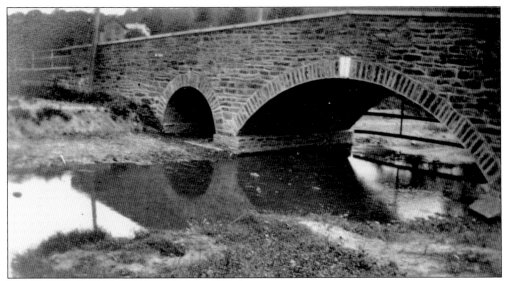

The Baltimore Pike (old Route 1) joins Route 41 in Avondale and crosses the White Clay Creek over this stone bridge that at one time gave Avondale its early name. A tollbooth was once set up near this bridge when the Gap–Newport Pike was first constructed. In 1915, a postcard was sent describing this structure as the "new" stone bridge. Despite its tranquil look, the White Clay Creek supported many mills, including a gristmill, sawmill, and tannery. There were 16 listed in the late 1800s, including Pine Bark Mill, Excelsior Rolling Mill, Gilbert's Mill, Wickerton Roller Mill, and Jesse Pennock's Flour Mill in Chatham.

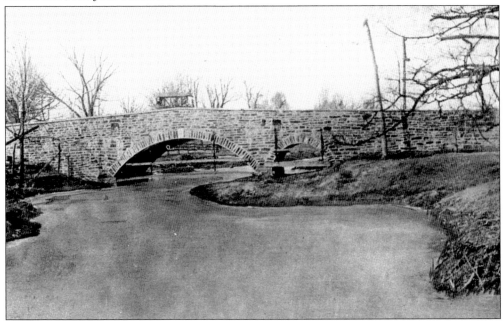

H. H. Corson and Son ran a nursery near Avondale called Brae Mawr Farm. They grew fruit, shade, and evergreen trees, ornamental shrubs, peonies, perennials, and small fruits. Katherine Corson sent this image of their home in 1908.

This unusual view of Chatham Street shows the homes at 209 (left) and 213. The young girl by the tree is Humphreyann Logan. Members of her family worked at the Excelsior Rolling Mill and telephone exchange.

This photograph was taken in 1912 and shows some of the family that lived in the home at that time. The house can be found today as a double house at 217 and 215 New Street in Avondale. It has been extensively remodeled.

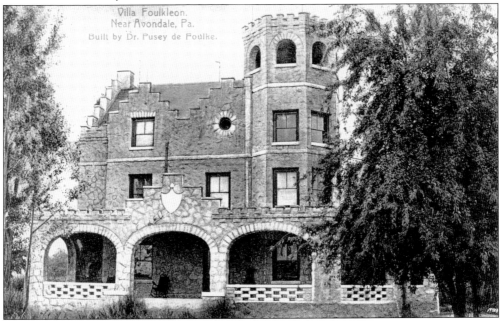

Built by Dr. Pusey de Foulke as a home and office, this castlelike structure on Route 41 outside of Avondale near Star Road was named Villa Foulkleon. Later F&M Scientific, a division of Hewlett Packard, used the building for offices. It was torn down about 1961, and a 20,000-square-foot plant was opened by Hewlett Packard to make gas chromatographs. That business has now closed.

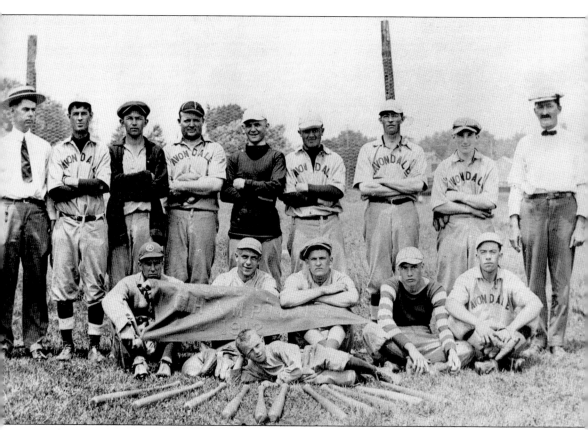

The Avondale baseball team was a strong one for many years. In 1912, it won the Chester County League championship. The team members seated at the front center are holding the Chester County League championship pennant they earned. From left to right are (standing) Edward S. Thomas (umpire), W. P. "Buff" Nichols (catcher), Ralph Mullen, Roy Miller (infielder), John Miller (infielder), Joe Johnson (pitcher or infielder), Evan "Pete" Keating, Harold McCue (infielder), and James Townsend (manager), (seated) Joel Skelton (pitcher), Horace Ruth (catcher), Leslie Gregg (pitcher or infielder), Milton Moore, and Ralph Rosazza. In front with the bats is the mascot, a young man whose last name was Speakman. When the local schools consolidated, a Southern Chester County High School League was established in 1928, and the strong sports heritage continued. From 1928 to 1948, the Avon Grove baseball teams won three county titles. During that time period, they also won nine county championships in soccer and one in basketball. In 1970, the Avon Grove basketball team won the state championship for Class B, now called Double A, schools.

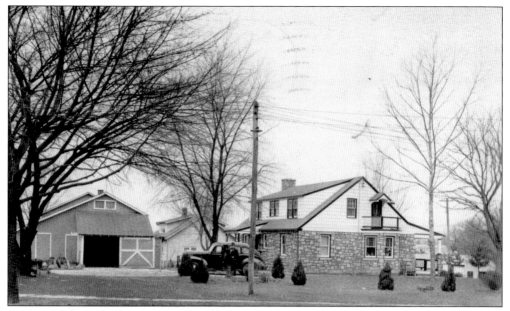

G. Roy Waltman's properties as they looked in 1948 are shown in this real–photo postcard. This home is still used as a residence and is across old Route 1 from the Red Rose Inn. A glass sunroom has been added on the front. This view was taken from the Route 796 side of the building. Waltman was the founder of Sunset Park.

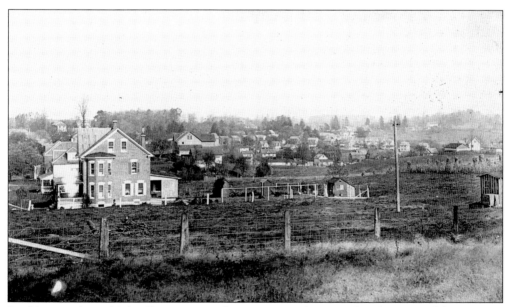

Looking north in this bird's-eye view of West Grove, the agricultural nature of the area can be seen in the many barns and fields and the row of corn shocks on the right. Harmony Grove Farm owned by the Jacksons was one of the earliest and largest in West Grove. The house in the foreground is 309 Prospect Avenue, followed by 217. Schrack's building is the last in that row.

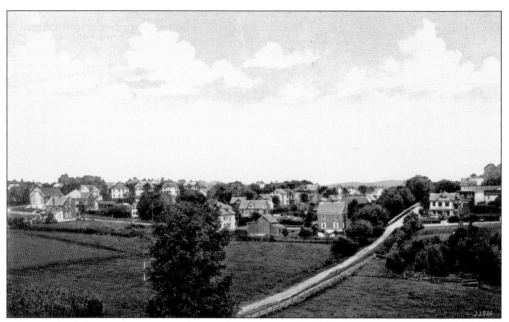

This view of the southern part of West Grove shows East Summit Avenue looking toward Prospect Avenue. The Methodist church is on the far left. Schrack's Dairy business was in the first brick building seen to the left of Summit.

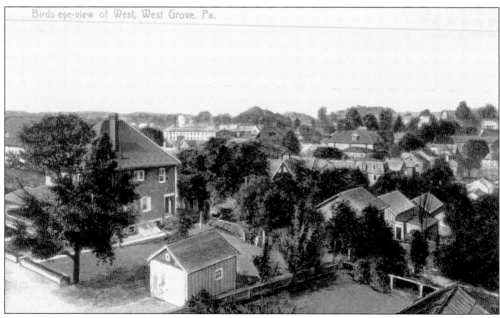

Birds-eye-view of West; West Grove, Pa.

In this view of the western part of West Grove, the Paxson Comfort casket factory can be seen on the left center in the distance. The other large building in the distance is what is now Eckerd's Drug Store and was previously Marvel and Smith Hardware and before that Hocking's store.

Mrs. Otis Coleman of New Jersey received this card from her sister Margaret, who wanted to show off her new home in West Grove. The home is still in use as a residence at 158 Prospect Avenue. It has many interesting architectural features, including the arched windows at the top and bottom of the "bump out" and the three windows topped by a decorative star (now a clover).

This house was one of a group of homes on East Baltimore Pike called "bungalow row." At 249 East Baltimore Pike, it looks the same today except that two windows have been added over the porch. At the time this card was sent, it was the home of Mrs. R. R. Pennock.

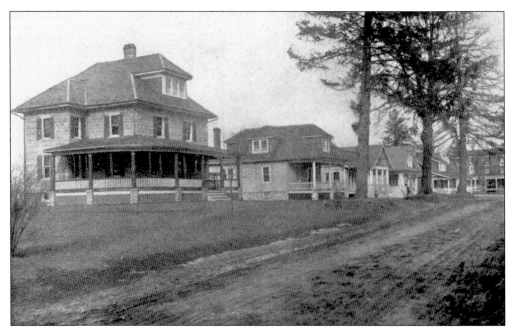

This section of houses in West Grove was known as bungalow row. The dirt road seen in the picture is old U. S. Route 1. The home in the foreground is at the corner of Route 841 north and East Evergreen Street and now houses Yerkes Insurance and offices for Daniel Signs, counseling, and Daniel Block, psychiatry. The next four homes are numbered 233, 249, 255, and 275.

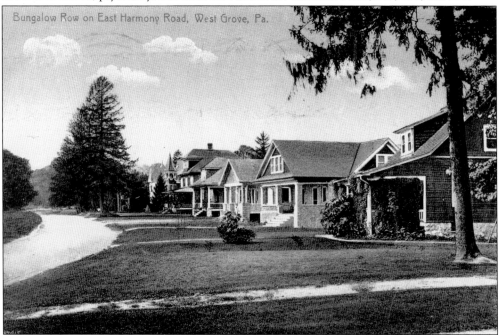

This view is the reverse of the card above starting with the house at 275, then 255, 249, 233, and the Yerkes Building. The Victorian residence that is the last visible building is now on what is called Harmony Road. The printing on the card labels the road East Harmony Road, but that is not its designation today.

Luman Beitler started working at Robert L. Pyle's store in 1880 and quickly became Pyle's partner, enabling him to buy this fine home built by Joseph Pyle in 1879. Originally surrounded by open fields, it had a commanding view of the town. Horace Beitler owned the home until 1974. The portico and wraparound porch are now gone; the house can be found at 145 Prospect Avenue.

Dr. Samuel Clifford Boston graduated from the University of Pennsylvania in 1898 and began his practice in 1900. He was the first black doctor in West Grove. Dr. Boston also served in the U. S. Army Medical Corps in World War I. This home is at 124 Rosehill Avenue has had some remodeling.

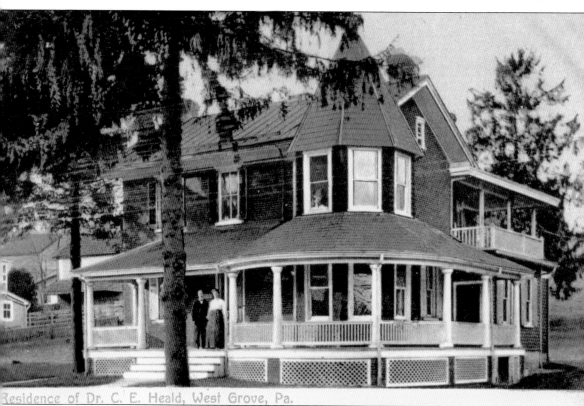

Residence of Dr. C. E. Heald, West Grove, Pa.

Francis Good built this home at 117 East Evergreen Street in the 1860s. In *History of Chester County, Pennsylvania with Genealogical and Biographical Sketches* by John Smith Futhey and Gilbert Cope, this property was listed as Letitia A. Pennington's Travelers Rest in 1883. Dr. Charles Heald opened his dentist office here in 1896. He served as register of wills in Chester County and was mayor of West Grove from 1920 to 1928 and again from 1934 to 1939. Dr. Heald was active in many community organizations such as the West Grove Building Association, the West Grove Fire Company, the New London Lodge 545 F and M, and the Masons. He was director of AAA and a member of the board of trustees at Embreeville Hospital. The Kin-Mar Hatchery, owned by George March and John Kinney, was behind Dr. Heald's home. It raised turkeys and handled feed and poultry supplies.

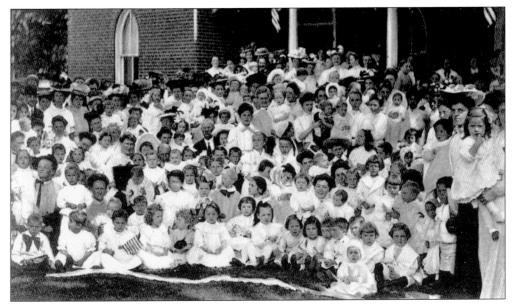

As part of the July Fourth celebration in 1907, a baby show was held on the lawn at Dr. William B. Ewing's. Beginning with Robert Black Ewing and ending with Agnew Ross Ewing, who retired in 1986, West Grove was in the care of Ewing doctors for 116 years. All of the Ewing doctors were also contributing members to the community, serving in various capacities. The young lady in the front row, third from the girl with the flag, is Ruth Ewing.

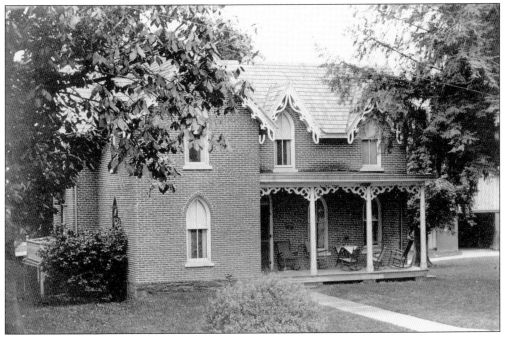

This is another view of the home where the baby show was held. Dr. John Russell McClurg, who practiced medicine and surgery, originally built it. The home was later owned by Dr. William B. Ewing. The building still stands today at the corner of Evergreen Street and Prospect Avenue. The Victorian bric-a-brac has been removed, and the Citizen's Bank now calls it home.

George and Margaret Fraser owned this home at 118 Hillside Avenue for many years. George was an agent for Farm Bureau Insurance and then Nationwide. Margaret took over the business after his death and became one of the first female insurance agents in Chester County. The house is still used as a dwelling today, but the tree has been cut down, and the barn behind has been demolished.

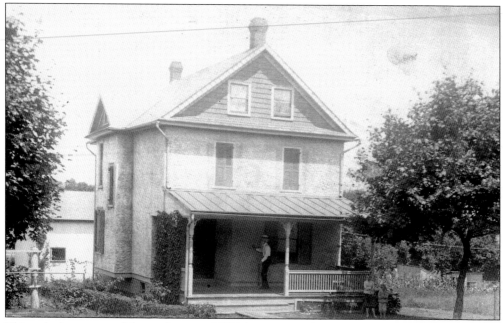

This real-photo postcard shows a home on Hillside Avenue and was sent from a woman named Edna. It is probably the home at 151 Hillside Avenue that matches it exactly. However, the home next-door, at 161, is an identical design without the front porch, which could have been removed.

This magnificent home with the unusual chimneys was built in the 1860s and was the home of Charles Dingee, a partner in the Dingee and Conard Company, famous for its roses. Later J. Ralph Edwards, West Grove's first undertaker, owned it. In 1954, he was succeeded by Thomas Foulk. Matthew Grieco now owns the business at 200 Rosehill Avenue.

ATTENTION, GRANGERS, and you shall hear
Of an all-day PICNIC that's drawing near:
On AUGUST 7th, at ten o'clock,
The members of London Grove will flock
To the shaded lawn and delightful view
Of Andrew Jackson and Ella McCue.

Come in the carriage and bring your lunch,
Ice-cream and coffee, served for the bunch;
There will be sports and games for all,
Quoits, croquet and, of course, base ball;
All of the members there you'll see—
Present, past, and that ought to be.

P. S.—This invitation is meant to include
Yourself, the Mrs. and all your brood;
If you happen to have one, don't hesitate
To bring the stranger within your gate.

Granges were an important part of this rich agricultural district. These were local lodges of the Patrons of Husbandry, which was established in 1867 for the mutual welfare and advancement of those who worked the land. The first grange in Chester County was organized in West Grove in 1873. This postcard announces a picnic for the London Grove grangers at the home of Andrew Jackson and Ella McCue.

Lone Crest, the home of B. F. Slater, still stands at 106 East State Road between West Grove and Avondale, next to the Avon Grove Charter School (formerly Avon Grove High School and then Avon Grove Elementary). The oval glass insert in the door with the star is still intact. The home was built around 1885 and was named Lone Crest.

What makes this multi-view card unusual is the advertisement for the West Grove Printing House. Sent as a New Year's greeting, it touts the "unsurpassed facilities" that were available from the establishment. William T. Dantz was the editor of the *West Grove Independent* from 1901 to 1914. C. A. Johnston was in charge of the actual printing. He became one-third partner in 1905. Shown are the New Stone Road, Orthodox meetinghouse, and Catholic church.

126

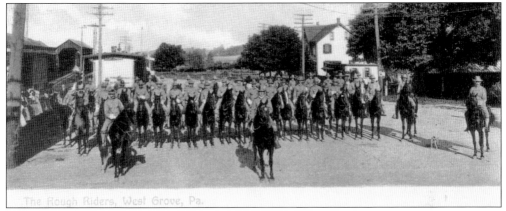

In 1905, William T. Dantz formed the Rough Rider group shown here next to the West Grove railroad station. Both Dantz and Forrest McNeil, also from the area, were members of Theodore Roosevelt's Rough Riders. Dantz served with Roosevelt in the Badlands, and after Roosevelt was elected president, Dantz received an appointment to be the West Grove postmaster. In this picture, the small dog on the right was named Teddy and belonged to Dantz's son, Theodore Roosevelt Dantz. The group pictured consisted of 56 experienced horsemen and expert riders. The captain was P. J. Lynch of West Grove; other members included Dr. F. B. West of Kemblesville, Dr. William B. Ewing from West Grove, and many Republicans from surrounding townships in the area.

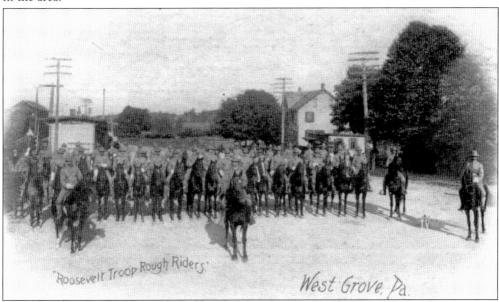

ACROSS AMERICA, PEOPLE ARE DISCOVERING
SOMETHING WONDERFUL. *THEIR HERITAGE.*

Arcadia Publishing is the leading local history publisher in the United States. With more than 3,000 titles in print and hundreds of new titles released every year, Arcadia has extensive specialized experience chronicling the history of communities and celebrating America's hidden stories, bringing to life the people, places, and events from the past. To discover the history of other communities across the nation, please visit:

www.arcadiapublishing.com

Customized search tools allow you to find regional history books about the town where you grew up, the cities where your friends and family live, the town where your parents met, or even that retirement spot you've been dreaming about.

PREFACE

When I created the first design for my book **Crochet Comfortable Socks** back in 2019, I immediately saw the versatility of this crochet technique.

Just like for socks, there weren't a lot of patterns to crochet soft and supple mittens. It took a little time to perfect the pattern and fit, but I really loved how they turned out. The prototype was instantly approved by both the testers and my own family.

From the mittens, it was a logical step to also try to make matching hats. It's so much fun to create sets of hats and mittens suitable for every age and style. In this book you'll find a variety of different items that can be combined together as a set.

Out of all the designs I have made in my life, I can honestly say that these projects are the ones that received the most love and use from my family. As soon as a hat came off the hook, it was claimed and never returned. That's why my husband and children often have an unfinished yarn-end hanging from their hats, because I don't even get the chance to finish them!

This book is the first book where I had the privilege of taking all the photos myself. It was so special to be able to give a little peek into the entire process from behind the scenes. As a result, this book really became a personal story.

I wish you lots of fun browsing, picking out colors and patterns, crocheting, wearing, and gifting.

Love, Sascha

CONTENTS

CONTENTS

Chapter 1

MATERIALS

Crochet Hooks

Many crocheters still use the thin metal hooks from Grandmother's time, but now there are a lot of beautiful and practical options! There are many ergonomic designs that feel a lot more pleasant in your hands. Wooden crochet hooks come in many variations and are worth a try. You will likely find either metal or wood more pleasant to work with; few crocheters use both. Wood is a lot warmer in the hand and has a little more grip on the yarn, where a metal or plastic hook is a lot smoother and slides easily through the yarn. The most special crochet hooks are handmade, as shown in the picture! These fancy wooden ergonomic hooks are hand-turned by Allan Marshall from Bowltech Crochet Hooks.

Stitch Markers

Stitch markers mark stitches where, for example, a stitch must be increased or decreased, but they also can indicate your end or starting point. There are several types of plastic and metal markers on the market, but a paper clip or safety pin also works fine.

Yarn Needle

You will need a thick needle with a large eye for finishing the socks.

Scissors

Use a fine, sharp pair of scissors to cut yarn.

Measuring Tape

Measuring is indispensable for matching the stitching gauge, and it's helpful for sizing.

Project Bag

A small tote or bag will keep your work neat, clean, and easily portable—because you can crochet hats and mittens anywhere!

SOCK YARN

You can find sock yarn in many types and varieties. All projects in this book are crocheted with the most common thickness, 4-ply sock yarn for hook sizes US B-1 to E-4 (2.25 to 3.5 mm). You can often find this thickness on skeins of 3.5 oz./459 yd (100 g./420 m) or 1.7 oz./230 yd (50 g./210 m). Here is a small overview of the differences in yarn properties.

Fibers

The most common sock yarns are made from virgin wool. This means that the wool has been sheared directly from a live sheep. This fiber has the perfect properties for items that are heavily used! It is very strong and durable, but it is also moisture-absorbent and breathable. Other animal fibers used are Merino wool from the Merino sheep, alpaca wool, or even cashmere for softer, more luxurious socks. Cotton yarn is also available but has a completely different effect than wool. It wears and crochets very pleasantly, but to make it stretchy, elastic is added to the cotton yarn, which gives it a different feel when you crochet with it. It will give your stitches very nice definition, but crocheting with cotton takes some getting used to.

Appearance

Skeins of sock yarn are often so beautiful that this is reason enough for an enthusiast to buy them! Of course, you can make nice color patterns with single-color yarns, but you can also buy skeins in which the color pattern is already incorporated. For example, you will find yarns with short repeating runs of color that are especially fun to use with simple patterns. Long gradients are suitable for more intricate patterns. I also love heathered and tweed yarns. These two variants seem plainer, but they make your pattern take center stage and give it just a little extra depth!

Yarn Brands

Many brands have a line with this type of yarn in their range. Some examples of different brand lines include: Durable Soqs (various lines), Lang Yarns Jawoll (various lines), Schachenmayr Regia 4-ply (various lines), Lana Grossa Meilenweit (various lines), and Lamana Merida. A few yarns with a slight difference in yardage that are also suitable are: Scheepjes Metropolis and Onion Nettle Sock yarn.

SIZE AND GAUGE

Ideally, you choose the size by measuring the hand or head. If you don't have that information, you can also rely on age, but not everyone has the same measurements. The exact amount of yarn you need for each size can be found in the patterns.

Hat Sizes

The circumference of the head is measured on the widest part of the head, just above the ears.

Age/Size	Head Circumference
0–6 months	14 in (35.5 cm)
6–12 months	17 in (43 cm)
1–3 years	19 in (48.5 cm)
4 years–teen	20 in (51 cm)
Medium	22 in (56 cm)
Large	23 in (58.5 cm)

Mitten Sizes

The circumference of the hand is measured on the widest part of the hand, around the knuckles, excluding the thumb. Measure the length of the hand from the top of the middle finger to the start of the wrist.

Age/Size	Hand Circumference	Hand Length
0–1 year	4 in (10 cm)	3.5 in (9 cm)
1–3 years	5 in (12.5 cm)	4 in (10 cm)
4–8 years	6 in (15 cm)	5 in (12.5 cm)
Small	7 in (17.5 cm)	6 in (15 cm)
Medium	8 in (20 cm)	7.5 in (19 cm)
Large	9 in (22.5 cm)	9 in (22.5 cm)

Gauge

Gauge is very important! To make sure that your projects turn out the right size, check your gauge. To do this, make a small test piece (or at least check the gauge as you crochet).

The gauge for projects in this book is: 5 sts wide and 4 rnds high = 0.7 in (2 cm) square.

If your ratio does not match, try a different size crochet hook. If you have more stitches than this ratio, try a larger crochet hook (US size 7/4.5 mm); if you have fewer stitches, try a smaller crochet hook (US size E-4/3.5 mm).

Chapter 4

CROCHET STITCHES

MAGIC LOOP

Wrap the yarn around the palm of your hand forming a circle; the working yarn, which comes from the skein, should be over the yarn tail. Insert your crochet hook into the ring and wrap the working yarn from back to front around your hook so that you have a "yarn over" on your crochet hook. Pull the "yarn over" through the ring, yarn over again and hook one chain stitch. Then crochet the type and number of stitches into the ring as the pattern states, working around both the yarn of the ring and the loose end. Once you have the desired number of stitches, pull the tail end of the yarn tightly to close the ring. Continue working according to the pattern.

CHAIN

In the illustration, there is a setup chain already on the crochet hook; otherwise, begin with a slipknot on your hook. Insert the crochet hook under the working yarn so that you put a wrap, or yarn over, on your hook, and then pull the yarn through the loop on your hook. You have made one chain.

SLIP STITCH

Insert the crochet hook into the stitch from front to back, yarn over with the working yarn then pull the yarn through the two loops on your hook. You have worked a slip stitch.

SINGLE CROCHET

Insert the crochet hook from front to back, yarn over with the working yarn then pull the yarn through the stitch. Yarn over again and pull the working yarn through the two loops on your hook. You have made a single crochet.

HALF DOUBLE CROCHET

Yarn over your crochet hook from back to front and insert the hook into the stitch from front to back. Yarn over and pull the yarn through the stitch. You have three loops on your hook. Yarn over again and pull the yarn through all three loops. You have made a half double crochet.

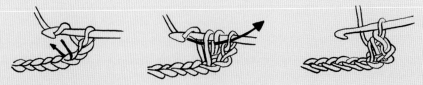

DOUBLE CROCHET

Yarn over your crochet hook from back to front and insert the hook into the stitch from front to back. Yarn over and pull the yarn through the stitch. You have three loops on your hook. Yarn over again and pull the yarn through two of the loops on your hook. Yarn over again and pull the yarn through the last two loops on your hook. You have worked a double crochet.

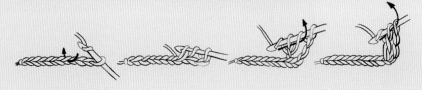

TREBLE CROCHET

Wrap yarn over your crochet hook twice from back to front so you have two yarn-overs on your hook. Insert the hook into the stitch from front to back, yarn over, and pull the yarn through the stitch, * yarn over again, pull yarn through the first two loops on your hook *, repeat from * to * two more times. You have worked a treble crochet.

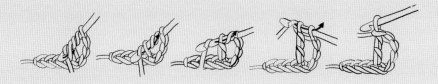

POST STITCHES

Post stitches are just like normal
stitches, but instead of your hook
going into the top of the stitch, you
work the hook around the leg of the
stitch.

Front Post Double Crochet

For a front post double crochet, yarn
over and insert the hook from front
to back behind the stitch and back to
the front again; then work the double
crochet as usual.

Back Post Double Crochet

Work just like a normal double
crochet stitch, but instead of
inserting the hook into the top of the
stitch, work it around the leg of the
stitch from back to front and back
behind again.

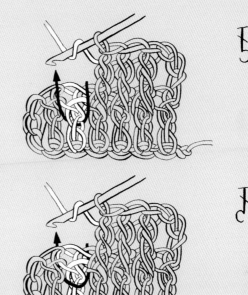

Front Post Half Double Crochet

Work just like a normal half double crochet, but insert the hook around the
stitch from front to back and then to the front again.

Back Post Half Double Crochet

Work just like a normal half double crochet, but insert the hook around the
stitch from back to front and then to the back again.

Front Post Treble Crochet

Work just like a normal treble crochet, but insert the hook around the stitch
from front to back and then to the front again.

Back Post Treble Crochet

Work just like a normal treble crochet, but insert the hook around the stitch from
back to front and then to the back again.

CROCHETING THE THUMB AND THUMBHOLE IN PICTURES

CROCHETING THE THUMBHOLE

CROCHETING THE THUMB

Chapter 6

PATTERNS

Skill Level: 2 of 5

DECEMBER MITTENS

MATERIALS

Yarn
Fingering weight sock yarn. Samples
shown in:

Cream
Lana Grossa Meilenweit Tweed; 80%
wool, 20% nylon; 3.5 oz/459 yd (100
g/420 m); #106 Cream

Beige Blend
Borgo de Pazzi Bice; 75% wool, 25%
nylon; 3.5 oz/459 yd (100 g/420 m);
#330 Beige Melange

Crochet Hook
US size G-6 (4 mm)

Estimate of Yarn Required

0–1 year	230 yd (210 m)
1–3 years	230 yd (210 m)
4–8 years	460 yd (420 m)
Small	460 yd (420 m)
Medium	460 yd (420 m)
Large	690 yd (630 m)

Size and Gauge
For help choosing a size and matching
gauge, refer to Size and Gauge on
pages 12–13.

ABBREVIATIONS

⬯	ch	chain
✕	sc	single crochet
⬮	sl st	slip stitch
⊤	dc	double crochet
⊤	hdc	half double crochet
⌐	fpdc	front post double crochet
⌐	bpdc	back post double crochet
⋏	fpdc2tog	fpdc 2 together
⋏	2fpdcin	2 fpdc in next stitch

SIZE: 0-1 YEAR (no thumb)

RND 1: Start with a magic loop, ch2 (first ch2 doesn't count as first dc throughout the pattern), 6dc in the loop, sl st in first dc. (6)

RND 2: Ch2, 2fpdc in each stitch around, sl st in first fpdc. (12)

RND 3: Ch2, *fpdc1, 2fpdcin*, repeat * to * 2 more times, hdc1, 2fpdcin, repeat * to * 2 more times, sl st in first fpdc. (18)

RND 4: Ch2, *fpdc2, 2fpdcin*, repeat * to * 2 more times, hdc1, fpdc1, 2fpdcin, repeat * to * 2 more times, sl st in first fpdc. (24)

RND 5: Ch2, *fpdc3, 2fpdcin*, repeat * to * 2 more times, hdc1, fpdc2, 2fpdcin, repeat * to * 2 more times, sl st in first fpdc. (30)

RNDS 6-18: Ch2, fpdc15, hdc1, fpdc14, sl st in first fpdc. (30)

You can customize the mitten by adding more repeats of the round above. This part should cover the fingers and hand, down to just above the wrist. Make sure to leave a little bit of room above the fingers for free movement.

RND 19: Ch2, fpdc13, fpdc2tog, hdc1, fpdc2tog, fpdc12, sl st in first fpdc. (28)

RND 20: Ch2, fpdc12, fpdc2tog, hdc1, fpdc2tog, fpdc11, sl st in first fpdc. (26)

RNDS 21-25: Ch2, *fpdc1, bpdc1*, repeat around, sl st in first fpdc. (26)

If you like to have a longer or fold-over cuff, you can repeat the round above for as long as you like. Cut yarn, fasten off, and weave in ends.

STACKPOLE BOOKS

An imprint of Globe Pequot, the trade division of
The Rowman & Littlefield Publishing Group, Inc.
4501 Forbes Blvd., Ste. 200
Lanham, MD 20706
www.rowman.com

Distributed by NATIONAL BOOK NETWORK

British Library Cataloguing in Publication Information available

Library of Congress Cataloging-in-Publication Data Available

ISBN 978-0-8117-7471-0 (paper: alk. paper)
ISBN 978-0-8117-7472-7 (electronic)

♾™ The paper used in this publication meets the minimum requirements of American National
Standard for Information Sciences—Permanence of Paper for Printed Library Materials, ANSI/
NISO Z39.48-1992.

CROCHET HATS AND MITTENS FOR EVERYONE

WINTER ESSENTIALS IN SIZES NEWBORN TO ADULT LARGE

SASCHA BLASE-VAN WAGTENDONK

STACKPOLE
BOOKS
ESSEX, CONNECTICUT
BLUE RIDGE SUMMIT, PENNSYLVANIA

PREFACE

When I created the first design for my book **Crochet Comfortable Socks** back in 2019, I immediately saw the versatility of this crochet technique.

Just like for socks, there weren't a lot of patterns to crochet soft and supple mittens. It took a little time to perfect the pattern and fit, but I really loved how they turned out. The prototype was instantly approved by both the testers and my own family.

From the mittens, it was a logical step to also try to make matching hats. It's so much fun to create sets of hats and mittens suitable for every age and style. In this book you'll find a variety of different items that can be combined together as a set.

Out of all the designs I have made in my life, I can honestly say that these projects are the ones that received the most love and use from my family. As soon as a hat came off the hook, it was claimed and never returned. That's why my husband and children often have an unfinished yarn-end hanging from their hats, because I don't even get the chance to finish them!

This book is the first book where I had the privilege of taking all the photos myself. It was so special to be able to give a little peek into the entire process from behind the scenes. As a result, this book really became a personal story.

I wish you lots of fun browsing, picking out colors and patterns, crocheting, wearing, and gifting.

Love, Sascha

CONTENTS

CONTENTS

Chapter 1

MATERIALS

Crochet Hooks

Many crocheters still use the thin metal hooks from Grandmother's time, but now there are a lot of beautiful and practical options! There are many ergonomic designs that feel a lot more pleasant in your hands. Wooden crochet hooks come in many variations and are worth a try. You will likely find either metal or wood more pleasant to work with; few crocheters use both. Wood is a lot warmer in the hand and has a little more grip on the yarn, where a metal or plastic hook is a lot smoother and slides easily through the yarn. The most special crochet hooks are handmade, as shown in the picture! These fancy wooden ergonomic hooks are hand-turned by Allan Marshall from Bowltech Crochet Hooks.

Stitch Markers

Stitch markers mark stitches where, for example, a stitch must be increased or decreased, but they also can indicate your end or starting point. There are several types of plastic and metal markers on the market, but a paper clip or safety pin also works fine.

Yarn Needle
You will need a thick needle with a large eye for finishing the socks.

Scissors
Use a fine, sharp pair of scissors to cut yarn.

Measuring Tape
Measuring is indispensable for matching the stitching gauge, and it's helpful for sizing.

Project Bag
A small tote or bag will keep your work neat, clean, and easily portable—because you can crochet hats and mittens anywhere!

Chapter 2

SOCK YARN

You can find sock yarn in many types and varieties. All projects in this book are crocheted with the most common thickness, 4-ply sock yarn for hook sizes US B-1 to E-4 (2.25 to 3.5 mm). You can often find this thickness on skeins of 3.5 oz./459 yd (100 g./420 m) or 1.7 oz./230 yd (50 g./210 m). Here is a small overview of the differences in yarn properties.

Fibers

The most common sock yarns are made from virgin wool. This means that the wool has been sheared directly from a live sheep. This fiber has the perfect properties for items that are heavily used! It is very strong and durable, but it is also moisture-absorbent and breathable. Other animal fibers used are Merino wool from the Merino sheep, alpaca wool, or even cashmere for softer, more luxurious socks. Cotton yarn is also available but has a completely different effect than wool. It wears and crochets very pleasantly, but to make it stretchy, elastic is added to the cotton yarn, which gives it a different feel when you crochet with it. It will give your stitches very nice definition, but crocheting with cotton takes some getting used to.

Appearance

Skeins of sock yarn are often so beautiful that this is reason enough for an enthusiast to buy them! Of course, you can make nice color patterns with single-color yarns, but you can also buy skeins in which the color pattern is already incorporated. For example, you will find yarns with short repeating runs of color that are especially fun to use with simple patterns. Long gradients are suitable for more intricate patterns. I also love heathered and tweed yarns. These two variants seem plainer, but they make your pattern take center stage and give it just a little extra depth!

Yarn Brands

Many brands have a line with this type of yarn in their range. Some examples of different brand lines include: Durable Soqs (various lines), Lang Yarns Jawoll (various lines), Schachenmayr Regia 4-ply (various lines), Lana Grossa Meilenweit (various lines), and Lamana Merida. A few yarns with a slight difference in yardage that are also suitable are: Scheepjes Metropolis and Onion Nettle Sock yarn.

SIZE AND GAUGE

Ideally, you choose the size by measuring the hand or head. If you don't have that information, you can also rely on age, but not everyone has the same measurements. The exact amount of yarn you need for each size can be found in the patterns.

Hat Sizes

The circumference of the head is measured on the widest part of the head, just above the ears.

Age/Size	Head Circumference
0–6 months	14 in (35.5 cm)
6–12 months	17 in (43 cm)
1–3 years	19 in (48.5 cm)
4 years–teen	20 in (51 cm)
Medium	22 in (56 cm)
Large	23 in (58.5 cm)

Mitten Sizes

The circumference of the hand is measured on the widest part of the hand, around the knuckles, excluding the thumb. Measure the length of the hand from the top of the middle finger to the start of the wrist.

Age/Size	Hand Circumference	Hand Length
0–1 year	4 in (10 cm)	3.5 in (9 cm)
1–3 years	5 in (12.5 cm)	4 in (10 cm)
4–8 years	6 in (15 cm)	5 in (12.5 cm)
Small	7 in (17.5 cm)	6 in (15 cm)
Medium	8 in (20 cm)	7.5 in (19 cm)
Large	9 in (22.5 cm)	9 in (22.5 cm)

Gauge

Gauge is very important! To make sure that your projects turn out the right size, check your gauge. To do this, make a small test piece (or at least check the gauge as you crochet).

The gauge for projects in this book is: 5 sts wide and 4 rnds high = 0.7 in (2 cm) square.

If your ratio does not match, try a different size crochet hook. If you have more stitches than this ratio, try a larger crochet hook (US size 7/4.5 mm); if you have fewer stitches, try a smaller crochet hook (US size E-4/3.5 mm).

Chapter 4

CROCHET STITCHES

MAGIC LOOP

Wrap the yarn around the palm of your hand forming a circle; the working yarn, which comes from the skein, should be over the yarn tail. Insert your crochet hook into the ring and wrap the working yarn from back to front around your hook so that you have a "yarn over" on your crochet hook. Pull the "yarn over" through the ring, yarn over again and hook one chain stitch. Then crochet the type and number of stitches into the ring as the pattern states, working around both the yarn of the ring and the loose end. Once you have the desired number of stitches, pull the tail end of the yarn tightly to close the ring. Continue working according to the pattern.

CHAIN

In the illustration, there is a setup chain already on the crochet hook; otherwise, begin with a slipknot on your hook. Insert the crochet hook under the working yarn so that you put a wrap, or yarn over, on your hook, and then pull the yarn through the loop on your hook. You have made one chain.

SLIP STITCH

Insert the crochet hook into the stitch from front to back, yarn over with the working yarn then pull the yarn through the two loops on your hook. You have worked a slip stitch.

SINGLE CROCHET

Insert the crochet hook from front to back, yarn over with the working yarn then pull the yarn through the stitch. Yarn over again and pull the working yarn through the two loops on your hook. You have made a single crochet.

HALF DOUBLE CROCHET

Yarn over your crochet hook from back to front and insert the hook into the stitch from front to back. Yarn over and pull the yarn through the stitch. You have three loops on your hook. Yarn over again and pull the yarn through all three loops. You have made a half double crochet.

DOUBLE CROCHET

Yarn over your crochet hook from back to front and insert the hook into the stitch from front to back. Yarn over and pull the yarn through the stitch. You have three loops on your hook. Yarn over again and pull the yarn through two of the loops on your hook. Yarn over again and pull the yarn through the last two loops on your hook. You have worked a double crochet.

TREBLE CROCHET

Wrap yarn over your crochet hook twice from back to front so you have two yarn-overs on your hook. Insert the hook into the stitch from front to back, yarn over, and pull the yarn through the stitch, * yarn over again, pull yarn through the first two loops on your hook *, repeat from * to * two more times. You have worked a treble crochet.

POST STITCHES

Post stitches are just like normal stitches, but instead of your hook going into the top of the stitch, you work the hook around the leg of the stitch.

Front Post Double Crochet
For a front post double crochet, yarn over and insert the hook from front to back behind the stitch and back to the front again; then work the double crochet as usual.

Back Post Double Crochet
Work just like a normal double crochet stitch, but instead of inserting the hook into the top of the stitch, work it around the leg of the stitch from back to front and back behind again.

Front Post Half Double Crochet
Work just like a normal half double crochet, but insert the hook around the stitch from front to back and then to the front again.

Back Post Half Double Crochet
Work just like a normal half double crochet, but insert the hook around the stitch from back to front and then to the back again.

Front Post Treble Crochet
Work just like a normal treble crochet, but insert the hook around the stitch from front to back and then to the front again.

Back Post Treble Crochet
Work just like a normal treble crochet, but insert the hook around the stitch from back to front and then to the back again.

CROCHETING THE THUMB AND THUMBHOLE IN PICTURES

CROCHETING THE THUMBHOLE

CROCHETING THE THUMB

Chapter 6

PATTERNS

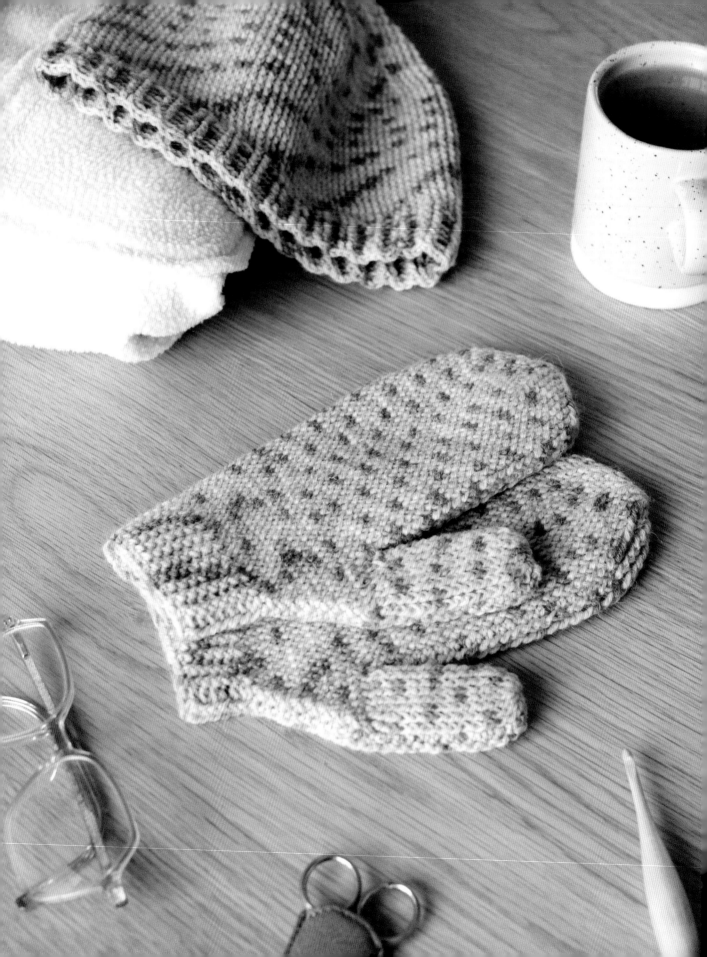

Skill Level: 2 of 5

DECEMBER MITTENS

MATERIALS

Yarn
Fingering weight sock yarn. Samples shown in:

Cream
Lana Grossa Meilenweit Tweed; 80% wool, 20% nylon; 3.5 oz/459 yd (100 g/420 m); #106 Cream

Beige Blend
Borgo de Pazzi Bice; 75% wool, 25% nylon; 3.5 oz/459 yd (100 g/420 m); #330 Beige Melange

Crochet Hook
US size G-6 (4 mm)

Estimate of Yarn Required

0–1 year	230 yd (210 m)
1–3 years	230 yd (210 m)
4–8 years	460 yd (420 m)
Small	460 yd (420 m)
Medium	460 yd (420 m)
Large	690 yd (630 m)

Size and Gauge
For help choosing a size and matching gauge, refer to Size and Gauge on pages 12–13.

ABBREVIATIONS

⬭	**ch**	chain
✕	**sc**	single crochet
⬬	**sl st**	slip stitch
⊥	**dc**	double crochet
⊥	**hdc**	half double crochet
↯	**fpdc**	front post double crochet
↶	**bpdc**	back post double crochet
⤩	**fpdc2tog**	fpdc 2 together
⤪	**2fpdcin**	2 fpdc in next stitch

SIZE: 0-1 YEAR (no thumb)

. .

RND 1: Start with a magic loop, ch2 (first ch2 doesn't count as first dc throughout the pattern), 6dc in the loop, sl st in first dc. (6)

RND 2: Ch2, 2fpdc in each stitch around, sl st in first fpdc. (12)

RND 3: Ch2, *fpdc1, 2fpdcin*, repeat * to * 2 more times, hdc1, 2fpdcin, repeat * to * 2 more times, sl st in first fpdc. (18)

RND 4: Ch2, *fpdc2, 2fpdcin*, repeat * to * 2 more times, hdc1, fpdc1, 2fpdcin, repeat * to * 2 more times, sl st in first fpdc. (24)

RND 5: Ch2, *fpdc3, 2fpdcin*, repeat * to * 2 more times, hdc1, fpdc2, 2fpdcin, repeat * to * 2 more times, sl st in first fpdc. (30)

RNDS 6-18: Ch2, fpdc15, hdc1, fpdc14, sl st in first fpdc. (30)

You can customize the mitten by adding more repeats of the round above. This part should cover the fingers and hand, down to just above the wrist. Make sure to leave a little bit of room above the fingers for free movement.

RND 19: Ch2, fpdc13, fpdc2tog, hdc1, fpdc2tog, fpdc12, sl st in first fpdc. (28)

RND 20: Ch2, fpdc12, fpdc2tog, hdc1, fpdc2tog, fpdc11, sl st in first fpdc. (26)

RNDS 21-25: Ch2, *fpdc1, bpdc1*, repeat around, sl st in first fpdc. (26)

If you like to have a longer or fold-over cuff, you can repeat the round above for as long as you like. Cut yarn, fasten off, and weave in ends.

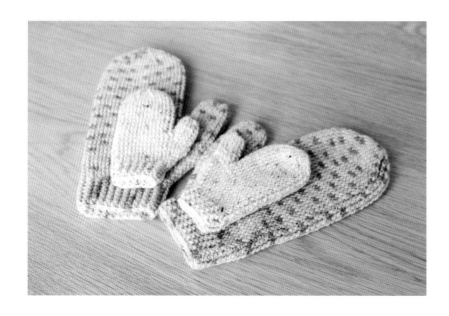

SIZE: 1-3 YEARS

· ·

RND 1: Start with a magic loop, ch2 (first ch2 doesn't count as first dc throughout the pattern), 6dc in the loop, sl st in first dc. (6)

RND 2: Ch2, 2fpdc in each stitch around, sl st in first fpdc. (12)

RND 3: Ch2, *fpdc1, 2fpdcin*, repeat * to * 2 more times, hdc1, 2fpdcin, repeat * to * 2 more times, sl st in first fpdc. (18)

RND 4: Ch2, *fpdc2, 2fpdcin*, repeat * to * 2 more times, hdc1, fpdc1, 2fpdcin, repeat * to * 2 more times, sl st in first fpdc. (24)

RND 5: Ch2, *fpdc3, 2fpdcin*, repeat * to * 2 more times, hdc1, fpdc2, 2fpdcin, repeat * to * 2 more times, sl st in first fpdc. (30)

RNDS 6-15: Ch2, fpdc15, hdc1, fpdc14, sl st in first fpdc. (30)

You can customize the mitten by adding more repeats of the round above. This part should cover the fingers and hand, down to the start of the thumb. Make sure to leave a little bit of room above the fingers for free movement.

RND 16: Ch2, fpdc15, ch9, skip 1 hdc, fpdc14, sl st in first fpdc. (38) See photo 1 on page 19.

RND 17: Ch2, fpdc15, dc4, hdc1, dc4, fpdc14, sl st in first fpdc. (38) See photo 2 on page 19.

RND 18: Ch2, fpdc17, fpdc2tog, hdc1, fpdc2tog, fpdc16, sl st in first fpdc. (36)

RND 19: Ch2, fpdc16, fpdc2tog, hdc1, fpdc2tog, fpdc15, sl st in first fpdc. (34)

RND 20: Ch2, fpdc15, fpdc2tog, hdc1, fpdc2tog, fpdc14, sl st in first fpdc. (32)

RND 21: Ch2, fpdc14, fpdc2tog, hdc1, fpdc2tog, fpdc13, sl st in first fpdc. (30)

RND 22: Ch2, fpdc13, fpdc2tog, hdc1, fpdc2tog, fpdc12, sl st in first fpdc. (28)

RND 23: Ch2, fpdc12, fpdc2tog, hdc1, fpdc2tog, fpdc11, sl st in first fpdc. (26)

RNDS 24-28: Ch2, *fpdc1, bpdc1*, repeat around, sl st in first fpdc. (26)

If you like to have a longer or fold-over cuff, you can repeat the round above for as long as you like. Cut yarn, fasten off, and weave in ends.

THUMB

RND 1: Attach the yarn with a sl st in the ch of Rnd 16 above the hdc of Rnd 17, ch2, fpdc4, sc1 in the side of the dc of Rnd 15, sc1 before the hdc of Rnd 15, sc1 after the hdc of Rnd 15, sc1 in the side of the dc of Rnd 16, fpdc4, sl st in first fpdc. (12) See photos 3-10 on page 19.

RND 2: Ch2, fpdc4, dc4, fpdc4, sl st in first fpdc. (12)

RNDS 3-5: Ch2, fpdc12, sl st in first fpdc. (12)

RND 6: Ch2, *fpdc2tog*, repeat around, sl st in first fpdc. (6)

Cut yarn, weave through the loops of the remaining stitches, pull tight, fasten off, and weave in ends.

SIZE: 4–8 YEARS

. .

RND 1: Start with a magic loop, ch2 (first ch2 doesn't count as first dc throughout the pattern), 6dc in the loop, sl st in first dc. (6)

RND 2: Ch2, 2fpdc in each stitch around, sl st in first fpdc. (12)

RND 3: Ch2, *fpdc1, 2fpdcin*, repeat * to * 2 more times, hdc1, 2fpdcin, repeat * to * 2 more times, sl st in first fpdc. (18)

RND 4: Ch2, *fpdc2, 2fpdcin*, repeat * to * 2 more times, hdc1, fpdc1, 2fpdcin, repeat * to * 2 more times, sl st in first fpdc. (24)

RND 5: Ch2, *fpdc3, 2fpdcin*, repeat * to * 2 more times, hdc1, fpdc2, 2fpdcin, repeat * to * 2 more times, sl st in first fpdc. (30)

RND 6: Ch2, *fpdc4, 2fpdcin*, repeat * to * 2 more times, hdc1, fpdc3, 2fpdcin, repeat * to * 2 more times, sl st in first fpdc. (36)

RNDS 7–20: Ch2, fpdc18, hdc1, fpdc17, sl st in first fpdc. (36)

You can customize the mitten by adding more repeats of the round above. This part should cover the fingers and hand, down to the start of the thumb. Make sure to leave a little bit of room above the fingers for free movement.

RND 21: Ch2, fpdc18, ch11, skip 1 hdc, fpdc17, sl st in first fpdc. (46) See photo 1 on page 19.

RND 22: Ch2, fpdc18, dc5, hdc1, dc5, fpdc17, sl st in first fpdc. (46) See photo 2 on page 19.

RND 23: Ch2, fpdc21, fpdc2tog, hdc1, fpdc2tog, fpdc20, sl st in first fpdc. (44)

RND 24: Ch2, fpdc20, fpdc2tog, hdc1, fpdc2tog, fpdc19, sl st in first fpdc. (42)

RND 25: Ch2, fpdc19, fpdc2tog, hdc1, fpdc2tog, fpdc18, sl st in first fpdc. (40)

RND 26: Ch2, fpdc18, fpdc2tog, hdc1, fpdc2tog, fpdc17, sl st in first fpdc. (38)

RND 27: Ch2, fpdc17, fpdc2tog, hdc1, fpdc2tog, fpdc16, sl st in first fpdc. (36)

RND 28: Ch2, fpdc16, fpdc2tog, hdc1, fpdc2tog, fpdc15, sl st in first fpdc. (34)

RND 29: Ch2, fpdc15, fpdc2tog, hdc1, fpdc2tog, fpdc14, sl st in first fpdc. (32)

RNDS 30–35: Ch2, *fpdc1, bpdc1*, repeat around, sl st in first fpdc. (32)

If you like to have a longer or fold-over cuff, you can repeat the round above for as long as you like. Cut yarn, fasten off, and weave in ends.

THUMB

RND 1: Attach the yarn with a sl st in the ch of Rnd 21 above the hdc of Rnd 22, ch2, fpdc5, sc1 in the side of the dc of Rnd 21, sc1 before the hdc of Rnd 20, sc1 after the hdc of Rnd 20, sc1 in the side of the dc of Rnd 21, fpdc5, sl st in first fpdc. (14) See photos 3–10 on page 19.

RND 2: Ch2, fpdc5, dc4, fpdc5, sl st in first fpdc. (14)

RNDS 3–8: Ch2, fpdc14, sl st in first fpdc. (14)

RND 9: Ch2, *fpdc2tog*, repeat around, sl st in first fpdc. (7)

Cut yarn, weave through the loops of the remaining stitches, pull tight, fasten off, and weave in ends.

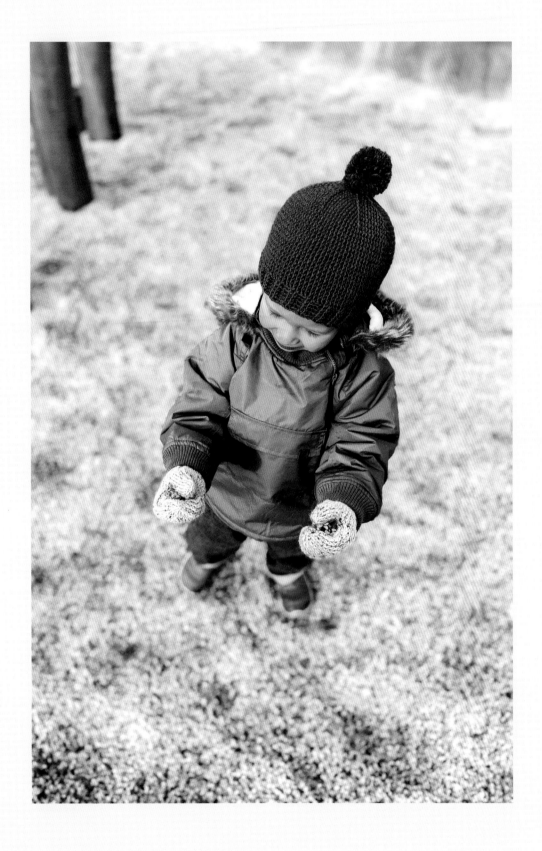

SIZE: SMALL

RND 1: Start with a magic loop, ch2 (first ch2 doesn't count as first dc throughout the pattern), 6dc in the loop, sl st in first dc. (6)

RND 2: Ch2, 2fpdc in each stitch around, sl st in first fpdc. (12)

RND 3: Ch2, *fpdc1, 2fpdcin*, repeat * to * 2 more times, hdc1, 2fpdcin, repeat * to * 2 more times, sl st in first fpdc. (18)

RND 4: Ch2, *fpdc2, 2fpdcin*, repeat * to * 2 more times, hdc1, fpdc1, 2fpdcin, repeat * to * 2 more times, sl st in first fpdc. (24)

RND 5: Ch2, *fpdc3, 2fpdcin*, repeat * to * 2 more times, hdc1, fpdc2, 2fpdcin, repeat * to * 2 more times, sl st in first fpdc. (30)

RND 6: Ch2, *fpdc4, 2fpdcin*, repeat * to * 2 more times, hdc1, fpdc3, 2fpdcin, repeat * to * 2 more times, sl st in first fpdc. (36)

RND 7: Ch2, *fpdc5, 2fpdcin*, repeat * to * 2 more times, hdc1, fpdc4, 2fpdcin, repeat * to * 2 more times, sl st in first fpdc. (42)

RNDS 8-25: Ch2, fpdc21, hdc1, fpdc20, sl st in first fpdc. (42)

You can customize the mitten by adding more repeats of the round above. This part should cover the fingers and hand, down to the start of the thumb. Make sure to leave a little bit of room above the fingers for free movement.

RND 26: Ch2, fpdc21, ch13, skip 1 hdc, fpdc20, sl st in first fpdc. (54) See photo 1 on page 19.

RND 27: Ch2, fpdc21, dc6, hdc1, dc6, fpdc20, sl st in first fpdc. (54) See photo 2 on page 19.

RND 28: Ch2, fpdc25, fpdc2tog, hdc1, fpdc2tog, fpdc24, sl st in first fpdc. (52)

RND 29: Ch2, fpdc24, fpdc2tog, hdc1, fpdc2tog, fpdc23, sl st in first fpdc. (50)

RND 30: Ch2, fpdc23, fpdc2tog, hdc1, fpdc2tog, fpdc22, sl st in first fpdc. (48)

RND 31: Ch2, fpdc22, fpdc2tog, hdc1, fpdc2tog, fpdc21, sl st in first fpdc. (46)

RND 32: Ch2, fpdc21, fpdc2tog, hdc1, fpdc2tog, fpdc20, sl st in first fpdc. (44)

RND 33: Ch2, fpdc20, fpdc2tog, hdc1, fpdc2tog, fpdc19, sl st in first fpdc. (42)

RND 34: Ch2, fpdc19, fpdc2tog, hdc1, fpdc2tog, fpdc18, sl st in first fpdc. (40)

RND 35: Ch2, fpdc18, fpdc2tog, hdc1, fpdc2tog, fpdc17, sl st in first fpdc. (38)

RNDS 36-41: Ch2, *fpdc1, bpdc1*, repeat around, sl st in first fpdc. (38)

If you like to have a longer or fold-over cuff, you can repeat the round above for as long as you like. Cut yarn, fasten off, and weave in ends.

THUMB

RND 1: Attach the yarn with a sl st in
the ch of Rnd 26 above the hdc of Rnd
27, ch2, fpdc6, sc1 in the side of
the dc of Rnd 26, sc1 before the hdc
of Rnd 25, sc1 after the hdc of Rnd
25, sc1 in the side of the dc of Rnd
26, fpdc6, sl st in first fpdc. (16)
See photos 3-10 on page 19.

RND 2: Ch2, fpdc6, dc4, fpdc6, sl st in
first fpdc. (16)

RNDS 3-10: Ch2, fpdc16, sl st in first
fpdc. (16)

RND 11: Ch2, *fpdc2tog*, repeat around,
sl st in first fpdc. (8)

Cut yarn, weave through the loops of the
remaining stitches, pull tight, fasten
off, and weave in ends.

SIZE: MEDIUM

· ·

RND 1: Start with a magic loop, ch2 (first ch2 doesn't count as first dc throughout the pattern), 6dc in the loop, sl st in first dc. (6)

RND 2: Ch2, 2fpdc in each stitch around, sl st in first fpdc. (12)

RND 3: Ch2, *fpdc1, 2fpdcin*, repeat * to * 2 more times, hdc1, 2fpdcin, repeat * to * 2 more times, sl st in first fpdc. (18)

RND 4: Ch2, *fpdc2, 2fpdcin*, repeat * to * 2 more times, hdc1, fpdc1, 2fpdcin, repeat * to * 2 more times, sl st in first fpdc. (24)

RND 5: Ch2, *fpdc3, 2fpdcin*, repeat * to * 2 more times, hdc1, fpdc2, 2fpdcin, repeat * to * 2 more times, sl st in first fpdc. (30)

RND 6: Ch2, *fpdc4, 2fpdcin*, repeat * to * 2 more times, hdc1, fpdc3, 2fpdcin, repeat * to * 2 more times, sl st in first fpdc. (36)

RND 7: Ch2, *fpdc5, 2fpdcin*, repeat * to * 2 more times, hdc1, fpdc4, 2fpdcin, repeat * to * 2 more times, sl st in first fpdc. (42)

RND 8: Ch2, *fpdc6, 2fpdcin*, repeat * to * 2 more times, hdc1, fpdc5, 2fpdcin, repeat * to * 2 more times, sl st in first fpdc. (48)

RNDS 9-30: Ch2, fpdc24, hdc1, fpdc23, sl st in first fpdc. (48)

You can customize the mitten by adding more repeats of the round above. This part should cover the fingers and hand, down to the start of the thumb. Make sure to leave a little bit of room above the fingers for free movement.

RND 31: Ch2, fpdc24, ch15, skip 1 hdc, fpdc23, sl st in first fpdc. (62) See photo 1 on page 19.

RND 32: Ch2, fpdc24, dc7, hdc1, dc7, fpdc23, sl st in first fpdc. (62) See photo 2 on page 19.

RND 33: Ch2, fpdc29, fpdc2tog, hdc1, fpdc2tog, fpdc28, sl st in first fpdc. (60)

RND 34: Ch2, fpdc28, fpdc2tog, hdc1, fpdc2tog, fpdc27, sl st in first fpdc. (58)

RND 35: Ch2, fpdc27, fpdc2tog, hdc1, fpdc2tog, fpdc26, sl st in first fpdc. (56)

RND 36: Ch2, fpdc26, fpdc2tog, hdc1, fpdc2tog, fpdc25, sl st in first fpdc. (54)

RND 37: Ch2, fpdc25, fpdc2tog, hdc1, fpdc2tog, fpdc24, sl st in first fpdc. (52)

RND 38: Ch2, fpdc24, fpdc2tog, hdc1, fpdc2tog, fpdc23, sl st in first fpdc. (50)

RMD 39: Ch2, fpdc23, fpdc2tog, hdc1, fpdc2tog, fpdc22, sl st in first fpdc. (48)

RND 40: Ch2, fpdc22, fpdc2tog, hdc1, fpdc2tog, fpdc21, sl st in first fpdc. (46)

RND 41: Ch2, fpdc21, fpdc2tog, hdc1, fpdc2tog, fpdc20, sl st in first fpdc. (44)

RNDS 42-48: Ch2, *fpdc1, bpdc1*, repeat around, sl st in first fpdc. (44)

If you like to have a longer or fold-over cuff, you can repeat the round above for as long as you like. Cut yarn, fasten off, and weave in ends.

THUMB

RND 1: Attach the yarn with a sl st in the ch of Rnd 31 above the hdc of Rnd 32, ch2, fpdc7, sc1 in the side of the dc of Rnd 31, sc1 before the hdc of Rnd 30, sc1 after the hdc of Rnd 30, sc1 in the side of the dc of Rnd 31, fpdc7, sl st in first fpdc. (18) See photos 3-10 on page 19.

RND 2: Ch2, fpdc7, dc4, fpdc7, sl st in first fpdc (18)

RNDS 3-11: Ch2, fpdc18, sl st in first fpdc (18)

RND 12: Ch2, *fpdc2tog*, repeat around, sl st in first fpdc, (9)

Cut yarn, weave through the loops of the remaining stitches, pull tight, fasten off, and weave in ends.

SIZE: LARGE

. .

RND 1: Start with a magic loop, ch2 (first ch2 doesn't count as first dc throughout the pattern), 6dc in the loop, sl st in first dc. (6)

RND 2: Ch2, 2fpdc in each stitch around, sl st in first fpdc. (12)

RND 3: Ch2, *fpdc1, 2fpdcin*, repeat * to * 2 more times, hdc1, 2fpdcin, repeat * to * 2 more times, sl st in first fpdc. (18)

RND 4: Ch2, *fpdc2, 2fpdcin*, repeat * to * 2 more times, hdc1, fpdc1, 2fpdcin, repeat * to * 2 more times, sl st in first fpdc. (24)

RND 5: Ch2, *fpdc3, 2fpdcin*, repeat * to * 2 more times, hdc1, fpdc2, 2fpdcin, repeat * to * 2 more times, sl st in first fpdc. (30)

RND 6: Ch2, *fpdc4, 2fpdcin*, repeat * to * 2 more times, hdc1, fpdc3, 2fpdcin, repeat * to * 2 more times, sl st in first fpdc. (36)

RND 7: Ch2, *fpdc5, 2fpdcin*, repeat * to * 2 more times, hdc1, fpdc4, 2fpdcin, repeat * to * 2 more times, sl st in first fpdc. (42)

RND 8: Ch2, *fpdc6, 2fpdcin*, repeat * to * 2 more times, hdc1, fpdc5, 2fpdcin, repeat * to * 2 more times, sl st in first fpdc. (48)

RND 9: Ch2, *fpdc7, 2fpdcin*, repeat * to * 2 more times, hdc1, fpdc6, 2fpdcin, repeat * to * 2 more times, sl st in first fpdc. (54)

RNDS 10-35: Ch2, fpdc27, hdc1, fpdc26, sl st in first fpdc. (54)

You can customize the mitten by adding more repeats of the round above. This part should cover the fingers and hand, down to the start of the thumb. Make sure to leave a little bit of room above the fingers to allow free movement.

RND 36: Ch2, fpdc27, ch17, skip 1 hdc, fpdc26, sl st in first fpdc. (70) See photo 1 on page 19.

RND 37: Ch2, fpdc27, dc8, hdc1, dc8, fpdc26, sl st in first fpdc. (70) See photo 2 on page 19.

RND 38: Ch2, fpdc33, fpdc2tog, hdc1, fpdc2tog, fpdc32, sl st in first fpdc. (68)

RND 39: Ch2, fpdc32, fpdc2tog, hdc1, fpdc2tog, fpdc31, sl st in first fpdc. (66)

RND 40: Ch2, fpdc31, fpdc2tog, hdc1, fpdc2tog, fpdc30, sl st in first fpdc. (64)

RND 41: Ch2, fpdc30, fpdc2tog, hdc1, fpdc2tog, fpdc29, sl st in first fpdc. (62)

RND 42: Ch2, fpdc29, fpdc2tog, hdc1, fpdc2tog, fpdc28, sl st in first fpdc. (60)

RND 43: Ch2, fpdc28, fpdc2tog, hdc1, fpdc2tog, fpdc27, sl st in first fpdc. (58)

RND 44: Ch2, fpdc27, fpdc2tog, hdc1, fpdc2tog, fpdc26, sl st in first fpdc. (56)

RND 45: Ch2, fpdc26, fpdc2tog, hdc1, fpdc2tog, fpdc25, sl st in first fpdc. (54)

RND 46: Ch2, fpdc25, fpdc2tog, hdc1, fpdc2tog, fpdc24, sl st in first fpdc. (52)

RND 47: Ch2, fpdc24, fpdc2tog, hdc1, fpdc2tog, fpdc23, sl st in first fpdc. (50)

RNDS 48-54: Ch2, *fpdc1, bpdc1*, repeat around, sl st in first fpdc. (50)

If you like to have a longer or fold-over cuff, you can repeat the round above for as long as you like. Cut yarn, fasten off, and weave in ends.

THUMB

RND 1: Attach the yarn with a sl st in the ch of Rnd 36 above the hdc of Rnd 37, ch2, fpdc8, sc1 in the side of the dc of Rnd 36, sc1 before the hdc of Rnd 35, sc1 after the hdc of Rnd 35, sc1 in the side of the dc of Rnd 36, fpdc8, sl st in first fpdc. (20) See photos 3-10 on page 19.

RND 2: Ch2, fpdc8, dc4, fpdc8, sl st in first fpdc. (20)

RNDS 3-12: Ch2, fpdc20, sl st in first fpdc. (20)

RND 13: Ch2, *fpdc2tog*, repeat around, sl st in first fpdc. (10)

Cut yarn, weave through the loops of the remaining stitches, pull tight, fasten off, and weave in ends.

ROLL UP
YOUR SLEEVES
AND MAKE
SOME MITTENS.

Skill Level: 2 of 5

DECEMBER HAT

MATERIALS

Yarn
Fingering weight sock yarn. Samples shown in:

Brown
Durable Soqs; 75% superwash wool, 25% polyamide; 1.7 oz/230 yd (50 g/210 m); #407 Almond

Green and Pink
Lang Yarns Jawoll; 75% wool, 25% nylon; 1.7 oz/230 yd (50 g/210 m); #118 Green and #248 Rouge

Beige Blend
Borgo de Pazzi Bice; 75% wool, 25% nylon; 3.5 oz/459 yd (100 g/420 m); #330 Beige Melange

Crochet Hook
US size G-6 (4 mm)

Estimate of Yarn Required

0–6 months	230 yd (210 m)
6–12 months	230 yd (210 m)
1–3 years	459 yd (420 m)
4 years–teen	459 yd (420 m)
Medium	459 yd (420 m)
Large	459 yd (420 m)

Size and Gauge
For help choosing a size and matching gauge, refer to Size and Gauge on pages 12–13.

ABBREVIATIONS

⬭	**ch**	chain
⬤	**sl st**	slip stitch
⊢⊣	**dc**	double crochet
⌐Ϟ	**fpdc**	front post double crochet
Ϟ⌐	**bpdc**	back post double crochet
⋬	**2fpdcin**	2 fpdc in next stitch

PATTERN

RND 1: Start with a magic loop, ch2 (first ch2 doesn't count as first dc throughout the pattern), 8dc in the loop, sl st in first dc. (8)

RND 2: Ch2, 2fpdc in each stitch around, sl st in first fpdc. (16)

RND 3: Ch2, *fpdc1, 2fpdcin*, repeat * to * around, sl st in first fpdc. (24)

RND 4: Ch2, *fpdc1 in each fpdc to the second fpdc of the 2fpdcin of previous row, 2fpdcin*, repeat * to * around, sl st in first fpdc. (8 increases after each round)

Repeat Rnd 4 until your piece has a diameter of (or as close as possible to):

0-6 months	4.13 in (10.5 cm)
6-12 months	5 in (12.5 cm)
1-3 years	5.5 in (14 cm)
4 years-teen	5.75 in (14.6 cm)
Medium	6.25 in (16 cm)
Large	6.75 in (17 cm)

RND 5: Ch2, fpdc1 in each fpdc around, sl st in first fpdc. (no increases)

Repeat Rnd 5 until your piece has a length of (or as close as possible to):

0-6 months	4.25 in (10.8 cm)
6-12 months	5.5 in (14 cm)
1-3 years	6.25 in (16 cm)
4 years-teen	6.75 in (17 cm)
Medium	7.5 in (19 cm)
Large	7.5 in (19 cm)

RND 6: Ch2, *fpdc2, bpdc2*, repeat around, sl st in first fpdc (no increases).

Repeat Rnd 6 until your piece has a length of (or as close as possible to):

0-6 months	5.25 in (13.3 cm)
6-12 months	6.5 in (16.5 cm)
1-3 years	7.25 in (18.5 cm)
4 years-teen	7.75 in (19.5 cm)
Medium	8.5 in (21.5 cm)
Large	8.75 in (22 cm)

Cut yarn and weave in ends.

Skill Level: 3 of 5

FINGERLESS MITTENS OR MITTENS WITH FLAP

MATERIALS

Yarn
Fingering weight sock yarn. Samples shown in:

Dark Gray and Turquoise
Durable Soqs; 75% superwash wool, 25% polyamide; 3.5 oz/460 yd (100 g/420 m); #2234 Marble and #371 Turquoise

Brown/Gray/White
Lana Grossa Meilenweit Tweed; 80% wool, 20% nylon; 3.5 oz/459 yd (100 g/420 m); #106 Cream, #167 Brick, and #110 Gray

Blue and Burgundy
Scheepjes Metropolis; 75% extra fine Merino wool, 25% nylon; 1.7 oz/437.5 yd (100g/400 m); #19 Marseilles

Purple Blend
Lana Grossa Meilenweit Seta Cocoon; 55% virgin wool, 25% polyamide, 20% silk; 3.5 oz/437 yd (100 g/400 m): #3355

Crochet Hook
US size G-6 (4 mm)

Estimate of Yarn Required
(includes flap; fingerless mittens require less yarn)

1–3 years	230 yd (210 m)
4–8 years	460 yd (420 m)
Small	460 yd (420 m)
Medium	690 yd (630 m)
Large	690 yd (630 m)

Size and Gauge
For help choosing a size and matching gauge, refer to Size and Gauge on pages 12–13.

ABBREVIATIONS

⬭	ch	chain
✕	sc	single crochet
⬮	sl st	slip stitch
╼┼	dc	double crochet
╼┤	hdc	half double crochet
⊊	fpdc	front post double crochet
⊋	bpdc	back post double crochet
⋋	fpdc2tog	fpdc 2 together
⋌	2fpdcin	2 fpdc in next stitch

. .. ,. ,.

RIGHT FLAP

RND 1: Start with a magic loop, ch2
(first ch2 doesn't count as first dc
throughout the pattern), 6dc in the
loop, sl st in first dc. (6)

RND 2: Ch2, 2fpdc in each stitch around,
sl st in first fpdc. (12)

RND 3: Ch2, *fpdc1, 2fpdcin*, repeat *
to * 2 more times, hdc1, 2fpdcin,
repeat * to * 2 more times, sl st in
first fpdc. (18)

RND 4: Ch2, *fpdc2, 2fpdcin*, repeat
* to * 2 more times, hdc1, fpdc1,
2fpdcin, repeat * to * 2 more times,
sl st in first fpdc. (24)

RND 5: Ch2, *fpdc3, 2fpdcin*, repeat
* to * 2 more times, hdc1, fpdc2,
2fpdcin, repeat * to * 2 more times,
sl st in first fpdc. (30)

RNDS 6-9: Ch2, fpdc15, hdc1, fpdc14, sl
st in first fpdc. (30)

RNDS 10-12: Ch2, *fpdc2, bpdc2*, repeat
to 3 stitches before the hdc, fpdc2,
bpdc1, hdc1, fpdc14, sl st in first
fpdc. (30)

Cut yarn, fasten off, and weave in ends.

RIGHT MITTEN

RND 1: Ch30 (not too loose), sl st in the
first ch to close the ring and make
sure the chains aren't twisted. Ch2
(first ch2 doesn't count as first
dc throughout the pattern), dc1 in
each stitch around, sl st in first
dc. (30)

RNDS 2 AND 3: Ch2, *fpdc2, bpdc2*,
repeat to last 2 stitches, fpdc2, sl
st in first fpdc. (30)

RND 4: Ch2, fpdc15, hdc1, fpdc14, sl st
in first fpdc. (30)

RND 5: Fingerless mittens: Work the same
as Rnd 4.
Mittens with Flaps: Ch2, fpdc15,
hdc1, place the piece that you just
made inside the flap, in the same
working direction. Make sure the
hdc of the two parts are aligned.
Now fpdc14 but go through both the
stitch of the flap and the under-
lying stitch of the mitten, as shown
on page 52, sl st in first fpdc.

From now on you'll continue working only
on the mitten.

> **TIP:** If this way of attaching
> the flap isn't easy for you, you
> can repeat Rnd 4 for Rnd 5 and
> sew the flap to Rnd 5 in the end.

RNDS 6–8: Ch2, fpdc15, hdc1, fpdc14, sl st in first fpdc. (30)

RND 9: Ch2, fpdc15, ch9, skip 1 hdc, fpdc14, sl st in first fpdc. (38) See photo 1 on page 19.

RND 10: Ch2, fpdc15, dc4, hdc1, dc4, fpdc14, sl st in first fpdc. (38) See photo 2 on page 19.

RND 11: Ch2, fpdc17, fpdc2tog, hdc1, fpdc2tog, fpdc16, sl st in first fpdc. (36)

RND 12: Ch2, fpdc16, fpdc2tog, hdc1, fpdc2tog, fpdc15, sl st in first fpdc. (34)

RND 13: Ch2, fpdc15, fpdc2tog, hdc1, fpdc2tog, fpdc14, sl st in first fpdc. (32)

RND 14: Ch2, fpdc14, fpdc2tog, hdc1, fpdc2tog, fpdc13, sl st in first fpdc. (30)

RND 15: Ch2, fpdc13, fpdc2tog, hdc1, fpdc2tog, fpdc12, sl st in first fpdc. (28)

RMD 16: Ch2, fpdc12, fpdc2tog, hdc1, fpdc2tog, fpdc11, sl st in first fpdc. (26)

RNDS 17–19: Ch2, *fpdc2, bpdc2*, repeat to last 2 stitches, fpdc2, sl st in first fpdc. (26)

If you like to have a longer or fold-over cuff, you can repeat the round above for as long as you like. Cut yarn, fasten off, and weave in ends.

LEFT FLAP

RNDS 1–9: Same as Rnds 1–9 of the Right Flap.

RNDS 10–12: Ch2, fpdc15, hdc1, fpdc2, *bpdc2, fpdc2*, repeat to end, sl st in first fpdc. (30)

Cut yarn, fasten off, and weave in ends.

LEFT MITTEN

RNDS 1–4: Same as Rnds 1–4 of the Right Mitten.

RND 5: Fingerless mittens: Work the same as Rnd 4.

Mittens with flaps: Ch2, place the piece that you just made inside the flap, in the same working direction. Make sure the hdc of the two parts are aligned. Now fpdc15 but go through both the stitch of the flap and the underlying stitch of the mitten, as shown on page 52. From now on you'll continue working only on the mitten, hdc1, fpdc14, sl st in first fpdc. (30)

RNDS 6–19: Same as Rnds 6–19 of the Right Mitten.

THUMB FOR MITTENS WITH FLAPS

NOTE: If you are making the fingerless version, you can find instructions to finish the thumb on page 53.

RND 1: Attach the yarn with a sl st in the ch of Rnd 9 above the hdc of Rnd 10, ch2, fpdc4, sc1 in the side of the dc of Rnd 9, sc1 before the hdc of Rnd 8, sc1 after the hdc of Rnd 8, sc1 in the side of the dc of Rnd 9, fpdc4, sl st in first fpdc. (12) See photos 3–10 on page 19.

RND 2: Ch2, fpdc4, dc4, fpdc4, sl st in first fpdc. (12)

RNDS 3–5: Ch2, fpdc12, sl st in first fpdc. (12)

RND 6: Ch2, *fpdc2tog*, repeat around, sl st in first fpdc. (6)

Cut yarn, weave through the loops of the remaining stitches, pull tight, fasten off, and weave in ends.

.

RIGHT FLAP

RND 1: Start with a magic loop, ch2
(first ch2 doesn't count as first dc
throughout the pattern), 6dc in the
loop, sl st in first dc. (6)

RND 2: Ch2, 2fpdc in each stitch around,
sl st in first fpdc. (12)

RND 3: Ch2, *fpdc1, 2fpdcin*, repeat *
to * 2 more times, hdc1, 2fpdcin,
repeat * to * 2 more times, sl st in
first fpdc. (18)

RND 4: Ch2, *fpdc2, 2fpdcin*, repeat
* to * 2 more times, hdc1, fpdc1,
2fpdcin, repeat * to * 2 more times,
sl st in first fpdc. (24)

RND 5: Ch2, *fpdc3, 2fpdcin*, repeat
* to * 2 more times, hdc1, fpdc2,
2fpdcin, repeat * to * 2 more times,
sl st in first fpdc. (30)

RND 6: Ch2, *fpdc4, 2fpdcin*, repeat
* to * 2 more times, hdc1, fpdc3,
2fpdcin, repeat * to * 2 more times,
sl st in first fpdc. (36)

RNDS 7-13: Ch2, fpdc18, hdc1, fpdc17, sl
st in first fpdc. (36)

RNDS 14-16: Ch2, *fpdc2, bpdc2*, repeat
to 2 stitches before the hdc, fpdc2,
hdc1, fpdc17, sl st in first fpdc.
(36)

Cut yarn, fasten off, and weave in ends.

RIGHT MITTEN

RND 1: Ch36 (not too loose), sl st in the
first ch to close the ring and make
sure the chains aren't twisted.
Ch2, (first ch2 doesn't count as
first dc throughout the pattern),
dc1 in each stitch around, sl st in
first dc. (36)

RNDS 2 AND 3: Ch2, *fpdc2, bpdc2*, repeat
around, sl st in first fpdc. (36)

RND 4: Ch2, fpdc18, hdc1, fpdc17, sl st
in first fpdc. (36)

RND 5: Fingerless mittens: Work same as
Rnd 4.
Mittens with flap: Ch2, fpdc18,
hdc1, place the piece that you just
made inside the flap, in the same
working direction. Make sure the
hdc of the two parts, are aligned.
Now fpdc17 but go though both the
stitch of the flap and the under-
lying stitch of the mitten, as shown
on page 52, sl st in first fpdc.

From now on you'll continue working only
on the mitten.

> **TIP:** If this way of attaching
> the flap isn't easy for you, you
> can repeat Rnd 4 for Rnd 5 and
> sew the flap to Rnd 5 in the end.

RNDS 6-9: Ch2, fpdc18, hdc1, fpdc17, sl
st in first fpdc. (36)

RND 10: Ch2, fpdc18, ch11, skip 1 hdc,
fpdc17, sl st in first fpdc. (46)
See photo 1 on page 19.

RND 11: Ch2, fpdc18, dc5, hdc1, dc5,
fpdc17, sl st in first fpdc. (46)
See photo 2 on page 19.

RND 12: Ch2, fpdc21, fpdc2tog, hdc1, fpdc2tog, fpdc20, sl st in first fpdc. (44)

RND 13: Ch2, fpdc20, fpdc2tog, hdc1, fpdc2tog, fpdc19, sl st in first fpdc. (42)

RND 14: Ch2, fpdc19, fpdc2tog, hdc1, fpdc2tog, fpdc18, sl st in first fpdc. (40)

RND 15: Ch2, fpdc18, fpdc2tog, hdc1, fpdc2tog, fpdc17, sl st in first fpdc. (38)

RND 16: Ch2, fpdc17, fpdc2tog, hdc1, fpdc2tog, fpdc16, sl st in first fpdc. (36)

RND 17: Ch2, fpdc16, fpdc2tog, hdc1, fpdc2tog, fpdc15, sl st in first fpdc. (34)

RND 18: Ch2, fpdc15, fpdc2tog, hdc1, fpdc2tog, fpdc14, sl st in first fpdc. (32)

RNDS 19–23: Ch2, *fpdc2, bpdc2*, repeat around, sl st in first fpdc. (32)

If you like to have a longer or fold-over cuff, you can repeat the round above for as long as you like. Cut yarn, fasten off, and weave in ends.

LEFT FLAP

RNDS 1–13: Same as Rnds 1–13 of the Right Flap.

RNDS 14–16: Ch2, fpdc18, hdc1, *fpdc2, bpdc2*, repeat to last stitch, fpdc1, sl st in first fpdc. (36)

Cut yarn, fasten off, and weave in ends.

LEFT MITTEN

RNDS 1–4: Same as Rnds 1–4 of the Right Mitten.

RND 5: Fingerless mittens: Work same as Rnd 4.
Mittens with flap: Ch2, place the piece that you just made inside the flap, in the same working direction. Make sure the hdc of the two parts are aligned. Now fpdc18 but go through both the stitch of the flap and the underlying stitch of the mitten, as shown on page 52. From now on you'll continue working only on the mitten, hdc1, fpdc17, sl st in first fpdc. (36)

RNDS 6–23: Same as Rnds 6–23 of the Right Mitten.

THUMB FOR MITTENS WITH FLAP

NOTE: If you are making the fingerless version, you can find instructions to finish the thumb on page 53.

RND 1: Attach the yarn with a sl st in the ch of Rnd 10 above the hdc of Rnd 11, ch2, fpdc5, sc1 in the side of the dc of Rnd 10, sc1 before the hdc of Rnd 9, sc1 after the hdc of Rnd 9, sc1 in the side of the dc of Rnd 10, fpdc5, sl st in first fpdc. (14) See photos 3–10 on page 19.

RND 2: Ch2, fpdc5, dc4, fpdc5, sl st in first fpdc. (14)

RNDS 3–8: Ch2, fpdc14, sl st in first fpdc. (14)

RND 9: Ch2, *fpdc2tog*, repeat around, sl st in first fpdc. (7)

Cut yarn, weave through the loops of the remaining stitches, pull tight, fasten off, and weave in ends.

SIZE: SMALL

RIGHT FLAP

RND 1: Start with a magic loop, ch2
(first ch2 doesn't count as first dc
throughout the pattern), 6dc in the
loop, sl st in first dc. (6)

RND 2: Ch2, 2fpdc in each stitch around,
sl st in first fpdc. (12)

RND 3: Ch2, *fpdc1, 2fpdcin*, repeat *
to * 2 more times, hdc1, 2fpdcin,
repeat * to * 2 more times, sl st in
first fpdc. (18)

RND 4: Ch2, *fpdc2, 2fpdcin*, repeat
* to * 2 more times, hdc1, fpdc1,
2fpdcin, repeat * to * 2 more times,
sl st in first fpdc. (24)

RND 5: Ch2, *fpdc3, 2fpdcin*, repeat
* to * 2 more times, hdc1, fpdc2,
2fpdcin, repeat * to * 2 more times,
sl st in first fpdc. (30)

RND 6: Ch2, *fpdc4, 2fpdcin*, repeat
* to * 2 more times, hdc1, fpdc3,
2fpdcin, repeat * to * 2 more times,
sl st in first fpdc. (36)

RND 7: Ch2, *fpdc5, 2fpdcin*, repeat
* to * 2 more times, hdc1, fpdc4,
2fpdcin, repeat * to * 2 more times,
sl st in first fpdc. (42)

RNDS 8-17: Ch2, fpdc21, hdc1, fpdc20, sl
st in first fpdc. (42)

RNDS 18-20: Ch2, *fpdc2, bpdc2*, repeat
to 1 stitch before the hdc, fpdc1,
hdc1, fpdc20, sl st in first fpdc.
(42)

Cut yarn, fasten off, and weave in ends.

RIGHT MITTEN

RND 1: Ch42 (not too loose), sl st in the
first ch to close the ring and make
sure the chains aren't twisted.
Ch2, (first ch2 doesn't count as
first dc throughout the pattern),
dc1 in each stitch around, sl st in
first dc. (42)

RNDS 2 AND 3: Ch2, *fpdc2, bpdc2*,
repeat to last 2 stitches, fpdc2, sl
st in first fpdc. (42)

RNDS 4 AND 5: Ch2, fpdc21, hdc1, fpdc20,
sl st in first fpdc. (42)

RND 6: Fingerless mittens: Work same as
Rnd 5.
Mittens with flap: Ch2, fpdc21,
hdc1, place the piece that you just
made inside the flap, in the same
working direction. Make sure the
hdc of the two parts are aligned.
Now fpdc20 but go through both the
stitch of the flap and the under-
lying stitch of the mitten, as shown
on page 52, sl st in first fpdc.

From now on you'll continue working only
on the mitten.

> **TIP:** If this way of attaching
> the flap isn't easy for you, you
> can repeat Rnd 5 for Rnd 6 and
> sew the flap to Rnd 6 in the end.

RNDS 7-11: Ch2, fpdc21, hdc1, fpdc20, sl
st in first fpdc. (42)

RND 12: Ch2, fpdc21, ch13, skip 1 hdc,
fpdc20, sl st in first fpdc. (54)
See photo 1 on page 19.

RND 13: Ch2, fpdc21, dc6, hdc1, dc6,
fpdc20, sl st in first fpdc. (54)
See photo 2 on page 19.

RND 14: Ch2, fpdc25, fpdc2tog, hdc1, fpdc2tog, fpdc24, sl st in first fpdc. (52)

RND 15: Ch2, fpdc24, fpdc2tog, hdc1, fpdc2tog, fpdc23, sl st in first fpdc. (50)

RND 16: Ch2, fpdc23, fpdc2tog, hdc1, fpdc2tog, fpdc22, sl st in first fpdc. (48)

RND 17: Ch2, fpdc22, fpdc2tog, hdc1, fpdc2tog, fpdc21, sl st in first fpdc. (46)

RND 18: Ch2, fpdc21, fpdc2tog, hdc1, fpdc2tog, fpdc20, sl st in first fpdc. (44)

RND 19: Ch2, fpdc20, fpdc2tog, hdc1, fpdc2tog, fpdc19, sl st in first fpdc. (42)

RND 20: Ch2, fpdc19, fpdc2tog, hdc1, fpdc2tog, fpdc18, sl st in first fpdc. (40)

RND 21: Ch2, fpdc18, fpdc2tog, hdc1, fpdc2tog, fpdc17, sl st in first fpdc. (38)

RNDS 22-27: Ch2, *fpdc2, bpdc2*, repeat to last 2 stitches, fpdc2, sl st in first fpdc. (38)

If you like to have a longer or fold-over cuff, you can repeat the round above for as long as you like. Cut yarn, fasten off, and weave in ends.

LEFT FLAP

RNDS 1-17: Work same as Rnds 1-17 of the Right Flap.

RNDS 18-20: Ch2, fpdc21, hdc1, *fpdc2, bpdc2*, repeat to end, sl st in first fpdc. (42)

Cut yarn, fasten off, and weave in ends.

LEFT MITTEN

RNDS 1-5: Work same as Rnds 1-5 of the Right Mitten.

RND 6: Fingerless mittens: Same as Rnd 5.

Mittens with flap: Ch2, place the piece that you just made inside the flap, in the same working direction. Make sure the hdc of the two parts are aligned. Now fpdc21 but go through both the stitch of the flap and the underlying stitch of the mitten, as shown on page 52. From now on you'll continue working only on the mitten, hdc1, fpdc20, sl st in first fpdc. (42)

RNDS 7-27: Work same as Rnds 7-27 of the Right Mitten.

THUMB FOR MITTENS WITH FLAPS

NOTE: If you are making the fingerless version, you can find instructions to finish the thumb on page 53.

RND 1: Attach the yarn with a sl st in the ch of Rnd 12 above the hdc of Rnd 13, ch2, fpdc6, sc1 in the side of the dc of Rnd 12, sc1 before the hdc of Rnd 11, sc1 after the hdc of Rnd 11, sc1 in the side of the dc of Rnd 12, fpdc6, sl st in first fpdc. (16) See photos 3-10 on page 19.

RND 2: Ch2, fpdc6, dc4, fpdc6, sl st in first fpdc. (16)

RNDS 3-10: Ch2, fpdc16, sl st in first fpdc. (16)

RNDS 11: Ch2, *fpdc2tog*, repeat around, sl st in first fpdc. (8)

Cut yarn, weave through the loops of the remaining stitches, pull tight, fasten off, and weave in ends.

SIZE: MEDIUM

. .

RIGHT FLAP

RND 1: Start with a magic loop, ch2 (first ch2 doesn't count as first dc throughout the pattern), 6dc in the loop, sl st in first dc. (6)

RND 2: Ch2, 2fpdc in each stitch around, sl st in first fpdc. (12)

RND 3: Ch2, *fpdc1, 2fpdcin*, repeat * to * 2 more times, hdc1, 2fpdcin, repeat * to * 2 more times, sl st in first fpdc. (18)

RND 4: Ch2, *fpdc2, 2fpdcin*, repeat * to * 2 more times, hdc1, fpdc1, 2fpdcin, repeat * to * 2 more times, sl st in first fpdc. (24)

RND 5: Ch2, *fpdc3, 2fpdcin*, repeat * to * 2 more times, hdc1, fpdc2, 2fpdcin, repeat * to * 2 more times, sl st in first fpdc. (30)

RND 6: Ch2, *fpdc4, 2fpdcin*, repeat * to * 2 more times, hdc1, fpdc3, 2fpdcin, repeat * to * 2 more times, sl st in first fpdc. (36)

RND 7: Ch2, *fpdc5, 2fpdcin*, repeat * to * 2 more times, hdc1, fpdc4, 2fpdcin, repeat * to * 2 more times, sl st in first fpdc. (42)

RND 8: Ch2, *fpdc6, 2fpdcin*, repeat * to * 2 more times, hdc1, fpdc5, 2fpdcin, repeat * to * 2 more times, sl st in first fpdc. (48)

RNDS 9–21: Ch2, fpdc24, hdc1, fpdc23, sl st in first fpdc. (48)

RNDS 22–24: Ch2, *fpdc2, bpdc2*, repeat to the hdc, hdc1, fpdc23, sl st in first fpdc. (48)

Cut yarn, fasten off, and weave in ends.

RIGHT MITTEN

RND 1: Ch48 (not too loose), sl st in the first ch to close the ring and make sure the chains aren't twisted. Ch2, (first ch2 doesn't count as first dc throughout the pattern), dc1 in each stitch around, sl st in first dc. (48)

RNDS 2 AND 3: Ch2, *fpdc2, bpdc2*, repeat around, sl st in first fpdc. (48)

RNDS 4 AND 5: Ch2, fpdc24, hdc1, fpdc23, sl st in first fpdc. (48)

RND 6: Fingerless mittens: Same as Rnd 5. Mittens with flaps: Ch2, fpdc24, hdc1, place the piece that you just made inside the flap, in the same working direction. Make sure the hdc of the two parts are aligned. Now fpdc23 but go through both the stitch of the flap and the underlying stitch of the mitten, as shown on page 52, sl st in first fpdc.

From now on you'll continue working only on the mitten.

> **TIP:** If this way of attaching the flap isn't easy for you, you can repeat Rnd 5 for Rnd 6 and sew the flap to Rnd 6 in the end.

RNDS 7–12: Ch2, fpdc24, hdc1, fpdc23, sl st in first fpdc. (48)

RND 13: Ch2, fpdc24, ch15, skip 1 hdc, fpdc23, sl st in first fpdc. (62) See photo 1 on page 19.

RND 14: Ch2, fpdc24, dc7, hdc1, dc7, fpdc23, sl st in first fpdc. (62) See photo 2 on page 19.

RND 15: Ch2, fpdc29, fpdc2tog, hdc1, fpdc2tog, fpdc28, sl st in first fpdc. (60)

RND 16: Ch2, fpdc28, fpdc2tog, hdc1, fpdc2tog, fpdc27, sl st in first fpdc. (58)

RND 17: Ch2, fpdc27, fpdc2tog, hdc1, fpdc2tog, fpdc26, sl st in first fpdc. (56)

RND 18: Ch2, fpdc26, fpdc2tog, hdc1, fpdc2tog, fpdc25, sl st in first fpdc. (54)

RND 19: Ch2, fpdc25, fpdc2tog, hdc1, fpdc2tog, fpdc24, sl st in first fpdc. (52)

RND 20: Ch2, fpdc24, fpdc2tog, hdc1, fpdc2tog, fpdc23, sl st in first fpdc. (50)

RND 21: Ch2, fpdc23, fpdc2tog, hdc1, fpdc2tog, fpdc22, sl st in first fpdc. (48)

RND 22: Ch2, fpdc22, fpdc2tog, hdc1, fpdc2tog, fpdc21, sl st in first fpdc. (46)

RND 23: Ch2, fpdc21, fpdc2tog, hdc1, fpdc2tog, fpdc20, sl st in first fpdc. (44)

RNDS 24-30: Ch2, *fpdc2, bpdc2*, repeat around, sl st in first fpdc. (44)

If you like to have a longer or fold-over cuff, you can repeat the round above for as long as you like. Cut yarn, fasten off, and weave in ends.

LEFT FLAP

RNDS 1-21: Work same as Rnds 1-21 of the Right Flap.

RNDS 22-24: Ch2, fpdc24, hdc1, *fpdc2, bpdc2*, repeat to last 3 stitches, fpdc2, bpdc1, sl st in first fpdc. (48)

Cut yarn, fasten off, and weave in ends.

LEFT MITTEN

RNDS 1-5: Work same as Rnds 1-5 of the Right Mitten.

RND 6: Fingerless mittens: Same as Rnd 5. Mittens with flaps: Ch2, place the piece that you just made inside the flap, in the same working direction. Make sure the hdc of the two parts are aligned. Now fpdc24 but go through both the stitch of the flap and the underlying stitch of the mitten, as shown on page 52. From now on you'll continue working only on the mitten, hdc1, fpdc23, sl st in first fpdc. (48)

RNDS 7-30: Work same as Rnds 7-30 of the Right Mitten.

THUMB FOR MITTENS WITH FLAPS

NOTE: If you are making the fingerless version, you can find instructions to finish the thumb on page 53.

RND 1: Attach the yarn with a sl st in the ch of Rnd 13 above the hdc of Rnd 14, ch2, fpdc7, sc1 in the side of the dc of Rnd 13, sc1 before the hdc of Rnd 12, sc1 after the hdc of Rnd 12, sc1 in the side of the dc of Rnd 13, fpdc7, sl st in first fpdc. (18) See photos 3-10 on page 19.

RND 2: Ch2, fpdc7, dc4, fpdc7, sl st in first fpdc. (18)

RNDS 3-11: Ch2, fpdc18, sl st in first fpdc. (18)

RND 12: Ch2, *fpdc2tog*, repeat around, sl st in first fpdc. (9)

Cut yarn, weave through the loops of the remaining stitches, pull tight, fasten off, and weave in ends.

. .

RIGHT FLAP

RND 1: Start with a magic loop, ch2 (first ch2 doesn't count as first dc throughout the pattern), 6dc in the loop, sl st in first dc. (6)

RND 2: Ch2, 2fpdc in each stitch around, sl st in first fpdc. (12)

RND 3: Ch2, *fpdc1, 2fpdcin*, repeat * to * 2 more times, hdc1, 2fpdcin, repeat * to * 2 more times, sl st in first fpdc. (18)

RND 4: Ch2, *fpdc2, 2fpdcin*, repeat * to * 2 more times, hdc1, fpdc1, 2fpdcin, repeat * to * 2 more times, sl st in first fpdc. (24)

RND 5: Ch2, *fpdc3, 2fpdcin*, repeat * to * 2 more times, hdc1, fpdc2, 2fpdcin, repeat * to * 2 more times, sl st in first fpdc. (30)

RND 6: Ch2, *fpdc4, 2fpdcin*, repeat * to * 2 more times, hdc1, fpdc3, 2fpdcin, repeat * to * 2 more times, sl st in first fpdc. (36)

RND 7: Ch2, *fpdc5, 2fpdcin*, repeat * to * 2 more times, hdc1, fpdc4, 2fpdcin, repeat * to * 2 more times, sl st in first fpdc. (42)

RND 8: Ch2, *fpdc6, 2fpdcin*, repeat * to * 2 more times, hdc1, fpdc5, 2fpdcin, repeat * to * 2 more times, sl st in first fpdc. (48)

RND 9: Ch2, *fpdc7, 2fpdcin*, repeat * to * 2 more times, hdc1, fpdc6, 2fpdcin, repeat * to * 2 more times, sl st in first fpdc. (54)

RNDS 10-25: Ch2, fpdc27, hdc1, fpdc26, sl st in first fpdc. (54)

RNDS 26-28: Ch2, *fpdc2, bpdc2*, repeat to 3 stitches before the hdc, fpdc2, bpdc1, hdc1, fpdc26, sl st in first fpdc. (54)

Cut yarn, fasten off, and weave in ends.

RIGHT MITTEN

RND 1: Ch54 (not too loose), sl st in the first ch to close the ring and make sure the chains aren't twisted. Ch2, (first ch2 doesn't count as first dc throughout the pattern), dc1 in each stitch around, sl st in first dc. (54)

RNDS 2 AND 3: Ch2, *fpdc2, bpdc2*, repeat to last 2 stitches, fpdc2, sl st in first fpdc. (54)

RNDS 4 AND 5: Ch2, fpdc27, hdc1, fpdc26, sl st in first fpdc. (54)

RNDS 6: Fingerless mittens: Same as Rnd 5. Mittens with flaps: Ch2, fpdc27, hdc1, place the piece that you just made inside the flap, in the same working direction. Make sure the hdc of the two parts are aligned. Now fpdc26 but go around both the stitch of the flap and the under-lying stitch of the mitten, as shown on page 52, sl st in first fpdc.

From now on you'll continue working only on the mitten.

> **TIP:** If this way of attaching the flap isn't convenient for you, you can repeat Rnd 5 for Rnd 6 and sew the flap to Rnd 6 in the end.

RNDS 7–14: Ch2, fpdc27, hdc1, fpdc26, sl st in first fpdc. (54)

RND 15: Ch2, fpdc27, ch17, skip 1 hdc, fpdc26, sl st in first fpdc. (70) See photo 1 on page 19.

RND 16: Ch2, fpdc27, dc8, hdc1, dc8, fpdc26, sl st in first fpdc. (70) See photo 2 on page 19.

RND 17: Ch2, fpdc33, fpdc2tog, hdc1, fpdc2tog, fpdc32, sl st in first fpdc. (68)

RND 18: Ch2, fpdc32, fpdc2tog, hdc1, fpdc2tog, fpdc31, sl st in first fpdc. (66)

RND 19: Ch2, fpdc31, fpdc2tog, hdc1, fpdc2tog, fpdc30, sl st in first fpdc. (64)

RND 20: Ch2, fpdc30, fpdc2tog, hdc1, fpdc2tog, fpdc29, sl st in first fpdc. (62)

RND 21: Ch2, fpdc29, fpdc2tog, hdc1, fpdc2tog, fpdc28, sl st in first fpdc. (60)

RND 22: Ch2, fpdc28, fpdc2tog, hdc1, fpdc2tog, fpdc27, sl st in first fpdc. (58)

RND 23: Ch2, fpdc27, fpdc2tog, hdc1, fpdc2tog, fpdc26, sl st in first fpdc. (56)

RND 24: Ch2, fpdc26, fpdc2tog, hdc1, fpdc2tog, fpdc25, sl st in first fpdc. (54)

RND 25: Ch2, fpdc25, fpdc2tog, hdc1, fpdc2tog, fpdc24, sl st in first fpdc. (52)

RND 26: Ch2, fpdc24, fpdc2tog, hdc1, fpdc2tog, fpdc23, sl st in first fpdc. (50)

RNDS 27–33: Ch2, *fpdc2, bpdc2*, repeat to last 2 stitches, fpdc2, sl st in first fpdc. (50)

If you like to have a longer or fold-over cuff, you can repeat the round above for as long as you like. Cut yarn, fasten off, and weave in ends.

LEFT FLAP

RNDS 1–25: Work same as Rnds 1–25 of the Right Flap.

RNDS 26–28: Ch2, fpdc27, hdc1, *fpdc2, bpdc2*, repeat to last 2 stitches, fpdc2, sl st in first fpdc. (54)

Cut yarn, fasten off, and weave in ends.

LEFT MITTEN

RNDS 1-5: Work same as Rnds 1-5 of the Right Mitten.

RND 6: Fingerless mittens: Same as Rnd 5. Mittens with flaps: Ch2, place the piece that you just made inside the flap, in the same working direction. Make sure the hdc of the two parts are aligned. Now fpdc27 but go through both the stitch of the flap and the underlying stitch of the mitten, as shown below. From now on you'll continue working only on the mitten, hdc1, fpdc26, sl st in first fpdc. (54)

RNDS 7-33: Work same as Rnds 7-33 of the Right Mitten.

THUMB FOR MITTENS WITH FLAPS

NOTE: If you are making the fingerless version, you can find instructions to finish the thumb on page 53.

RND 1: Attach the yarn with a sl st in the ch of Rnd 15 above the hdc of Rnd 16, ch2, fpdc8, sc1 in the side of the dc of Rnd 15, sc1 before the hdc of Rnd 14, sc1 after the hdc of Rnd 14, sc1 in the side of the dc of Rnd 15, fpdc8, sl st in first fpdc. (20) See photos 3-10 on page 19.

RND 2: Ch2, fpdc8, dc4, fpdc8, sl st in first fpdc. (20)

RNDS 3-12: Ch2, fpdc20, sl st in first fpdc. (20)

RND 13: Ch2, *fpdc2tog*, repeat around, sl st in first fpdc. (10)

Cut yarn, weave through the loops of the remaining stitches, pull tight, fasten off, and weave in ends.

ATTACHING THE FLAP

1

2

3

4

5

FINISHING THE THUMB FOR FINGERLESS MITTENS

Work Rnds 1 and 2 for Thumb for Mittens with Flaps, as instructed in the pattern.
Then crochet:

Size 1-3 Years
RND 3: Ch2, fpdc12, sl st in first fpdc. (12)
RND 4: Ch2, *fpdc2, bpdc2*, repeat around, sl st in first fpdc. (12)

Size 4-8 Years
RND 3: Ch2, fpdc14, sl st in first fpdc. (14)
RNDS 4 AND 5: Ch2, *fpdc2, bpdc2*, repeat to last 2 stitches, fpdc2, sl st in first fpdc. (14)

Size Small
RNDS 3 AND 4: Ch2, fpdc16, sl st in first fpdc. (16)
RNDS 5 AND 6: Ch2, *fpdc2, bpdc2*, repeat around, sl st in first fpdc. (16)

Size Medium
RNDS 3 AND 4: Ch2, fpdc18, sl st in first fpdc. (18)
RNDS 5 AND 6: Ch2, *fpdc2, bpdc2*, repeat to last 2 stitches, fpdc2, sl st in first fpdc. (18)

Size Large
RNDS 3-5: Ch2, fpdc20, sl st in first fpdc. (20)
RNDS 6 AND 7: Ch2, *fpdc2, bpdc2*, repeat around, sl st in first fpdc. (20)

For all sizes: cut yarn, fasten off, and weave in ends.

Skill Level: 3 of 5

JEWEL BERET

MATERIALS

Yarn
Fingering weight sock yarn. Samples shown in:

Brown and Blue
Onion Yarns Nettle Sock; 70% superwash wool, 30% nettle fiber; 1.7 oz/202 yd (50 g/185 m); #1020 Sky Blue and #1032 Golden Brown

Beige Blend
Durable Soqs; 75% superwash wool, 25% polyamide; 1.7 oz/230 yd (50 g/210 m); #409 Bleached Sand

Purple Blend
Lana Grossa Meilenweit Seta Cocoon; 55% virgin wool, 25% polyamide, 20% silk; 3.5 oz/437 yd (100 g/400 m); #3355

Crochet Hook
US size G-6 (4 mm)

Estimate of Yarn Required

0–6 months	230 yd (210 m)
6–12 months	230 yd (210 m)
1–3 years	460 yd (420 m)
4 years–teen	460 yd (420 m)
Medium	460 yd (420 m)
Large	690 yd (630 m)

Size and Gauge
For help choosing a size and matching gauge, refer to Size and Gauge on pages 12–13.

ABBREVIATIONS

⌒	**ch**	chain
✕	**sc**	single crochet
⬮	**sl st**	slip stitch
⊢	**dc**	double crochet
⊢	**fpdc**	front post double crochet
⋋	**fpdc2tog**	fpdc 2 together
⋌	**2fpdcin**	2 fpdc in next stitch

PATTERN

. .

RND 1: Start with a magic loop, 6sc in the loop. (6)

RNDS 2 AND 3: Sc1 in each stitch around. (6) If you want the little nub on the beret to be longer, you can add more repeats of this round.

RND 4: Sl st in first sc, ch2 (first ch2 doesn't count as first dc throughout the pattern), *2dc in each of the next 2 stitches, dc1*, repeat * to * one more time, sl st in first dc. (10)

RND 5: Ch2, 2fpdc in each stitch around, sl st in first fpdc. (20)

RND 6: Ch2, *fpdc1, 2fpdcin*, repeat * to * around, sl st in first fpdc. (30)

RND 7: Ch2, *fpdc1 in each fpdc to the second fpdc of the 2fpdcin of previous row, 2fpdcin*, repeat * to * around, sl st in first fpdc (10 increases after each round)

Repeat Rnd 7 until your piece has a diameter (or as close as possible to) as written below in the chart. See photo 1 on page 57.

0-6 months ———— 6.5 in (16.5 cm)
6-12 months ———— 7.25 in (18.5 cm)
1-3 years ———— 7.8 in (20 cm)
4 years-teen ———— 8.1 in (20.6 cm)
Medium ———— 8.6 in (22 cm)
Large ———— 9.1 in (23 cm)

Note: Count the number of fpdc stitches in between the ch2 and the 2fpdcin of the last rnd you made and write down that number.

RND 8: Ch2, fpdc1 in each stitch around, sl st in first fpdc (no increases).

Repeat Rnd 8 until your piece has a length (or as close as possible to) as written below in the chart. Measure from the top but without the little nub.

0-6 months ———— 3.5 in (9 cm)
6-12 months ———— 4.3 in (11 cm)
1-3 years ———— 4.7 in (12 cm)
4 years-teen ———— 5.1 in (13 cm)
Medium ———— 5.9 in (15 cm)
Large ———— 5.9 in (15 cm)

Note: Fill in the number that you wrote down after Rnd 7 on the ellipses below.

RND 9: Ch2, *fpdc . . . , fpdc2tog*, repeat * to * around, sl st in first fpdc. (10 decreases)

RND 10: Ch2, *fpdc1 in each fpdc to one stitch before the decrease of previous row, fpdc2tog*, repeat * to * around, sl st in first fpdc. (10 decreases each round)

Repeat Rnd 10 until the opening of the beret has a diameter (or as close as possible to) as written below in the chart.

Place the beret on a flat surface and even it out. (If you don't like to measure all the time, you can also measure the needed diameter on the top of your beret and count the number of fpdc you made in between the ch2 and the 2fpdcin; then you can decrease until you have the same number of fpdc in between the ch2 and the 2fpdcin and then measure.)

0-6 months ——————— 3 in (7.5 cm)
6-12 months —————— 3.7 in (9.5 cm)
1-3 years ——————— 4.3 in (11 cm)
4 years-teen —————— 4.5 in (11.5 cm)
Medium ——————————— 5.1 in (13 cm)
Large ————————————— 5.5 in (14 cm)

RND 11: Ch2, fpdc1 in each stitch around, sl st in first fpdc. (no decreases)

RND 12: Ch1 (doesn't counts as first sc), now insert your hook into the top of the first fpdc and the top of the fpdc from the round below and make 1 sc. It's important that you do not make this round too tight; if that's difficult for you, you can use a crochet hook 0.5 mm larger. Make 1 sc for each stitch around in the same way as described for the first stitch, sl st in first sc. (no decreases)

Cut yarn and weave in ends.

Julia is the model and inspiration for the Jewel Beret. I wanted
to design a hat for her, and a beret or alpine hat had been on my
wishlist for a long time. It also matched perfectly with the vibe of this
wonderful and artistic little girl, making it the ideal combination.

Together we chose this color, perfected the fit, and determined the name!
I am incredibly proud of this little gem.

HATS TO WEAR, GIFT, ADMIRE, KEEP, AND LOVE

OLLIE'S MITTENS

MATERIALS

Yarn
Fingering weight sock yarn. Samples shown in:

Blue/Gray
Durable Soqs; 75% superwash wool, 25% polyamide; 1.7 oz/230 yd (50 g/210 m); #321 Navy and #415 Chateau Grey

Red/Gray
Durable Soqs; 75% superwash wool, 25% polyamide; 1.7 oz/230 yd (50 g/210 m); #414 Anemone and #415 Chateau Grey

Golden Yellow/Gray
Durable Soqs; 75% superwash wool, 25% polyamide; 1.7 oz/230 yd (50 g/210 m); #2145 Golden Olive and #415 Chateau Grey

Crochet Hook
US size G-6 (4 mm)

Estimate of Yarn Required

0–1 year	230 yd (210 m)
1–3 years	230 yd (210 m)
4–8 years	230 yd (210 m)
Small	460 yd (420 m)
Medium	460 yd (420 m)
Large	690 yd (630 m)

Size and Gauge
For help choosing a size and matching gauge, refer to Size and Gauge on pages 12–13.

ABBREVIATIONS

⬯	**ch**	chain
✕	**sc**	single crochet
⬮	**sl st**	slip stitch
⊣	**dc**	double crochet
⊣	**hdc**	half double crochet
⊶⊣	**fpdc**	front post double crochet
⊶⊣	**bpdc**	back post double crochet
⅄	**fpdc2tog**	fpdc 2 together
⅋	**2fpdcin**	2 fpdc in next stitch

CHANGING COLORS
The best way to change colors is to complete the last step of the stitch before the color change with the new color. For these mittens that means: when making the last fpdc before the color change, use the new color for the last yarn over and pull through (so the sl st doesn't count as the last stitch). In between the color changes, you don't have to cut the color you're not using. You can simply pick it up again when needed, but make sure the loops of yarn are loose enough to stretch them a bit.

SIZE: 0-6 MONTHS (no thumb)

. .

RND 1: With color for the top, start with a magic loop, ch2 (first ch2 doesn't count as first dc throughout the pattern), 6dc in the loop, sl st in first dc. (6)

RND 2: Ch2, 2fpdc in each stitch around, sl st in first fpdc. (12)

RND 3: Ch2, *fpdc1, 2fpdcin*, repeat * to * 2 more times, hdc1, 2fpdcin, repeat * to * 2 more times, sl st in first fpdc. (18)

RND 4: Ch2, *fpdc2, 2fpdcin*, repeat * to * 2 more times, hdc1, fpdc1, 2fpdcin, repeat * to * 2 more times, sl st in first fpdc. (24)

RND 5: Ch2, *fpdc3, 2fpdcin*, repeat * to * 2 more times, hdc1, fpdc2, 2fpdcin, repeat * to * 2 more times, sl st in first fpdc. (30)

RND 6: Ch2, fpdc2, *bpdc2, fpdc2*, repeat * to * to 1 stitch before the hdc, bpdc1, hdc1, fpdc2, *bpdc2, fpdc2*, repeat * to * to end, sl st in first fpdc. (30)

Continue with the second color and change colors after each rnd (see page 63).

RNDS 7-18: Ch2, fpdc2, *bpdc2, fpdc2*, repeat * to * to 1 stitch before the hdc, bpdc1, hdc1, fpdc2, *bpdc2, fpdc2*, repeat * to * to end, sl st in first fpdc. (30)

You can customize the mitten by adding more repeats of the round above. This part should cover the fingers and hand, down to just above the wrist. Make sure to leave a little bit of room above the fingers for free movement.

RND 19: Ch2, *fpdc2, bpdc2*, repeat * to * to 3 stitches before the hdc, fpdc1, fpdc2tog, hdc1, fpdc2tog, *bpdc2, fpdc2*, repeat * to * to end, sl st in first fpdc. (28)

RND 20: Ch2, *fpdc2, bpdc2*, repeat * to * to 2 stitches before the hdc, fpdc2tog, hdc1, fpdc2tog, bpdc1, fpdc2, *bpdc2, fpdc2*, repeat * to * to end, sl st in first fpdc. (26)

Continue with the color of the top; you can cut the other color.

RNDS 21-25: Ch2, *fpdc1, bpdc1*, repeat around, sl st in first fpdc (26)

If you like to have a longer or fold-over cuff, you can repeat the round above for as long as you like. Cut yarn, fasten off, and weave in ends.

SIZE: 1–3 YEARS

. .

RND 1: With color for the top, start with a magic loop, ch2 (first ch2 doesn't count as first dc throughout the pattern), 6dc in the loop, sl st in first dc. (6)

RND 2: Ch2, 2fpdc in each stitch around, sl st in first fpdc. (12)

RND 3: Ch2, *fpdc1, 2fpdcin*, repeat * to * 2 more times, hdc1, 2fpdcin, repeat * to * 2 more times, sl st in first fpdc. (18)

RND 4: Ch2, *fpdc2, 2fpdcin*, repeat * to * 2 more times, hdc1, fpdc1, 2fpdcin, repeat * to * 2 more times, sl st in first fpdc. (24)

RND 5: Ch2, *fpdc3, 2fpdcin*, repeat * to * 2 more times, hdc1, fpdc2, 2fpdcin, repeat * to * 2 more times, sl st in first fpdc. (30)

RND 6: Ch2, fpdc2, *bpdc2, fpdc2*, repeat * to * to 1 stitch before the hdc, bpdc1, hdc1, fpdc2, *bpdc2, fpdc2*, repeat * to * to end, sl st in first fpdc. (30)

Continue with the second color and change colors after each rnd (see page 63).

RNDS 7–15: Ch2, fpdc2, *bpdc2, fpdc2*, repeat * to * to 1 stitch before the hdc, bpdc1, hdc1, fpdc2, *bpdc2, fpdc2*, repeat * to * to end, sl st in first fpdc. (30)

You can customize the mitten by adding more repeats of the round above. This part should cover the fingers and hand, down to just above the wrist. Make sure to leave a little bit of room above the fingers for free movement.

RND 16: Ch2, fpdc2, *bpdc2, fpdc2*, repeat * to * to 1 stitch before the hdc, bpdc1, ch9, skip 1 hdc, fpdc2, *bpdc2, fpdc2*, repeat * to * to end, sl st in first fpdc. (38) See photo 1 on page 19.

RND 17: Ch2, fpdc2, *bpdc2, fpdc2*, repeat * to * to 1 stitch before the chains, bpdc1, dc4, hdc1, dc4, *fpdc2, bpdc2*, repeat * to * to last 2 stitches, fpdc2, sl st in first fpdc. (38) See photo 2 on page 19.

RND 18: Ch2, fpdc2, *bpdc2, fpdc2*, repeat * to * to 1 stitch before the first dc, bpdc1, fpdc2, fpdc2tog, hdc1, fpdc2tog, fpdc4, *bpdc2, fpdc2*, repeat * to * to end, sl st in first fpdc. (36)

RND 19: Ch2, fpdc2, *bpdc2, fpdc2*, repeat * to * to 4 stitches before the hdc, bpdc1, fpdc1, fpdc2tog, hdc1, fpdc2tog, fpdc3, *bpdc2, fpdc2*, repeat * to * to end, sl st in first fpdc. (34)

RND 20: Ch2, fpdc2, *bpdc2, fpdc2*, repeat * to * to 3 stitches before the hdc, bpdc1, fpdc2tog, hdc1, fpdc2tog, fpdc2, *bpdc2, fpdc2*, repeat * to * to end, sl st in first fpdc. (32)

RND 21: Ch2, fpdc2, *bpdc2, fpdc2*, repeat * to * to 2 stitches before the hdc, fpdc2tog, hdc1, fpdc2tog, fpdc1, *bpdc2, fpdc2*, repeat * to * to end, sl st in first fpdc. (30)

RND 22: Ch2, *fpdc2, bpdc2*, repeat * to * to 3 stitches before the hdc, fpdc1, fpdc2tog, hdc1, fpdc2tog, *bpdc2, fpdc2*, repeat * to * to end, sl st in first fpdc. (28)

RND 23: Ch2, *fpdc2, bpdc2*, repeat *
to * to 2 stitches before the hdc,
fpdc2tog, hdc1, fpdc2tog, bpdc1,
fpdc2, *bpdc2, fpdc2*, repeat * to *
to end, sl st in first fpdc. (26)

Continue with the color of the top; you
can cut the other color.

RNDS 24-28: Ch2, *fpdc1, bpdc1*, repeat
around, sl st in first fpdc. (26)

If you like to have a longer or fold-
over cuff, you can repeat the round
above for as long as you like. Cut yarn,
fasten off, and weave in ends.

THUMB

RND 1: With the color for the top and the
cuff, attach the yarn with a sl st
in the ch of Rnd 16 above the hdc of
Rnd 17, ch2, fpdc4, sc1 in the side
of the dc of Rnd 15, sc1 before the
hdc of Rnd 15, sc1 after the hdc of
Rnd 15, sc1 in the side of the dc of
Rnd 16, fpdc4, sl st in first fpdc.
(12) See photos 3-10 on page 19.
RND 2: Ch2, fpdc4, dc4, fpdc4, sl st in
first fpdc. (12)
RNDS 3-5: Ch2, fpdc12, sl st in first
fpdc. (12)
RND 6: Ch2, *fpdc2tog*, repeat around,
sl st in first fpdc. (6)

Cut yarn, weave through the loops of the
remaining stitches, pull tight, fasten
off, and weave in ends.

SIZE: 4–8 YEARS

.

RND 1: With color for the top, start with a magic loop, ch2 (first ch2 doesn't count as first dc throughout the pattern), 6dc in the loop, sl st in first dc. (6)

RND 2: Ch2, 2fpdc in each stitch around, sl st in first fpdc. (12)

RND 3: Ch2, *fpdc1, 2fpdcin*, repeat * to * 2 more times, hdc1, 2fpdcin, repeat * to * 2 more times, sl st in first fpdc. (18)

RND 4: Ch2, *fpdc2, 2fpdcin*, repeat * to * 2 more times, hdc1, fpdc1, 2fpdcin, repeat * to * 2 more times, sl st in first fpdc. (24)

RND 5: Ch2, *fpdc3, 2fpdcin*, repeat * to * 2 more times, hdc1, fpdc2, 2fpdcin, repeat * to * 2 more times, sl st in first fpdc. (30)

RND 6: Ch2, *fpdc4, 2fpdcin*, repeat * to * 2 more times, hdc1, fpdc3, 2fpdcin, repeat * to * 2 more times, sl st in first fpdc. (36)

RND 7: Ch2, fpdc2, *bpdc2, fpdc2*, repeat * to * to the hdc, hdc1, *fpdc2, bpdc2*, repeat * to * to last, fpdc1, sl st in first fpdc. (36)

Continue with the second color and change colors after each rnd (see page 63).

RNDS 8–20: Ch2, fpdc2, *bpdc2, fpdc2*, repeat * to * to the hdc, hdc1, *fpdc2, bpdc2*, repeat * to * to last, fpdc1, sl st in first fpdc. (36)

You can customize the mitten by adding more repeats of the round above. This part should cover the fingers and hand, down to just above the wrist. Make sure to leave a little bit of room above the fingers for free movement.

RND 21: Ch2, fpdc2, *bpdc2, fpdc2*, repeat * to * to the hdc, ch11, skip 1 hdc, *fpdc2, bpdc2*, repeat * to * to last, fpdc1, sl st in first fpdc. (46) See photo 1 on page 19.

RND 22: Ch2, fpdc2, *bpdc2, fpdc2*, repeat * to * to the chains, dc5, hdc1, dc5, *fpdc2, bpdc2*, repeat * to * to last, fpdc1, sl st in first fpdc. (46) See photo 2 on page 19.

RND 23: Ch2, fpdc2, *bpdc2, fpdc2*, repeat * to * to the first dc, fpdc3, fpdc2tog, hdc1, fpdc2tog, fpdc5, bpdc2, *fpdc2, bpdc2*, repeat * to * to last, fpdc1, sl st in first fpdc. (44)

RND 24: Ch2, fpdc2, *bpdc2, fpdc2*, repeat * to * to 4 stitches before the hdc, fpdc2, fpdc2tog, hdc1, fpdc2tog, fpdc4, bpdc2, *fpdc2, bpdc2*, repeat * to * to last, fpdc1, sl st in first fpdc. (42)

RND 25: Ch2, fpdc2, *bpdc2, fpdc2*, repeat * to * to 3 stitches before the hdc, fpdc1, fpdc2tog, hdc1, fpdc2tog, fpdc3, bpdc2, *fpdc2, bpdc2*, repeat * to * to last, fpdc1, sl st in first fpdc. (40)

RND 26: Ch2, fpdc2, *bpdc2, fpdc2*, repeat * to * to 2 stitches before the hdc, fpdc2tog, hdc1, fpdc2tog, *fpdc2, bpdc2*, repeat * to * to last, fpdc1, sl st in first fpdc. (38)

RND 27: Ch2, *fpdc2, bpdc2*, repeat * to * to 3 stitches before the hdc, fpdc1, fpdc2tog, hdc1, fpdc2tog, fpdc1, bpdc2, *fpdc2, bpdc2*, repeat * to * to last, fpdc1, sl st in first fpdc. (36)

RND 28: Ch2, *fpdc2, bpdc2*, repeat * to * to 2 stitches before the hdc, fpdc2tog, hdc1, fpdc2tog, *bpdc2, fpdc2*, repeat * to * to last, fpdc1, sl st in first fpdc. (34)

RND 29: Ch2, fpdc2, *bpdc2, fpdc2*, repeat * to * to 3 stitches before the hdc, bpdc1, fpdc2tog, hdc1, fpdc2tog, bpdc1, fpdc2, *bpdc2, fpdc2*, repeat * to * to last, fpdc1, sl st in first fpdc. (32)

Continue with the color of the top; you can cut the other color.

RNDS 30-35: Ch2, *bpdc1, fpdc1*, repeat around, sl st in first bpdc. (32)

If you like to have a longer or fold-over cuff, you can repeat the round above for as long as you like. Cut yarn, fasten off, and weave in ends.

THUMB

RND 1: With the color for the top and the cuff, attach the yarn with a sl st in the ch of Rnd 21 above the hdc of Rnd 22, ch2, fpdc5, sc1 in the side of the dc of Rnd 21, sc1 before the hdc of Rnd 20, sc1 after the hdc of Rnd 20, sc1 in the side of the dc of Rnd 21, fpdc5, sl st in first fpdc. (14) See photos 3-10 on page 19.

RND 2: Ch2, fpdc5, dc4, fpdc5, sl st in first fpdc. (14)

RNDS 3-8: Ch2, fpdc14, sl st in first fpdc. (14)

RND 9: Ch2, *fpdc2tog*, repeat around, sl st in first fpdc. (7)

Cut yarn, weave through the loops of the remaining stitches, pull tight, fasten off, and weave in ends.

SIZE: SMALL

RND 1: With color for the top, start with a magic loop, ch2 (first ch2 doesn't count as first dc throughout the pattern), 6dc in the loop, sl st in first dc. (6)

RND 2: Ch2, 2fpdc in each stitch around, sl st in first fpdc (12)

RND 3: Ch2, *fpdc1, 2fpdcin*, repeat * to * 2 more times, hdc1, 2fpdcin, repeat * to * 2 more times, sl st in first fpdc. (18)

RND 4: Ch2, *fpdc2, 2fpdcin*, repeat * to * 2 more times, hdc1, fpdc1, 2fpdcin, repeat * to * 2 more times, sl st in first fpdc. (24)

RND 5: Ch2, *fpdc3, 2fpdcin*, repeat * to * 2 more times, hdc1, fpdc2, 2fpdcin, repeat * to * 2 more times, sl st in first fpdc. (30)

RND 6: Ch2, *fpdc4, 2fpdcin*, repeat * to * 2 more times, hdc1, fpdc3, 2fpdcin, repeat * to * 2 more times, sl st in first fpdc. (36)

RND 7: Ch2, *fpdc5, 2fpdcin*, repeat * to * 2 more times, hdc1, fpdc4, 2fpdcin, repeat * to * 2 more times, sl st in first fpdc. (42)

RND 8: Ch2, *fpdc2, bpdc2*, repeat * to * to 1 stitch before the hdc, fpdc1, hdc1, *fpdc2, bpdc2*, repeat * to * to end, sl st in first fpdc. (42)

Continue with the second color and change colors after each rnd (see page 63).

RNDS 9-25: Ch2, *fpdc2, bpdc2*, repeat * to * to 1 stitch before the hdc, fpdc1, hdc1, *fpdc2, bpdc2*, repeat * to * to end, sl st in first fpdc (42)

You can customize the mitten by adding more repeats of the round above. This part should cover the fingers and hand, down to just above the wrist. Make sure to leave a little bit of room above the fingers for free movement.

RND 26: Ch2, *fpdc2, bpdc2*, repeat * to * to 1 stitch before the hdc, fpdc1, ch13, skip 1 hdc, *fpdc2, bpdc2*, repeat * to * to end, sl st in first fpdc. (54) See photo 1 on page 19.

RND 27: Ch2, *fpdc2, bpdc2*, repeat * to * to 1 stitch before the chains, fpdc1, dc6, hdc1, dc6, *fpdc2, bpdc2*, repeat * to * to end, sl st in first fpdc. (54) See photo 2 on page 19.

RND 28: Ch2, *fpdc2, bpdc2*, repeat * to * to 1 stitch before the first dc, fpdc5, fpdc2tog, hdc1, fpdc2tog, fpdc6, bpdc2, *fpdc2, bpdc2*, repeat * to * to end, sl st in first fpdc. (52)

RND 29: Ch2, *fpdc2, bpdc2*, repeat * to * to 6 stitches before the hdc, fpdc4, fpdc2tog, hdc1, fpdc2tog, fpdc5, bpdc2, *fpdc2, bpdc2*, repeat * to * to end, sl st in first fpdc. (50)

RND 30: Ch2, *fpdc2, bpdc2*, repeat * to * to 5 stitches before the hdc, fpdc3, fpdc2tog, hdc1, fpdc2tog, fpdc4, bpdc2, *fpdc2, bpdc2*, repeat * to * to end, sl st in first fpdc. (48)

RND 31: Ch2, *fpdc2, bpdc2*, repeat * to * to 4 stitches before the hdc, fpdc2, fpdc2tog, hdc1, fpdc2tog, fpdc3, bpdc2, *fpdc2, bpdc2*, repeat * to * to end, sl st in first fpdc. (46)

RND 32: Ch2, *fpdc2, bpdc2*, repeat * to * to 3 stitches before the hdc, fpdc1, fpdc2tog, hdc1, fpdc2tog, fpdc2, bpdc2, *fpdc2, bpdc2*, repeat * to * to end, sl st in first fpdc. (44)

RND 33: Ch2, *fpdc2, bpdc2*, repeat * to * to 2 stitches before the hdc, fpdc2tog, hdc1, fpdc2tog, fpdc1, *bpdc2, fpdc2*, repeat * to * to end, sl st in first fpdc. (42)

RND 34: Ch2, fpdc2, *bpdc2, fpdc2*, repeat * to * to 3 stitches before the hdc, bpdc1, fpdc2tog, hdc1, fpdc2tog, bpdc2, fpdc2, *bpdc2, fpdc2*, repeat * to * to end, sl st in first fpdc. (40)

RND 35: Ch2, fpdc2, *bpdc2, fpdc2*, repeat * to * to 2 stitches before the hdc, fpdc2tog, hdc1, fpdc2tog, bpdc1, fpdc2, *bpdc2, fpdc2*, repeat * to * to end, sl st in first fpdc. (38)

Continue with the color of the top; you can cut the other color.

RNDS 36-41: Ch2, *fpdc1, bpdc1*, repeat around, sl st in first fpdc. (38)

If you like to have a longer or fold-over cuff, you can repeat the round above for as long as you like. Cut yarn, fasten off, and weave in ends.

THUMB

RND 1: With the color for the top and the cuff, attach the yarn with a sl st in the ch of Rnd 26 above the hdc of Rnd 27, ch2, fpdc6, sc1 in the side of the dc of Rnd 26, sc1 before the hdc of Rnd 25, sc1 after the hdc of Rnd 25, sc1 in the side of the dc of Rnd 26, fpdc6, sl st in first fpdc. (16) See photos 3-10 on page 19.

RND 2: Ch2, fpdc6, dc4, fpdc6, sl st in first fpdc. (16)

RNDS 3-10: Ch2, fpdc16, sl st in first fpdc. (16)

RND 11: Ch2, *fpdc2tog*, repeat around, sl st in first fpdc. (8)

Cut yarn, weave through the loops of the remaining stitches, pull tight, fasten off, and weave in ends.

SIZE: MEDIUM

.

RND 1: With color for the top, start
with a magic loop, ch2 (first
ch2 doesn't count as first dc
throughout the pattern), 6dc in the
loop, sl st in first dc. (6)

RND 2: Ch2, 2fpdc in each stitch around,
sl st in first fpdc. (12)

RND 3: Ch2, *fpdc1, 2fpdcin*, repeat *
to * 2 more times, hdc1, 2fpdcin,
repeat * to * 2 more times, sl st in
first fpdc. (18)

RND 4: Ch2, *fpdc2, 2fpdcin*, repeat
* to * 2 more times, hdc1, fpdc1,
2fpdcin, repeat * to * 2 more times,
sl st in first fpdc. (24)

RND 5: Ch2, *fpdc3, 2fpdcin*, repeat
* to * 2 more times, hdc1, fpdc2,
2fpdcin, repeat * to * 2 more times,
sl st in first fpdc. (30)

RND 6: Ch2, *fpdc4, 2fpdcin*, repeat
* to * 2 more times, hdc1, fpdc3,
2fpdcin, repeat * to * 2 more times,
sl st in first fpdc. (36)

RND 7: Ch2, *fpdc5, 2fpdcin*, repeat
* to * 2 more times, hdc1, fpdc4,
2fpdcin, repeat * to * 2 more times,
sl st in first fpdc. (42)

RND 8: Ch2, *fpdc6, 2fpdcin*, repeat
* to * 2 more times, hdc1, fpdc5,
2fpdcin, repeat * to * 2 more times,
sl st in first fpdc. (48)

RND 9: Ch2, *fpdc2, bpdc2*, repeat * to
* to the hdc, hdc1, fpdc2, *bpdc2,
fpdc2*, repeat * to * to last
stitch, bpdc1, sl st in first fpdc.
(48)

Continue with the second color and
change colors after each rnd (see page
63).

RNDS 10-30: Ch2, *fpdc2, bpdc2*, repeat
* to * to the hdc, hdc1, fpdc2,
bpdc2, fpdc2, repeat * to * to
last stitch, bpdc1, sl st in first
fpdc. (48)

You can customize the mitten by adding
more repeats of the round above. This
part should cover the fingers and hand,
down to just above the wrist. Make sure
to leave a little bit of room above the
fingers for free movement.

RND 31: Ch2, *fpdc2, bpdc2*, repeat *
to * to the hdc, ch15, skip 1 hdc,
fpdc2, *bpdc2, fpdc2*, repeat * to *
to last stitch, bpdc1, sl st in first
fpdc. (62) See photo 1 on page 19.

RND 32: Ch2, *fpdc2, bpdc2*, repeat *
to * to the chains, dc7, hdc1, dc7,
fpdc2, *bpdc2, fpdc2*, repeat * to *
to last stitch, bpdc1, sl st in first
fpdc. (62) See photo 2 on page 19.

RND 33: Ch2, *fpdc2, bpdc2*, repeat * to
* to the first dc, fpdc5, fpdc2tog,
hdc1, fpdc2tog, fpdc7, *bpdc2,
fpdc2*, repeat * to * to the last
stitch, bpdc1, sl st in first fpdc.
(60)

RND 34: Ch2, *fpdc2, bpdc2*, repeat *
to * to 6 stitches before the hdc,
fpdc4, fpdc2tog, hdc1, fpdc2tog,
fpdc6, *bpdc2, fpdc2*, repeat * to *
to the last stitch, bpdc1, sl st in
first fpdc. (58)

RND 35: Ch2, *fpdc2, bpdc2*, repeat *
to * to 5 stitches before the hdc,
fpdc3, fpdc2tog, hdc1, fpdc2tog,
fpdc5, *bpdc2, fpdc2*, repeat * to *
to the last stitch, bpdc1, sl st in
first fpdc. (56)

RND 36: Ch2, *fpdc2, bpdc2*, repeat *
to * to 4 stitches before the hdc,
fpdc2, fpdc2tog, hdc1, fpdc2tog,
fpdc4, *bpdc2, fpdc2*, repeat * to *
to the last stitch, bpdc1, sl st in
first fpdc. (54)

RND 37: Ch2, *fpdc2, bpdc2*, repeat *
to * to 3 stitches before the hdc,
fpdc1, fpdc2tog, hdc1, fpdc2tog,
fpdc3, *bpdc2, fpdc2*, repeat * to *
to the last stitch, bpdc1, sl st in
first fpdc. (52)

RND 38: Ch2, *fpdc2, bpdc2*, repeat *
to * to 2 stitches before the hdc,
fpdc2tog, hdc1, fpdc2tog, fpdc2,
bpdc2, fpdc2, repeat * to * to the
last stitch, bpdc1, sl st in first
fpdc. (50)

RND 39: Ch2, fpdc2, *bpdc2, fpdc2*,
repeat * to * to 3 stitches before
the hdc, bpdc1, fpdc2tog, hdc1,
fpdc2tog, fpdc1, *bpdc2, fpdc2*,
repeat * to * to the last stitch,
bpdc1, sl st in first fpdc. (48)

RND 40: Ch2, fpdc2, *bpdc2, fpdc2*,
repeat * to * to 2 stitches before
the hdc, fpdc2tog, hdc1, fpdc2tog,
bpdc2, fpdc2, repeat * to * to the
last stitch, bpdc1, sl st in first
fpdc. (46)

RND 41: Ch2, *fpdc2, bpdc2*, repeat *
to * to 3 stitches before the hdc,
fpdc1, fpdc2tog, hdc1, fpdc2tog,
bpdc1, fpdc2, *bpdc2, fpdc2*,
repeat * to * to the last stitch,
bpdc1, sl st in first fpdc. (44)

Continue with the color of the top; you
can cut the other color.

RNDS 42–48: Ch2, *bpdc1, fpdc1*, repeat
around, sl st in first bpdc. (44)

If you like to have a longer or fold-
over cuff, you can repeat the round
above for as long as you like. Cut yarn,
fasten off, and weave in ends.

THUMB

RND 1: With the color for the top and the
cuff, attach the yarn with a sl st
in the ch of Rnd 31 above the hdc of
Rnd 32, ch2, fpdc7, sc1 in the side
of the dc of Rnd 31, sc1 before the
hdc of Rnd 30, sc1 after the hdc of
Rnd 30, sc1 in the side of the dc of
Rnd 31, fpdc7, sl st in first fpdc.
(18) See photos 3–10 on page 19.

RND 2: Ch2, fpdc7, dc4, fpdc7, sl st in
first fpdc. (18)

RNDS 3–11: Ch2, fpdc18, sl st in first
fpdc. (18)

RND 12: Ch2, *fpdc2tog*, repeat around,
sl st in first fpdc. (9)

Cut yarn, weave through the loops of the
remaining stitches, pull tight, fasten
off, and weave in ends.

SIZE: LARGE

. .

RND 1: With color for the top, start
with a magic loop, ch2 (first
ch2 doesn't count as first dc
throughout the pattern), 6dc in the
loop, sl st in first dc. (6)

RND 2: Ch2, 2fpdc in each stitch around,
sl st in first fpdc. (12)

RND 3: Ch2, *fpdc1, 2fpdcin*, repeat *
to * 2 more times, hdc1, 2fpdcin,
repeat * to * 2 more times, sl st in
first fpdc. (18)

RND 4: Ch2, *fpdc2, 2fpdcin*, repeat
* to * 2 more times, hdc1, fpdc1,
2fpdcin, repeat * to * 2 more times,
sl st in first fpdc. (24)

RND 5: Ch2, *fpdc3, 2fpdcin*, repeat
* to * 2 more times, hdc1, fpdc2,
2fpdcin, repeat * to * 2 more times,
sl st in first fpdc. (30)

RND 6: Ch2, *fpdc4, 2fpdcin*, repeat
* to * 2 more times, hdc1, fpdc3,
2fpdcin, repeat * to * 2 more times,
sl st in first fpdc. (36)

RND 7: Ch2, *fpdc5, 2fpdcin*, repeat
* to * 2 more times, hdc1, fpdc4,
2fpdcin, repeat * to * 2 more times,
sl st in first fpdc. (42)

RND 8: Ch2, *fpdc6, 2fpdcin*, repeat
* to * 2 more times, hdc1, fpdc5,
2fpdcin, repeat * to * 2 more times,
sl st in first fpdc. (48)

RND 9: Ch2, *fpdc7, 2fpdcin*, repeat
* to * 2 more times, hdc1, fpdc6,
2fpdcin, repeat * to * 2 more times,
sl st in first fpdc. (54)

RND 10: Ch2, fpdc2, *bpdc2, fpdc2*,
repeat * to * to 1 stitch before the
hdc, bpdc1, hdc1, fpdc2, *bpdc2,
fpdc2*, repeat * to * to end, sl st
in first fpdc. (54)

Continue with the second color and change
colors after each rnd (see page 63).

RNDS 11–35: Ch2, fpdc2, *bpdc2, fpdc2*,
repeat * to * to 1 stitch before the
hdc, bpdc1, hdc1, fpdc2, *bpdc2,
fpdc2*, repeat * to * to end, sl st
in first fpdc. (54)

You can customize the mitten by adding
more repeats of the round above. This
part should cover the fingers and hand,
down to just above the wrist. Make sure
to leave a little bit of room above the
fingers for free movement.

RND 36: Ch2, fpdc2, *bpdc2, fpdc2*,
repeat * to * to 1 stitch before the
hdc, bpdc1, ch17, skip 1 hdc, fpdc2,
bpdc2, fpdc2, repeat * to * to
end, sl st in first fpdc. (70) See
photo 1 on page 19.

RND 37: Ch2, fpdc2, *bpdc2, fpdc2*,
repeat * to * to 1 stitch before
the chains, bpdc1, dc8, hdc1, dc8,
fpdc2, *bpdc2, fpdc2*, repeat * to
* to end, sl st in first fpdc. (70)
See photo 2 on page 19.

RND 38: Ch2, fpdc2, *bpdc2, fpdc2*,
repeat * to * to 1 stitch before the
first dc, bpdc1, fpdc6, fpdc2tog,
hdc1, fpdc2tog, fpdc8, *bpdc2,
fpdc2*, repeat * to * to end, sl st
in first fpdc. (68)

RND 39: Ch2, fpdc2, *bpdc2, fpdc2*,
repeat * to * to 8 stitches before
the hdc, bpdc1, fpdc5, fpdc2tog,
hdc1, fpdc2tog, fpdc7, *bpdc2,
fpdc2*, repeat * to * to end, sl st
in first fpdc. (66)

RND 40: Ch2, fpdc2, *bpdc2, fpdc2*,
repeat * to * to 7 stitches before
the hdc, bpdc1, fpdc4, fpdc2tog,
hdc1, fpdc2tog, fpdc6, *bpdc2,
fpdc2*, repeat * to * to end, sl st
in first fpdc. (64)

RND 41: Ch2, fpdc2, *bpdc2, fpdc2*, repeat * to * to 6 stitches before the hdc, bpdc1, fpdc3, fpdc2tog, hdc1, fpdc2tog, fpdc5, *bpdc2, fpdc2*, repeat * to * to end, sl st in first fpdc. (62)

RND 42: Ch2, fpdc2, *bpdc2, fpdc2*, repeat * to * to 5 stitches before the hdc, bpdc1, fpdc2, fpdc2tog, hdc1, fpdc2tog, fpdc4, *bpdc2, fpdc2*, repeat * to * to end, sl st in first fpdc. (60)

RND 43: Ch2, fpdc2, *bpdc2, fpdc2*, repeat * to * to 4 stitches before the hdc, bpdc1, fpdc1, fpdc2tog, hdc1, fpdc2tog, fpdc3, *bpdc2, fpdc2*, repeat * to * to end, sl st in first fpdc. (58)

RND 44: Ch2, fpdc2, *bpdc2, fpdc2*, repeat * to * to 3 stitches before the hdc, bpdc1, fpdc2tog, hdc1, fpdc2tog, fpdc2, *bpdc2, fpdc2*, repeat * to * to end, sl st in first fpdc. (56)

RND 45: Ch2, fpdc2, *bpdc2, fpdc2*, repeat * to * to 2 stitches before the hdc, fpdc2tog, hdc1, fpdc2tog, fpdc1, *bpdc2, fpdc2*, repeat * to * to end, sl st in first fpdc. (54)

RND 46: Ch2, *fpdc2, bpdc2*, repeat * to * to 3 stitches before the hdc, fpdc1, fpdc2tog, hdc1, fpdc2tog, *bpdc2, fpdc2*, repeat * to * to end, sl st in first fpdc. (52)

RND 47: Ch2, *fpdc2, bpdc2*, repeat * to * to 2 stitches before the hdc, fpdc2tog, hdc1, fpdc2tog, bpdc1, fpdc2, *bpdc2, fpdc2*, repeat * to * to end, sl st in first fpdc. (50)

Continue with the color of the top; you can cut the other color.

RNDS 48-54: Ch2, *fpdc1, bpdc1*, repeat around, sl st in first fpdc. (50)

If you like to have a longer or fold-over cuff, you can repeat the round above for as long as you like. Cut yarn, fasten off, and weave in ends.

THUMB

RND 1: With the color for the top and the cuff, attach the yarn with a sl st in the ch of Rnd 36 above the hdc of Rnd 37, ch2, fpdc8, sc1 in the side of the dc of Rnd 36, sc1 before the hdc of Rnd 35, sc1 after the hdc of Rnd 35, sc1 in the side of the dc of Rnd 36, fpdc8, sl st in first fpdc. (20) See photos 3-10 on page 19.

RND 2: Ch2, fpdc8, dc4, fpdc8, sl st in first fpdc. (20)

RNDS 3-12: Ch2, fpdc20, sl st in first fpdc. (20)

RND 13: Ch2, *fpdc2tog*, repeat around, sl st in first fpdc. (10)

Cut yarn, weave through the loops of the remaining stitches, pull tight, fasten off, and weave in ends.

OLLIE'S HAT

MATERIALS

Yarn
Fingering weight sock yarn. Samples
shown in:

Blue/Gray
Durable Soqs; 75% superwash wool,
25% polyamide; 1.7 oz/230 yd (50 g/210
m); #321 Navy and #415 Chateau Grey

Brown/Cream
Scheepjes Metropolis; 75% extra fine
Merino wool, 25% nylon; 1.7 oz/437.5
yd (100g/400 m); #066 Copenhagen and
#078 Lyon

Crochet Hook
US size G-6 (4 mm)

Estimate of Yarn Required

0–6 months	230 yd (210 m)
6–12 months	230 yd (210 m)
1–3 years	460 yd (420 m)
4 years–teen	460 yd (420 m)
Medium	460 yd (420 m)
Large	460 yd (420 m)

Size and Gauge
For help choosing a size and matching
gauge, refer to Size and Gauge on
pages 12–13.

ABBREVIATIONS

⌒	**ch**	chain
✕	**sc**	single crochet
●	**sl st**	slip stitch
⊣	**dc**	double crochet
⌐	**fpdc**	front post double crochet
⌐	**bpdc**	back post double crochet
⋋	**2fpdcin**	2 fpdc in next stitch

CHANGING COLORS
The best way to change colors is to complete the last step of the stitch before the
color change with the new color. For this hat, that means: when making the last fpdc
before the color change, use the new color for the last yarn over and pull through
(so the sl st doesn't count as the last stitch). In between the color changes, you don't
have to cut the color you're not using. You can simply pick it up again when needed,
but make sure the loops of yarn are loose enough to stretch them a bit.

PATTERN

· ·

RND 1: With color for the top, start with a magic loop, ch2 (first ch2 doesn't count as first dc throughout the pattern), 8dc in the loop, sl st in first dc. (8)

RND 2: Ch2, 2fpdc in each stitch around, sl st in first fpdc. (16)

RND 3: Ch2, *fpdc1, 2fpdcin*, repeat * to * around, sl st in first fpdc. (24)

RND 4: Ch2, *fpdc1 in each fpdc to the second fpdc of the 2fpdcin of previous row, 2fpdcin*, repeat * to * around, sl st in first fpdc. (8 increases after each round)

Repeat Rnd 4 until your piece has a diameter (or as close as possible to) as written below in the chart.

0-6 months —————— 4.13 in (10.5 cm)
6-12 months ————— 5 in (12.5 cm)
1-3 years —————— 5.5 in (14 cm)
4 years-teen ———— 5.75 in (14.6 cm)
Medium —————————— 6.25 in (16 cm)
Large ——————————— 6.75 in (17 cm)

RND 5: Ch2, *fpdc2, bpdc2*, repeat * to * to end, sl st in first fpdc. (no increases)

Start Motif

Continue with the second color and change colors after each rnd (see page 77).

RND 6: Ch2, *fpdc2, bpdc2*, repeat * to * to end, sl st in first fpdc. (no increases)

Repeat Rnd 6 until your piece has a length (or as close as possible to) as written below in the chart, making sure to end with the same color as the brim will be.

0-6 months —————— 4.25 in (10.8 cm)
6-12 months ————— 5.5 in (14 cm)
1-3 years —————— 6.25 in (16 cm)
4 years-teen ———— 6.75 in (17 cm)
Medium —————————— 7.5 in (19.1 cm)
Large ——————————— 7.5 in (19.1 cm)

BRIM

Continue with the color for the brim; you can cut the other color.

RND 7: Ch2, *fpdc1, bpdc1*, repeat around, sl st in first dc. (no increases)

Repeat Rnd 7 until your piece has a length of (or as close as possible to):

0-6 months —————— 5.25 in (13.3 cm)
6-12 months ————— 6.5 in (16.5 cm)
1-3 years —————— 7.25 in (18.5 cm)
4 years-teen ———— 7.75 in (19.5 cm)
Medium —————————— 8.5 in (21.6 cm)
Large ——————————— 8.75 in (22.2 cm)

Cut yarn and weave in ends.

If you know me, you'll immediately know where the name of this hat is coming from. The blue version of this hat was designed for my son Olivier, the biggest fan of my crocheted hats, who couldn't wait for it to be finished! I didn't even have a chance to weave in the ends before he started wearing it everywhere.

When I couldn't come up with a suitable name, it suddenly occurred to me that we already had been calling it by the right name for a while: Ollie's Hat.

Skill Level: 4 of 5

CELTIC CABLE MITTENS

MATERIALS

Yarn
Fingering weight sock yarn. Samples shown in:

Yellow
Borgo de Pazzi Bice; 75% wool, 25% nylon; 3.5 oz/459 yd (100 g/420 m); #303

Gray
Durable Soqs; 75% superwash wool, 25% polyamide; 1.7 oz/230 yd (50 g/210 m); #0415 Chateau Grey

Green
Durable Soqs; 75% superwash wool, 25% polyamide; 1.7 oz/230 yd (50 g/210 m); #2133 Dark Mint

Crochet Hook
US size G-6 (4 mm)

Estimate of Yarn Required

1–3 years	230 yd (210 m)
4–8 years	230 yd (210 m)
Small	460 yd (420 m)
Medium	460 yd (420 m)
Large	690 yd (630 m)

Size and Gauge
For help choosing a size and matching gauge, refer to Size and Gauge on pages 12–13.

ABBREVIATIONS

⌒	ch	chain
✕	sc	single crochet
●	sl st	slip stitch
⊤	dc	double crochet
⌐⊤	fpdc	front post double crochet
⌐⊥	bpdc	back post double crochet
⋏	fpdc2tog	fpdc 2 together
⋀	2fpdcin	2 fpdc in next stitch

8

7

6

← left mitten

right mitten ⟶

SIZE: 1-3 YEAR

. .

LEFT MITTEN

RND 1: Start with a magic loop, ch2 (first ch2 doesn't count as first dc throughout the pattern), 6dc in the loop, sl st in first dc. (6)

RND 2: Ch2, 2fpdc in each stitch around, sl st in first fpdc. (12)

RND 3: Ch2, *fpdc1, 2fpdcin*, repeat * to * 2 more times, hdc1, 2fpdcin, repeat * to * 2 more times, sl st in first fpdc. (18)

RND 4: Ch2, *fpdc2, 2fpdcin*, repeat * to * 2 more times, hdc1, fpdc1, 2fpdcin, repeat * to * 2 more times, sl st in first fpdc. (24)

RND 5: Ch2, fpdc1, bpdc1, fpdc1, 2fpdcin, *fpdc3, 2fpdcin*, fpdc1, bpdc1, fpdc1, 2fpdcin, hdc1, fpdc2, 2fpdcin, repeat * to * 2 more times, sl st in first fpdc. (30)

RND 6: Ch2, fpdc1, bpdc2, skip 2, fptr2, fptr2 in the skipped stitches behind the previous stitches, skip 2, fptr2, fptr2 in the skipped stitches in front of the previous

stitches, bpdc2, fpdc2, hdc1, fpdc14, sl st in first fpdc. (30)

RNDS 7-8: Ch2, fpdc1, bpdc2, fpdc8, bpdc2, fpdc2, hdc1, fpdc14, sl st in first fpdc. (30)

RNDS 9-15: Repeat Rnds 6-8, ending with Rnd 6. (30)

You can customize the mitten by adding more or fewer repeats of the 3 rounds above. This part should cover the fingers and hand, down to the start of the thumb. Make sure to leave a little bit of room above the fingers for free movement.

RND 16: Ch2, fpdc1, bpdc2, fpdc8, bpdc2, fpdc2, ch9, skip 1 hdc, fpdc14, sl st in first fpdc. (38) See photo 1 on page 19.

RND 17: Ch2, fpdc1, bpdc2, fpdc8, bpdc2, fpdc2, dc4, hdc1, dc4, fpdc14, sl st in first fpdc. (38) See photo 2 on page 19.

RND 18: Ch2, fpdc1, bpdc2, skip 2, fptr2, fptr2 in the skipped stitches behind the previous stitches, skip 2, fptr2, fptr2 in the skipped stitches in front of the previous stitches, bpdc2, fpdc4, fpdc2tog, hdc1, fpdc2tog, fpdc16, sl st in first fpdc. (36)

RND 19: Ch2, fpdc1, bpdc2, fpdc8, bpdc2, fpdc3, fpdc2tog, hdc1, fpdc2tog, fpdc15, sl st in first fpdc. (34)

RND 20: Ch2, fpdc1, bpdc2, fpdc8, bpdc2, fpdc2, fpdc2tog, hdc1, fpdc2tog, fpdc14, sl st in first fpdc. (32)

RND 21: Ch2, fpdc1, bpdc2, skip 2, fptr2, fptr2 in the skipped stitches behind the previous stitches, skip 2, fptr2, fptr2 in the skipped stitches in front of the previous stitches, bpdc2, fpdc1, fpdc2tog, hdc1, fpdc2tog, fpdc13, sl st in first fpdc. (30)

RND 22: Ch2, fpdc1, bpdc2, fpdc8, bpdc2, fpdc2tog, hdc1, fpdc2tog, fpdc12, sl st in first fpdc. (28)

RND 23: Ch2, fpdc1, bpdc2, fpdc8, bpdc1, fpdc2tog, hdc1, fpdc2tog, fpdc11, sl st in first fpdc. (26)

RNDS 24-28: Ch2, *fpdc1, bpdc1*, repeat around, sl st in first fpdc. (26)

If you like to have a longer or fold-over cuff, you can repeat the round above for as long as you like. Cut yarn, fasten off, and weave in ends.

RIGHT MITTEN

RND 1: Start with a magic loop, ch2 (first ch2 doesn't count as first dc throughout the pattern), 6dc in the loop, sl st in first dc. (6)

RND 2: Ch2, 2fpdc in each stitch around, sl st in first fpdc. (12)

RND 3: Ch2, *fpdc1, 2fpdcin*, repeat * to * 1 more time, fpdc1, in next stitch: 1fpdc and 1hdc, repeat * to * 3 more times, sl st in first fpdc. (18)

RND 4: Ch2, *fpdc2, 2fpdcin*, repeat * to * 1 more time, fpdc1, 2fpdcin, hdc1, repeat * to * 3 more times, sl st in first fpdc. (24)

RND 5: Ch2, *fpdc3, 2fpdcin*, repeat * to * 1 more time, fpdc2, 2fpdcin, hdc1, fpdc2, bpdc1, 2fpdcin, fpdc3, 2fpdcin, fpdc2, bpdc1, 2fpdcin, sl st in first fpdc. (30)

RND 6: Ch2, fpdc14, hdc1, fpdc2, bpdc2, skip 2, fptr2, fptr2 in the skipped stitches behind the previous stitches, skip 2, fptr2, fptr2 in the skipped stitches in front of the previous stitches, bpdc2, fpdc1, sl st in first fpdc. (30)

RNDS 7-8: Ch2, fpdc14, hdc1, fpdc2, bpdc2, fpdc8, bpdc2, fpdc1, sl st in first fpdc. (30)

RNDS 9-15: Repeat Rnds 6-8, ending with Rnd 6. (30)

You can customize the mitten by adding more or fewer repeats of the 3 rounds above. This part should cover the fingers and hand, down to the start of the thumb. Make sure to leave a little bit of room above the fingers for free movement.

RND 16: Ch2, fpdc14, ch9, skip 1 hdc, fpdc2, bpdc2, fpdc8, bpdc2, fpdc1, sl st in first fpdc. (38) See photo 1 on page 19.

RND 17: Ch2, fpdc14, dc4, hdc1, dc4, fpdc2, bpdc2, fpdc8, bpdc2, fpdc1, sl st in first fpdc. (38) See photo 2 on page 19.

RND 18: Ch2, fpdc16, fpdc2tog, hdc1, fpdc2tog, fpdc4, bpdc2, skip 2, fptr2, fptr2 in the skipped stitches behind the previous stitches, skip 2, fptr2, fptr2 in the skipped stitches in front of the previous stitches, bpdc2, fpdc1, sl st in first fpdc. (36)

RND 19: Ch2, fpdc15, fpdc2tog, hdc1, fpdc2tog, fpdc3, bpdc2, fpdc8, bpdc2, fpdc1, sl st in first fpdc. (34)

RND 20: Ch2, fpdc14, fpdc2tog, hdc1, fpdc2tog, fpdc2, bpdc2, fpdc8, bpdc2, fpdc1, sl st in first fpdc. (32)

RND 21: Ch2, fpdc13, fpdc2tog, hdc1, fpdc2tog, fpdc1, bpdc2, skip 2, fptr2, fptr2 in the skipped stitches behind the previous stitches, skip 2, fptr2, fptr2 in the skipped stitches in front of the previous stitches, bpdc2, fpdc1, sl st in first fpdc. (30)

RND 22: Ch2, fpdc12, fpdc2tog, hdc1, fpdc2tog, bpdc2, fpdc8, bpdc2, fpdc1, sl st in first fpdc. (28)

RND 23: Ch2, fpdc11, fpdc2tog, hdc1, fpdc2tog, bpdc1, fpdc8, bpdc2, fpdc1, sl st in first fpdc. (26)

RNDS 24-28: Ch2, *bpdc1, fpdc1*, repeat around, sl st in first bpdc. (26)

If you like to have a longer or fold-over cuff, you can repeat the round above for as long as you like. Cut yarn, fasten off, and weave in ends.

THUMBS

RND 1: Attach the yarn with a sl st in the ch of Rnd 16 above the hdc of R17, ch2, fpdc4, sc1 in the side of the dc of R16, sc1 before the hdc of R15, sc1 after the hdc of R15, sc1 in the side of the dc of R16, fpdc4, sl st in first fpdc. (12) See photos 3-10 on page 19.

RND 2: Ch2, fpdc4, dc4, fpdc4, sl st in first fpdc. (12)

RNDS 3-5: Ch2, fpdc12, sl st in first fpdc. (12)

RND 6: Ch2, *fpdc2tog*, repeat around, sl st in first fpdc. (6)

Cut yarn, weave through the loops of the remaining stitches, pull tight, fasten off, and weave in ends.

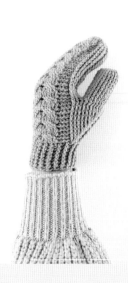

THE POWER OF POST STITCHES:
WARM, STRONG, STRETCHY, AND STYLISH!

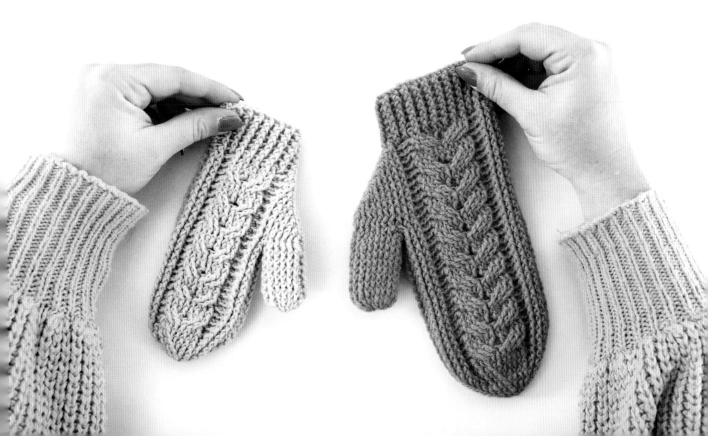

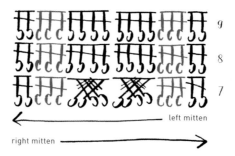

9

8

7

← left mitten

right mitten ⟶

SIZE: 4–8 YEARS

. .

LEFT MITTEN

RND 1: Start with a magic loop, ch2 (first ch2 doesn't count as first dc throughout the pattern), 6dc in the loop, sl st in first dc. (6)

RND 2: Ch2, 2fpdc in each stitch around, sl st in first fpdc. (12)

RND 3: Ch2, *fpdc1, 2fpdcin*, repeat * to * 2 more times, hdc1, 2fpdcin, repeat * to * 2 more times, sl st in first fpdc. (18)

RND 4: Ch2, *fpdc2, 2fpdcin*, repeat * to * 2 more times, hdc1, fpdc1, 2fpdcin, repeat * to * 2 more times, sl st in first fpdc. (24)

RND 5: Ch2, fpdc2, bpdc1, 2fpdcin, *fpdc3, 2fpdcin*, fpdc2, bpdc1, 2fpdcin, hdc1, fpdc2, 2fpdcin, repeat * to * 2 more times, sl st in first fpdc. (30)

RND 6: Ch2, fpdc2, bpdc2, 2fpdcin, *fpdc4, 2fpdcin*, fpdc2, bpdc2, 2fpdcin, hdc1, fpdc3, 2fpdcin, repeat * to * 2 more times, sl st in first fpdc. (36)

RND 7: Ch2, fpdc2, bpdc3, skip 2, fptr2, fptr2 in the skipped stitches behind the previous stitches, skip 2, fptr2, fptr2 in the skipped stitches in front of the previous stitches, bpdc3, fpdc2, hdc1, fpdc17, sl st in first fpdc. (36)

RNDS 8–9: Ch2, fpdc2, bpdc3, fpdc8, bpdc3, fpdc2, hdc1, fpdc17, sl st in first fpdc. (36)

RNDS 10–19: Repeat Rnds 7–9, ending with Rnd 7. (36)

You can customize the mitten by adding more or fewer repeats of the 3 rounds above. This part should cover the fingers and hand, down to the start of the thumb. Make sure to leave a little bit of room above the fingers for free movement.

RND 20: Ch2, fpdc2, bpdc3, fpdc8, bpdc3, fpdc2, ch11, skip 1 hdc, fpdc17, sl st in first fpdc. (46) See photo 1 on page 19.

RND 21: Ch2, fpdc2, bpdc3, fpdc8, bpdc3, fpdc2, dc5, hdc1, dc5, fpdc17, sl st in first fpdc. (46) See photo 2 on page 19.

RND 22: Ch2, fpdc2, bpdc3, skip 2, fptr2, fptr2 in the skipped stitches behind the previous stitches, skip 2, fptr2, fptr2 in the previously skipped stitches in front of the previous stitches, bpdc3, fpdc5, fpdc2tog, hdc1, fpdc2tog, fpdc20, sl st in first fpdc. (44)

RND 23: Ch2, fpdc2, bpdc3, fpdc8, bpdc3, fpdc4, fpdc2tog, hdc1, fpdc2tog, fpdc19, sl st in first fpdc. (42)

RND 24: Ch2, fpdc2, bpdc3, fpdc8, bpdc3, fpdc3, fpdc2tog, hdc1, fpdc2tog, fpdc18, sl st in first fpdc. (40)

RND 25: Ch2, fpdc2, bpdc3, skip 2, fptr2, fptr2 in the skipped stitches behind the previous stitches, skip 2, fptr2, fptr2 in the skipped stitches in front of the previous stitches, bpdc3, fpdc2, fpdc2tog, hdc1, fpdc2tog, fpdc17, sl st in first fpdc. (38)

RND 26: Ch2, fpdc2, bpdc3, fpdc8, bpdc3, fpdc1, fpdc2tog, hdc1, fpdc2tog, fpdc16, sl st in first fpdc. (36)

RND 27: Ch2, fpdc2, bpdc3, fpdc8, bpdc3, fpdc2tog, hdc1, fpdc2tog, fpdc15, sl st in first fpdc. (34)

RND 28: Ch2, fpdc2, bpdc3, fpdc8, bpdc2, fpdc2tog, hdc1, fpdc2tog, fpdc14, sl st in first fpdc. (32)

RNDS 29–34: Ch2, *fpdc1, bpdc1*, repeat around, sl st in first fpdc. (32)

If you like to have a longer or fold-over cuff, you can repeat the round above for as long as you like. Cut yarn, fasten off, and weave in ends.

RIGHT MITTEN

RND 1: Start with a magic loop, ch2 (first ch2 doesn't count as first dc throughout the pattern), 6dc in the loop, sl st in first dc. (6)

RND 2: Ch2, 2fpdc in each stitch around, sl st in first fpdc. (12)

RND 3: Ch2, *fpdc1, 2fpdcin*, repeat * to * 1 more time, fpdc1, in next stitch: 1fpdc and 1hdc, repeat * to * 3 more times, sl st in first fpdc. (18)

RND 4: Ch2, *fpdc2, 2fpdcin*, repeat * to * 1 more time, fpdc1, 2fpdcin, hdc1, repeat * to * 3 more times, sl st in first fpdc. (24)

RND 5: Ch2, *fpdc3, 2fpdcin*, repeat * to * 1 more time, fpdc2, 2fpdcin, hdc1, fpdc2, bpdc1, 2fpdcin, fpdc3, 2fpdcin, fpdc2, bpdc1, 2fpdcin, sl st in first fpdc. (30)

RND 6: Ch2, *fpdc4, 2fpdcin*, repeat * to * 1 more time, fpdc3, 2fpdcin, hdc1, fpdc2, bpdc2, 2fpdcin, fpdc4, 2fpdcin, fpdc2, bpdc2, 2fpdcin, sl st in first fpdc. (36)

RND 7: Ch2, fpdc17, hdc1, fpdc2, bpdc3, skip 2, fptr2, fptr2 in the skipped stitches behind the previous stitches, skip 2, fptr2, fptr2 in the skipped stitches in front of the previous stitches, bpdc3, fpdc2, sl st in first fpdc. (36)

RNDS 8 AND 9: Ch2, fpdc17, hdc1, fpdc2, bpdc3, fpdc8, bpdc3, fpdc2, sl st in first fpdc. (36)

RNDS 10–19: Repeat Rnds 7–9, ending with Rnd 7. (36)

You can customize the mitten by adding more or fewer repeats of the 3 rounds above. This part should cover the fingers and hand, down to the start of the thumb. Make sure to leave a little bit of room above the fingers for free movement.

RND 20: Ch2, fpdc17, ch11, skip 1 hdc, fpdc2, bpdc3, fpdc8, bpdc3, fpdc2, sl st in first fpdc. (46) See photo 1 on page 19.

RND 21: Ch2, fpdc17, dc5, hdc1, dc5, fpdc2, bpdc3, fpdc8, bpdc3, fpdc2, sl st in first fpdc (46) See photo 2 on page 19.

RND 22: Ch2, fpdc20, fpdc2tog, hdc1, fpdc2tog, fpdc5, bpdc3, skip 2, fptr2, fptr2 in the skipped stitches behind the previous stitches, skip 2, fptr2, fptr2 in the skipped stitches in front of the previous stitches, bpdc3, fpdc2, sl st in first fpdc. (44)

RND 23: Ch2, fpdc19, fpdc2tog, hdc1, fpdc2tog, fpdc4, bpdc3, fpdc8, bpdc3, fpdc2, sl st in first fpdc. (42)

RND 24: Ch2, fpdc18, fpdc2tog, hdc1, fpdc2tog, fpdc3, bpdc3, fpdc8, bpdc3, fpdc2, sl st in first fpdc. (40)

RND 25: Ch2, fpdc17, fpdc2tog, hdc1, fpdc2tog, fpdc2, bpdc3, skip 2, fptr2, fptr2 in the skipped stitches behind the previous stitches, skip 2, fptr2, fptr2 in the skipped stitches in front of the previous stitches, bpdc3, fpdc2, sl st in first fpdc. (38)

RND 26: Ch2, fpdc16, fpdc2tog, hdc1, fpdc2tog, fpdc1, bpdc3, fpdc8, bpdc3, fpdc2, sl st in first fpdc. (36)

RND 27: Ch2, fpdc15, fpdc2tog, hdc1, fpdc2tog, bpdc3, fpdc8, bpdc3, fpdc2, sl st in first fpdc. (34)

RND 28: Ch2, fpdc14, fpdc2tog, hdc1, fpdc2tog, bpdc2, fpdc8, bpdc3, fpdc2, sl st in first fpdc. (32)

RNDS 29-34: Ch2, *bpdc1, fpdc1*, repeat around, sl st in first bpdc. (32)

If you like to have a longer or fold-over cuff, you can repeat the round above for as long as you like. Cut yarn, fasten off, and weave in ends.

THUMBS

RND 1: Attach the yarn with a sl st in the ch of Rnd 20 above the hdc of Rnd 21, ch2, fpdc5, sc1 in the side of the dc of Rnd 20, sc1 before the hdc of Rnd 19, sc1 after the hdc of Rnd 19, sc1 in the side of the dc of Rnd 20, fpdc5, sl st in first fpdc. (14) See photos 3-10 on page 19.

RND 2: Ch2, fpdc5, dc4, fpdc5, sl st in first fpdc. (14)

RNDS 3-8: Ch2, fpdc14, sl st in first fpdc. (14)

RND 9: Ch2, *fpdc2tog*, repeat around, sl st in first fpdc. (7)

Cut yarn, weave through the loops of the remaining stitches, pull tight, fasten off, and weave in ends.

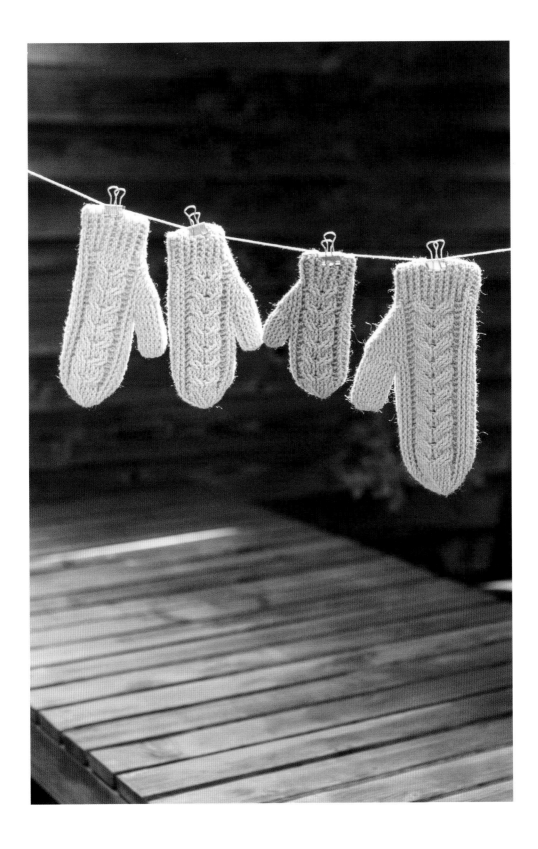

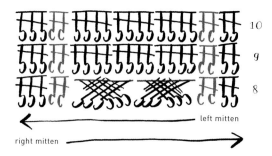

10

9

8

← left mitten

right mitten ——————————————→

SIZE: SMALL

· ·

LEFT MITTEN

RND 1: Start with a magic loop, ch2 (first ch2 doesn't count as first dc throughout the pattern), 6dc in the loop, sl st in first dc. (6)

RND 2: Ch2, 2fpdc in each stitch around, sl st in first fpdc. (12)

RND 3: Ch2, *fpdc1, 2fpdcin*, repeat * to * 2 more times, hdc1, 2fpdcin, repeat * to * 2 more times, sl st in first fpdc. (18)

RND 4: Ch2, *fpdc2, 2fpdcin*, repeat * to * 2 more times, hdc1, fpdc1, 2fpdcin, repeat * to * 2 more times, sl st in first fpdc. (24)

RND 5: Ch2, *fpdc3, 2fpdcin*, repeat * to * 2 more times, hdc1, fpdc2, 2fpdcin, repeat * to * 2 more times, sl st in first fpdc. (30)

RND 6: Ch2, fpdc2, bpdc1, fpdc1, 2fpdcin, *fpdc4, 2fpdcin*, fpdc2, bpdc1, fpdc1, 2fpdcin, hdc1, fpdc3, 2fpdcin, repeat * to * 2 more times, sl st in first fpdc. (36)

RND 7: Ch2, fpdc2, bpdc2, fpdc1, 2fpdcin, *fpdc5, 2fpdcin*, fpdc2, bpdc2, fpdc1, 2fpdcin, hdc1, fpdc4, 2fpdcin, repeat * to * 2 more times, sl st in first fpdc. (42)

RND 8: Ch2, fpdc2, bpdc2, skip 3, fptr3, fptr3 in the skipped stitches behind the previous stitches, skip 3, fptr3, fptr3 in the skipped stitches in front of the previous stitches, bpdc2, fpdc3, hdc1, fpdc20, sl st in first fpdc. (42)

RNDS 9 AND 10: Ch2, fpdc2, bpdc2, fpdc12, bpdc2, fpdc3, hdc1, fpdc20, sl st in first fpdc. (42)

RNDS 11-26: Repeat Rnds 8-10, ending with Rnd 8. (42)

You can customize the mitten by adding more or fewer repeats of the 3 rounds above. This part should cover the fingers and hand, down to the start of the thumb. Make sure to leave a little bit of room above the fingers for free movement.

RND 27: Ch2, fpdc2, bpdc2, fpdc12, bpdc2, fpdc3, ch13, skip 1 hdc, fpdc20, sl st in first fpdc. (54) See photo 1 on page 19.

RND 28: Ch2, fpdc2, bpdc2, fpdc12, bpdc2, fpdc3, dc6, hdc1, dc6, fpdc20, sl st in first fpdc. (54) See photo 2 on page 19.

RND 29: Ch2, fpdc2, bpdc2, skip 3, fptr3, fptr3 in the skipped stitches behind the previous stitches, skip 3, fptr3, fptr3 in the skipped stitches in front of the previous stitches, bpdc2, fpdc7, fpdc2tog, hdc1, fpdc2tog, fpdc24, sl st in first fpdc. (52)

RND 30: Ch2, fpdc2, bpdc2, fpdc12, bpdc2, fpdc6, fpdc2tog, hdc1, fpdc2tog, fpdc23, sl st in first fpdc. (50)

RND 31: Ch2, fpdc2, bpdc2, fpdc12, bpdc2, fpdc5, fpdc2tog, hdc1, fpdc2tog, fpdc22, sl st in first fpdc. (48)

RND 32: Ch2, fpdc2, bpdc2, skip3, fptr3, fptr3 in the skipped stitches behind the previous stitches, skip 3, fptr3, fptr3 in the skipped stitches in front of the previous stitches, bpdc2, fpdc4, fpdc2tog, hdc1, fpdc2tog, fpdc21, sl st in first fpdc. (46)

RND 33: Ch2, fpdc2, bpdc2, fpdc12, bpdc2, fpdc3, fpdc2tog, hdc1, fpdc2tog, fpdc20, sl st in first fpdc. (44)

RND 34: Ch2, fpdc2, bpdc2, fpdc12, bpdc2, fpdc2, fpdc2tog, hdc1, fpdc2tog, fpdc19, sl st in first fpdc. (42)

RND 35: Ch2, fpdc2, bpdc2, skip3, fptr3, fptr3 in the skipped stitches behind the previous stitches, skip 3, fptr3, fptr3 in the skipped

stitches in front of the previous stitches, bpdc2, fpdc1, fpdc2tog, hdc1, fpdc2tog, fpdc18, sl st in first fpdc. (40)

RND 36: Ch2, fpdc2, bpdc2, fpdc12, bpdc2, fpdc2tog, hdc1, fpdc2tog, fpdc17, sl st in first fpdc. (38)

RNDS 37–42: Ch2, *fpdc1, bpdc1*, repeat around, sl st in first fpdc. (38)

If you like to have a longer or fold-over cuff, you can repeat the round above for as long as you like. Cut yarn, fasten off, and weave in ends.

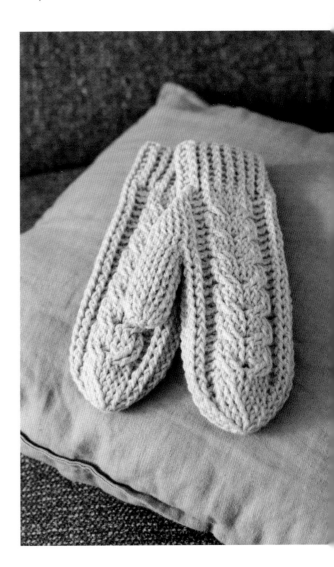

RIGHT MITTEN

RND 1: Start with a magic loop, ch2 (first ch2 doesn't count as first dc throughout the pattern), 6dc in the loop, sl st in first dc. (6)

RND 2: Ch2, 2fpdc in each stitch around, sl st in first fpdc. (12)

RND 3: Ch2, *fpdc1, 2fpdcin*, repeat * to * 1 more time, fpdc1, in next stitch: 1fpdc and 1hdc, repeat * to * 3 more times, sl st in first fpdc. (18)

RND 4: Ch2, *fpdc2, 2fpdcin*, repeat * to * 1 more time, fpdc1, 2fpdcin, hdc1, repeat * to * 3 more times, sl st in first fpdc. (24)

RND 5: Ch2, *fpdc3, 2fpdcin*, repeat * to * 1 more time, fpdc2, 2fpdcin, hdc1, repeat * to * 3 more times, sl st in first fpdc. (30)

RND 6: Ch2, *fpdc4, 2fpdcin*, repeat * to * 1 more time, fpdc3, 2fpdcin, hdc1, fpdc3, bpdc1, 2fpdcin, fpdc4, 2fpdcin, fpdc3, bpdc1, 2fpdcin, sl st in first fpdc. (36)

RND 7: Ch2, *fpdc5, 2fpdcin*, repeat * to * 1 more time, fpdc4, 2fpdcin, hdc1, fpdc3, bpdc2, 2fpdcin, fpdc5, 2fpdcin, fpdc3, bpdc2, 2fpdcin, sl st in first fpdc. (42)

RND 8: Ch2, fpdc20, hdc1, fpdc3, bpdc2, skip 3, fptr3, fptr3 in the skipped stitches behind the previous stitches, skip 3, fptr3, fptr3 in the skipped stitches in front of the previous stitches, bpdc2, fpdc2, sl st in first fpdc. (42)

RNDS 9 AND 10: Ch2, fpdc20, hdc1, fpdc3, bpdc2, fpdc12, bpdc2, fpdc2, sl st in first fpdc. (42)

RNDS 11-26: Repeat Rnds 8-10, ending with Rnd 8. (42)

You can customize the mitten by adding more or fewer repeats of the 3 rounds above. This part should cover the fingers and hand, down to the start of the thumb. Make sure to leave a little bit of room above the fingers for free movement.

RND 27: Ch2, fpdc20, ch13, skip 1 hdc, fpdc3, bpdc2, fpdc12, bpdc2, fpdc2, sl st in first fpdc. (54) See photo 1 on page 19.

RND 28: Ch2, fpdc20, dc6, hdc1, dc6, fpdc3, bpdc2, fpdc12, bpdc2, fpdc2, sl st in first fpdc. (54) See photo 2 on page 19.

RND 29: Ch2, fpdc24, fpdc2tog, hdc1, fpdc2tog, fpdc7, bpdc2, skip 3, fptr3, fptr3 in the skipped stitches behind the previous stitches, skip 3, fptr3, fptr3 in the skipped stitches in front of the previous stitches, bpdc2, fpdc2, sl st in first fpdc. (52)

RND 30: Ch2, fpdc23, fpdc2tog, hdc1, fpdc2tog, fpdc6, bpdc2, fpdc12, bpdc2, fpdc2, sl st in first fpdc. (50)

RND 31: Ch2, fpdc22, fpdc2tog, hdc1, fpdc2tog, fpdc5, bpdc2, fpdc12, bpdc2, fpdc2, sl st in first fpdc. (48)

RND 32: Ch2, fpdc21, fpdc2tog, hdc1, fpdc2tog, fpdc4, bpdc2, skip3, fptr3, fptr3 in the skipped stitches behind the previous stitches, skip 3, fptr3, fptr3 in the skipped stitches in front of the previous stitches, bpdc2, fpdc2, sl st in first fpdc. (46)

RND 33: Ch2, fpdc20, fpdc2tog, hdc1, fpdc2tog, fpdc3, bpdc2, fpdc12, bpdc2, fpdc2, sl st in first fpdc. (44)

RND 34: Ch2, fpdc19, fpdc2tog, hdc1, fpdc2tog, fpdc2, bpdc2, fpdc12, bpdc2, fpdc2, sl st in first fpdc. (42)

RND 35: Ch2, fpdc18, fpdc2tog, hdc1, fpdc2tog, fpdc1, bpdc2, skip3, fptr3, fptr3 in the skipped stitches behind the previous stitches, skip 3, fptr3, fptr3 in the skipped stitches in front of the previous stitches, bpdc2, fpdc2, sl st in first fpdc. (40)

RND 36: Ch2, fpdc17, fpdc2tog, hdc1, fpdc2tog, bpdc2, fpdc12, bpdc2, fpdc2, sl st in first fpdc. (38)

RND 37–42: Ch2, *bpdc1, fpdc1*, repeat around, sl st in first bpdc. (38)

If you like to have a longer or fold-over cuff, you can repeat the round above for as long as you like. Cut yarn, fasten off, and weave in ends.

THUMBS

RND 1: Attach the yarn with a sl st in the ch of Rnd 27 above the hdc of Rnd 28, ch2, fpdc6, sc1 in the side of the dc of Rnd 27, sc1 before the hdc of Rnd 26, sc1 after the hdc of Rnd 26, sc1 in the side of the dc of Rnd 27, fpdc6, sl st in first fpdc. (16) See photos 3–10 on page 19.

RND 2: Ch2, fpdc6, dc4, fpdc6, sl st in first fpdc. (16)

RNDS 3–10: Ch2, fpdc16, sl st in first fpdc. (16)

RND 11: Ch2, *fpdc2tog*, repeat around, sl st in first fpdc. (8)

Cut yarn, weave through the loops of the remaining stitches, pull tight, fasten off, and weave in ends.

11

10

9

←——————————————— left mitten

right mitten ——————————————→

SIZE: MEDIUM

· ·

LEFT MITTEN

RND 1: Start with a magic loop, ch2 (first ch2 doesn't count as first dc throughout the pattern), 6dc in the loop, sl st in first dc. (6)

RND 2: Ch2, 2fpdc in each stitch around, sl st in first fpdc. (12)

RND 3: Ch2, *fpdc1, 2fpdcin*, repeat * to * 2 more times, hdc1, 2fpdcin, repeat * to * 2 more times, sl st in first fpdc. (18)

RND 4: Ch2, *fpdc2, 2fpdcin*, repeat * to * 2 more times, hdc1, fpdc1, 2fpdcin, repeat * to * 2 more times, sl st in first fpdc. (24)

RND 5: Ch2, *fpdc3, 2fpdcin*, repeat * to * 2 more times, hdc1, fpdc2, 2fpdcin, repeat * to * 2 more times, sl st in first fpdc. (30)

RND 6: Ch2, fpdc3, bpdc1, 2fpdcin, *fpdc4, 2fpdcin*, fpdc2, bpdc1, fpdc1, 2fpdcin, hdc1, fpdc3, 2fpdcin, repeat * to * 2 more times, sl st in first fpdc. (36)

RND 7: Ch2, fpdc3, bpdc2, 2fpdcin, *fpdc5, 2fpdcin*, fpdc2, bpdc2, fpdc1, 2fpdcin, hdc1, fpdc4, 2fpdcin, repeat * to * 2 more times, sl st in first fpdc. (42)

RND 8: Ch2, fpdc3, bpdc3, 2fpdcin, *fpdc6, 2fpdcin*, fpdc2, bpdc3, fpdc1, 2fpdcin, hdc1, fpdc5, 2fpdcin, repeat * to * 2 more times, sl st in first fpdc. (48)

RND 9: Ch2, fpdc3, bpdc3, skip 3, fptr3, fptr3 in the skipped stitches behind the previous stitches, skip 3, fptr3, fptr3 in the skipped stitches in front of the previous stitches, bpdc3, fpdc3, hdc1, fpdc23, sl st in first fpdc. (48)

RNDS 10 AND 11: Ch2, fpdc3, bpdc3, fpdc12, bpdc3, fpdc3, hdc1, fpdc23, sl st in first fpdc. (48)

RNDS 12-30: Repeat Rnds 9-11, ending with Rnd 9. (48)

You can customize the mitten by adding more or fewer repeats of the 3 rounds above. This part should cover the fingers and hand, down to the start of the thumb. Make sure to leave a little bit of room above the fingers for free movement.

RND 31: Ch2, fpdc3, bpdc3, fpdc12, bpdc3, fpdc3, ch15, skip 1 hdc, fpdc23, sl st in first fpdc. (62) See photo 1 on page 19.

RND 32: Ch2, fpdc3, bpdc3, fpdc12, bpdc3, fpdc3, dc7, hdc1, dc7, fpdc23, sl st in first fpdc. (62) See photo 2 on page 19.

RND 33: Ch2, fpdc3, bpdc3, skip 3, fptr3, fptr3 in the skipped stitches behind the previous stitches, skip 3, fptr3, fptr3 in the skipped stitches in front of the previous stitches, bpdc3, fpdc8, fpdc2tog, hdc1, fpdc2tog, fpdc28, sl st in first fpdc. (60)

RND 34: Ch2, fpdc3, bpdc3, fpdc12, bpdc3, fpdc7, fpdc2tog, hdc1, fpdc2tog, fpdc27, sl st in first fpdc. (58)

RND 35: Ch2, fpdc3, bpdc3, fpdc12, bpdc3, fpdc6, fpdc2tog, hdc1, fpdc2tog, fpdc26, sl st in first fpdc. (56)

RND 36: Ch2, fpdc3, bpdc3, skip 3, fptr3, fptr3 in the skipped stitches behind the previous stitches, skip 3, fptr3, fptr3 in the skipped stitches in front of the previous stitches, bpdc3, fpdc5, fpdc2tog, hdc1, fpdc2tog, fpdc25, sl st in first fpdc. (54)

RND 37: Ch2, fpdc3, bpdc3, fpdc12, bpdc3, fpdc4, fpdc2tog, hdc1, fpdc2tog, fpdc24, sl st in first fpdc. (52)

RND 38: Ch2, fpdc3, bpdc3, fpdc12, bpdc3, fpdc3, fpdc2tog, hdc1, fpdc2tog, fpdc23, sl st in first fpdc. (50)

RND 39: Ch2, fpdc3, bpdc3, skip 3, fptr3, fptr3 in the skipped stitches behind the previous stitches, skip 3, fptr3, fptr3 in the skipped stitches in front of the previous stitches, bpdc3, fpdc2, fpdc2tog, hdc1, fpdc2tog, fpdc22, sl st in first fpdc. (48)

RND 40: Ch2, fpdc3, bpdc3, fpdc12, bpdc3, fpdc1, fpdc2tog, hdc1, fpdc2tog, fpdc21, sl st in first fpdc. (46)

RND 41: Ch2, fpdc3, bpdc3, fpdc12, bpdc3, fpdc2tog, hdc1, fpdc2tog, fpdc20, sl st in first fpdc. (44)

RNDS 42-48: Ch2, *fpdc1, bpdc1*, repeat around, sl st in first fpdc. (44)

If you like to have a longer or fold-over cuff, you can repeat the round above for as long as you like. Cut yarn, fasten off, and weave in ends.

RIGHT MITTEN

RND 1: Start with a magic loop, ch2 (first ch2 doesn't count as first dc throughout the pattern), 6dc in the loop, sl st in first dc. (6)

RND 2: Ch2, 2fpdc in each stitch around, sl st in first fpdc. (12)

RND 3: Ch2, *fpdc1, 2fpdcin*, repeat * to * 1 more time, fpdc1, in next stitch: 1fpdc and 1hdc, repeat * to * 3 more times, sl st in first fpdc. (18)

RND 4: Ch2, *fpdc2, 2fpdcin*, repeat * to * 1 more time, fpdc1, 2fpdcin, hdc1, repeat * to * 3 more times, sl st in first fpdc. (24)

RND 5: Ch2, *fpdc3, 2fpdcin*, repeat * to * 1 more time, fpdc2, 2fpdcin, hdc1, repeat * to * 3 more times, sl st in first fpdc. (30)

RND 6: Ch2, *fpdc4, 2fpdcin*, repeat * to * 1 more time, fpdc3, 2fpdcin, hdc1, fpdc3, bpdc1, 2fpdcin, fpdc4, 2fpdcin, fpdc2, bpdc1, fpdc1, 2fpdcin, sl st in first fpdc. (36)

RND 7: Ch2, *fpdc5, 2fpdcin*, repeat * to * 1 more time, fpdc4, 2fpdcin, hdc1, fpdc3, bpdc2, 2fpdcin, fpdc5, 2fpdcin, fpdc2, bpdc2, fpdc1, 2fpdcin, sl st in first fpdc. (42)

RND 8: Ch2, *fpdc6, 2fpdcin*, repeat * to * 1 more time, fpdc5, 2fpdcin, hdc1, fpdc3, bpdc3, 2fpdcin, fpdc6, 2fpdcin, fpdc2, bpdc3, fpdc1, 2fpdcin, sl st in first fpdc. (48)

RND 9: Ch2, fpdc23, hdc1, fpdc3, bpdc3, skip 3, fptr3, fptr3 in the skipped stitches behind the previous stitches, skip 3, fptr3, fptr3 in the skipped stitches in front of the previous stitches, bpdc3, fpdc3, sl st in first fpdc. (48)

RNDS 10 AND 11: Ch2, fpdc23, hdc1, fpdc3, bpdc3, fpdc12, bpdc3, fpdc3, sl st in first fpdc. (48)

RNDS 12–30: Repeat Rnds 9–11, ending with Rnd 9. (48)

You can customize the mitten by adding more or fewer repeats of the 3 rounds above. This part should cover the fingers and hand, down to the start of the thumb. Make sure to leave a little bit of room above the fingers for free movement.

RND 31: Ch2, fpdc23, ch15, skip 1 hdc, fpdc3, bpdc3, fpdc12, bpdc3, fpdc3, sl st in first fpdc. (62) See photo 1 on page 19.

RND 32: Ch2, fpdc23, dc7, hdc1, dc7, fpdc3, bpdc3, fpdc12, bpdc3, fpdc3, sl st in first fpdc. (62) See photo 2 on page 19.

RND 33: Ch2, fpdc28, fpdc2tog, hdc1, fpdc2tog, fpdc8, bpdc3, skip 3, fptr3, fptr3 in the skipped stitches behind the previous stitches, skip 3, fptr3, fptr3 in the skipped stitches in front of the previous stitches, bpdc3, fpdc3, sl st in first fpdc. (60)

RND 34: Ch2, fpdc27, fpdc2tog, hdc1, fpdc2tog, fpdc7, bpdc3, fpdc12, bpdc3, fpdc3, sl st in first fpdc. (58)

RND 35: Ch2, fpdc26, fpdc2tog, hdc1, fpdc2tog, fpdc6, bpdc3, fpdc12, bpdc3, fpdc3, sl st in first fpdc. (56)

RND 36: Ch2, fpdc25, fpdc2tog, hdc1, fpdc2tog, fpdc5, bpdc3, skip 3, fptr3, fptr3 in the skipped stitches behind the previous stitches, skip 3, fptr3, fptr3 in the skipped stitches in front of the previous stitches, bpdc3, fpdc3, sl st in first fpdc. (54)

RND 37: Ch2, fpdc24, fpdc2tog, hdc1, fpdc2tog, fpdc4, bpdc3, fpdc12, bpdc3, fpdc3, sl st in first fpdc. (52)

RND 38: Ch2, fpdc23, fpdc2tog, hdc1, fpdc2tog, fpdc3, bpdc3, fpdc12, bpdc3, fpdc3, sl st in first fpdc. (50)

RND 39: Ch2, fpdc22, fpdc2tog, hdc1, fpdc2tog, fpdc2, bpdc3, skip 3, fptr3, fptr3 in the skipped stitches behind the previous stitches, skip 3, fptr3, fptr3 in the skipped stitches in front of the previous stitches, bpdc3, fpdc3, sl st in first fpdc. (48)

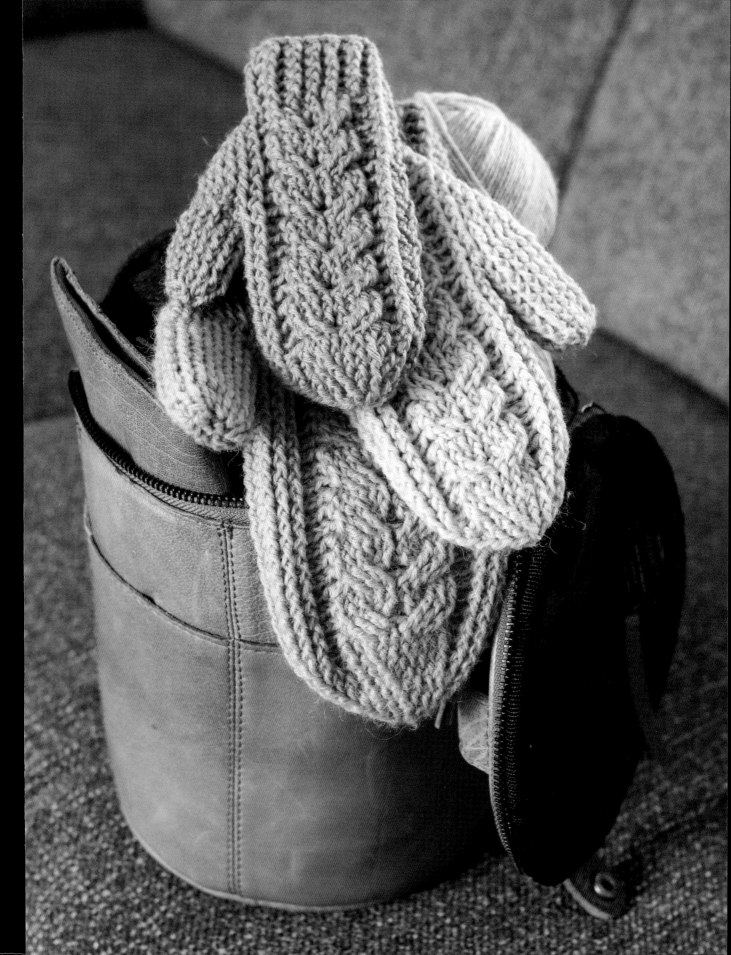

RND 40: Ch2, fpdc21, fpdc2tog, hdc1, fpdc2tog, fpdc1, bpdc3, fpdc12, bpdc3, fpdc3, sl st in first fpdc. (46)

RND 41: Ch2, fpdc20, fpdc2tog, hdc1, fpdc2tog, bpdc3, fpdc12, bpdc3, fpdc3, sl st in first fpdc. (44)

RNDS 42–48: Ch2, *bpdc1, fpdc1*, repeat around, sl st in first bpdc. (44)

If you like to have a longer or fold-over cuff, you can repeat the round above for as long as you like. Cut yarn, fasten off, and weave in ends.

THUMBS

RND 1: Attach the yarn with a sl st in the ch of Rnd 31 above the hdc of Rnd 32, ch2, fpdc7, sc1 in the side of the dc of Rnd 31, sc1 before the hdc of Rnd 30, sc1 after the hdc of Rnd 30, sc1 in the side of the dc of Rnd 31, fpdc7, sl st in first fpdc. (18) See photos 3–10 on page 19.

RND 2: Ch2, fpdc7, dc4, fpdc7, sl st in first fpdc. (18)

RNDS 3–11: Ch2, fpdc18, sl st in first fpdc. (18)

RND 12: Ch2, *fpdc2tog*, repeat around, sl st in first fpdc. (9)

Cut yarn, weave through the loops of the remaining stitches, pull tight, fasten off, and weave in ends.

SIZE: LARGE

LEFT MITTEN

RND 1: Start with a magic loop, ch2 (first ch2 doesn't count as first dc throughout the pattern), 6dc in the loop, sl st in first dc. (6)

RND 2: Ch2, 2fpdc in each stitch around, sl st in first fpdc. (12)

RND 3: Ch2, *fpdc1, 2fpdcin*, repeat * to * 2 more times, hdc1, 2fpdcin, repeat * to * 2 more times, sl st in first fpdc. (18)

RND 4: Ch2, *fpdc2, 2fpdcin*, repeat * to * 2 more times, hdc1, fpdc1, 2fpdcin, repeat * to * 2 more times, sl st in first fpdc. (24)

RND 5: Ch2, *fpdc3, 2fpdcin*, repeat * to * 2 more times, hdc1, fpdc2, 2fpdcin, repeat * to * 2 more times, sl st in first fpdc. (30)

RND 6: Ch2, *fpdc4, 2fpdcin*, repeat * to * 2 more times, hdc1, fpdc3, 2fpdcin, repeat * to * 2 more times, sl st in first fpdc. (36)

RND 7: Ch2, fpdc3, bpdc1, fpdc1, 2fpdcin, *fpdc5, 2fpdcin*, fpdc1, bpdc1, fpdc3, 2fpdcin, hdc1, fpdc4, 2fpdcin, repeat * to * 2 more times, sl st in first fpdc. (42)

RND 8: Ch2, fpdc3, bpdc2, fpdc1, 2fpdcin, *fpdc6, 2fpdcin*, fpdc1, bpdc2, fpdc3, 2fpdcin, hdc1, fpdc5, 2fpdcin, repeat * to * 2 more times, sl st in first fpdc. (48)

RND 9: Ch2, fpdc3, bpdc3, fpdc1, 2fpdcin, *fpdc7, 2fpdcin*, fpdc1, bpdc3, fpdc3, 2fpdcin, hdc1, fpdc6, 2fpdcin, repeat * to * 2 more times, sl st in first fpdc. (54)

RND 10: Ch2, fpdc3, bpdc4, skip 3, fptr3, fptr3 in the skipped

12

11

10

left mitten

right mitten

stitches behind the previous
stitches, skip 3, fptr3, fptr3 in
the skipped stitches in front of the
previous stitches, bpdc4, fpdc4,
hdc1, fpdc26, sl st in first fpdc.
(54)

RNDS 11 AND 12: Ch2, fpdc3, bpdc4,
fpdc12, bpdc4, fpdc4, hdc1, fpdc26,
sl st in first fpdc. (54)

RNDS 13–34: Repeat Rnds 10–12, ending
with Rnd 10. (54)

You can customize the mitten by adding
more or fewer repeats of the 3 rounds
above. This part should cover the
fingers and hand, down to the start of
the thumb. Make sure to leave a little
bit of room above the fingers for free
movement.

RND 35: Ch2, fpdc3, bpdc4, fpdc12,
bpdc4, fpdc4, ch17, skip 1 hdc,
fpdc26, sl st in first fpdc. (70)
See photo 1 on page 19.

RND 36: Ch2, fpdc3, bpdc4, fpdc12,
bpdc4, fpdc4, dc8, hdc1, dc8,
fpdc26, sl st in first fpdc. (70)
See photo 2 on page 19.

RND 37: Ch2, fpdc3, bpdc4, skip 3,
fptr3, fptr3 in the skipped

stitches behind the previous
stitches, skip 3, fptr3, fptr3 in
the skipped stitches in front of the
previous stitches, bpdc4, fpdc10,
fpdc2tog, hdc1, fpdc2tog, fpdc32,
sl st in first fpdc. (68)

RND 38: Ch2, fpdc3, bpdc4, fpdc12,
bpdc4, fpdc9, fpdc2tog, hdc1,
fpdc2tog, fpdc31, sl st in first
fpdc. (66)

RND 39: Ch2, fpdc3, bpdc4, fpdc12,
bpdc4, fpdc8, fpdc2tog, hdc1,
fpdc2tog, fpdc30, sl st in first
fpdc. (64)

RND 40: Ch2, fpdc3, bpdc4, skip 3,
fptr3, fptr3 in the skipped
stitches behind the previous
stitches, skip 3, fptr3, fptr3 in
the skipped stitches in front of the
previous stitches, bpdc4, fpdc7,
fpdc2tog, hdc1, fpdc2tog, fpdc29,
sl st in first fpdc. (62)

RND 41: Ch2, fpdc3, bpdc4, fpdc12,
bpdc4, fpdc6, fpdc2tog, hdc1,
fpdc2tog, fpdc28, sl st in first
fpdc. (60)

RND 42: Ch2, fpdc3, bpdc4, fpdc12,
bpdc4, fpdc5, fpdc2tog, hdc1,
fpdc2tog, fpdc27, sl st in first
fpdc. (58)

RND 43: Ch2, fpdc3, bpdc4, skip 3, fptr3, fptr3 in the skipped stitches behind the previous stitches, skip 3, fptr3, fptr3 in the skipped stitches in front of the previous stitches, bpdc4, fpdc4, fpdc2tog, hdc1, fpdc2tog, fpdc26, sl st in first fpdc. (56)

RND 44: Ch2, fpdc3, bpdc4, fpdc12, bpdc4, fpdc3, fpdc2tog, hdc1, fpdc2tog, fpdc25, sl st in first fpdc. (54)

RND 45: Ch2, fpdc3, bpdc4, fpdc12, bpdc4, fpdc2, fpdc2tog, hdc1, fpdc2tog, fpdc24, sl st in first fpdc. (52)

RND 46: Ch2, fpdc3, bpdc4, fpdc12, bpdc4, fpdc1, fpdc2tog, hdc1, fpdc2tog, fpdc23, sl st in first fpdc. (50)

RNDS 47-53: Ch2, *fpdc1, bpdc1*, repeat around, sl st in first fpdc. (50)

If you like to have a longer or fold-over cuff, you can repeat the round above for as long as you like. Cut yarn, fasten off, and weave in ends.

RIGHT MITTEN

RND 1: Start with a magic loop, ch2 (first ch2 doesn't count as first dc throughout the pattern), 6dc in the loop, sl st in first dc. (6)

RND 2: Ch2, 2fpdc in each stitch around, sl st in first fpdc. (12)

RND 3: Ch2, *fpdc1, 2fpdcin*, repeat * to * 1 more time, fpdc1, in next stitch: 1fpdc and 1hdc, repeat * to * 3 more times, sl st in first fpdc. (18)

RND 4: Ch2, *fpdc2, 2fpdcin*, repeat * to * 1 more time, fpdc1, 2fpdcin,

hdc1, repeat * to * 3 more times, sl st in first fpdc. (24)

RND 5: Ch2, *fpdc3, 2fpdcin*, repeat * to * 1 more time, fpdc2, 2fpdcin, hdc1, repeat * to * 3 more times, sl st in first fpdc. (30)

RND 6: Ch2, *fpdc4, 2fpdcin*, repeat * to * 1 more time, fpdc3, 2fpdcin, hdc1, repeat * to * 3 more times, sl st in first fpdc. (36)

RND 7: Ch2,*fpdc5, 2fpdcin*, repeat * to * 1 more time, fpdc4, 2fpdcin, hdc1, fpdc4, bpdc1, 2fpdcin, fpdc5, 2fpdcin, fpdc2, bpdc1, fpdc2, 2fpdcin, sl st in first fpdc. (42)

RND 8: Ch2,*fpdc6, 2fpdcin*, repeat * to * 1 more time, fpdc5, 2fpdcin, hdc1, fpdc4, bpdc2, 2fpdcin, fpdc6, 2fpdcin, fpdc2, bpdc2, fpdc2, 2fpdcin, sl st in first fpdc. (48)

RND 9: Ch2, *fpdc7, 2fpdcin*, repeat * to * 1 more time, fpdc6, 2fpdcin, hdc1, fpdc4, bpdc3, 2fpdcin, fpdc7, 2fpdcin, fpdc2, bpdc3, fpdc2, 2fpdcin, sl st in first fpdc. (54)

RND 10: Ch2, fpdc26, hdc1, fpdc4, bpdc4, skip 3, fptr3, fptr3 in the skipped stitches behind the previous stitches, skip 3, fptr3, fptr3 in the skipped stitches in front of the previous stitches, bpdc4, fpdc3, sl st in first fpdc. (54)

RNDS 11 AND 12: Ch2, fpdc26, hdc1, fpdc4, bpdc4, fpdc12, bpdc4, fpdc3, sl st in first fpdc. (54)

RNDS 13-34: Repeat Rnds 10-12, ending with Rnd 10. (54)

You can customize the mitten by adding more or fewer repeats of the 3 rounds above. This part should cover the fingers and hand, down to the start of the thumb. Make sure to leave a little bit of room above the fingers for free movement.

RND 35: Ch2, fpdc26, ch17, skip 1 hdc, fpdc4, bpdc4, fpdc12, bpdc4, fpdc3, sl st in first fpdc. (70) See photo 1 on page 19.

RND 36: Ch2, fpdc26, dc8, hdc1, dc8, fpdc4, bpdc4, fpdc12, bpdc4, fpdc3, sl st in first fpdc. (70) See photo 2 on page 19.

RND 37: Ch2, fpdc32, fpdc2tog, hdc1, fpdc2tog, fpdc10, bpdc4, skip 3, fptr3, fptr3 in the skipped stitches behind the previous stitches, skip 3, fptr3, fptr3 in the skipped stitches in front of the previous stitches, bpdc4, fpdc3, sl st in first fpdc. (68)

RND 38: Ch2, fpdc31, fpdc2tog, hdc1, fpdc2tog, fpdc9, bpdc4, fpdc12, bpdc4, fpdc3, sl st in first fpdc. (66)

RND 39: Ch2, fpdc30, fpdc2tog, hdc1, fpdc2tog, fpdc8, bpdc4, fpdc12, bpdc4, fpdc3, sl st in first fpdc. (64)

RND 40: Ch2, fpdc29, fpdc2tog, hdc1, fpdc2tog, fpdc7, bpdc4, skip 3, fptr3, fptr3 in the skipped stitches behind the previous stitches, skip 3, fptr3, fptr3 in the skipped stitches in front of the previous stitches, bpdc4, fpdc3, sl st in first fpdc. (62)

RND 41: Ch2, fpdc28, fpdc2tog, hdc1, fpdc2tog, fpdc6, bpdc4, fpdc12, bpdc4, fpdc3, sl st in first fpdc. (60)

RND 42: Ch2, fpdc27, fpdc2tog, hdc1, fpdc2tog, fpdc5, bpdc4, fpdc12, bpdc4, fpdc3, sl st in first fpdc. (58)

RND 43: Ch2, fpdc26, fpdc2tog, hdc1, fpdc2tog, fpdc4, bpdc4, skip 3, fptr3, fptr3 in the skipped stitches behind the previous stitches, skip 3, fptr3, fptr3 in the skipped stitches in front of the previous stitches, bpdc4, fpdc3, sl st in first fpdc. (56)

RND 44: Ch2, fpdc25, fpdc2tog, hdc1, fpdc2tog, fpdc3, bpdc4, fpdc12, bpdc4, fpdc3, sl st in first fpdc. (54)

RND 45: Ch2, fpdc24, fpdc2tog, hdc1, fpdc2tog, fpdc2, bpdc4, fpdc12, bpdc4, fpdc3, sl st in first fpdc. (52)

RND 46: Ch2, fpdc23, fpdc2tog, hdc1, fpdc2tog, fpdc1, bpdc4, fpdc12, bpdc4, fpdc3, sl st in first fpdc. (50)

RNDS 47–53: Ch2, *bpdc1, fpdc1*, repeat around, sl st in first bpdc. (50)

If you like to have a longer or fold-over cuff, you can repeat the round above for as long as you like. Cut yarn, fasten off, and weave in ends.

THUMBS

RND 1: Attach the yarn with a sl st in the ch of Rnd 35 above the hdc of Rnd 36, ch2, fpdc8, sc1 in the side of the dc of Rnd 35, sc1 before the hdc of Rnd 34, sc1 after the hdc of Rnd 34, sc1 in the side of the dc of Rnd 35, fpdc8, sl st in first fpdc. (20) See photos 3–10 on page 19.

RND 2: Ch2, fpdc8, dc4, fpdc8, sl st in first fpdc. (20)

RNDS 3–12: Ch2, fpdc20, sl st in first fpdc. (20)

RND 13: Ch2, *fpdc2tog*, repeat around, sl st in first fpdc. (10)

Cut yarn, weave through the loops of the remaining stitches, pull tight, fasten off, and weave in ends.

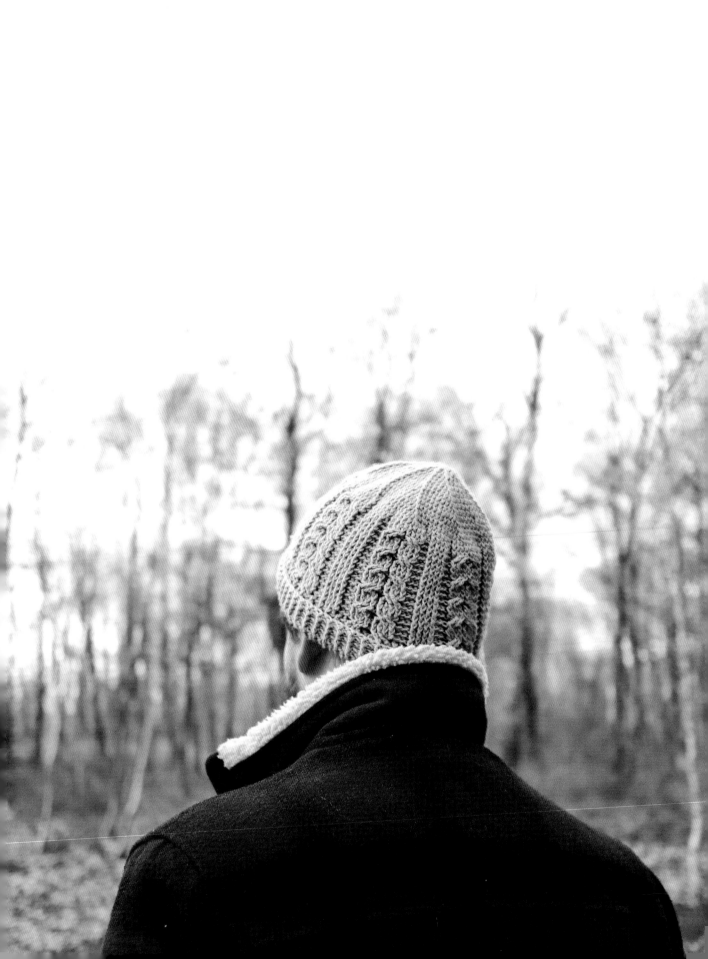

Skill Level: 4 of 5

CELTIC CABLE HAT

MATERIALS

Yarn
Fingering weight sock yarn. Samples
shown in:

Gray
Durable Soqs; 75% superwash wool,
25% polyamide; 1.7 oz/230 yd (50 g/210
m); #2234 Charcoal

Green
Durable Soqs; 75% superwash wool,
25% polyamide; 1.7 oz/230 yd (50 g/210
m); #2133 Dark

Crochet Hook
US size G-6 (4 mm)

Estimate of Yarn Required

0–6 months	230 yd (210 m)
6–12 months	230 yd (210 m)
1–3 years	460 yd (420 m)
4 years–teen	460 yd (420 m)
Medium	460 yd (420 m)
Large	690 yd (630 m)

Size and Gauge
For help choosing a size and matching
gauge, refer to Size and Gauge on
pages 12–13.

ABBREVIATIONS

⬯	**ch**	chain
✕	**sc**	single crochet
⬤	**sl st**	slip stitch
⊤	**dc**	double crochet
	fpdc	front post double crochet
	bpdc	back post double crochet
	fpdc2tog	fpdc 2 together
	2fpdcin	2 fpdc in next stitch

PATTERN

. .

RND 1: Start with a magic loop, ch2 (first ch2 doesn't count as first dc throughout the pattern), 8dc in the loop, sl st in first dc. (8)

RND 2: Ch2, 2fpdc in each stitch around, sl st in first fpdc. (16)

RND 3: Ch2, *fpdc1, 2fpdcin*, repeat * to * around, sl st in first fpdc. (24)

RND 4: Ch2, *fpdc1 in each fpdc to the second fpdc of the 2fpdcin of previous row, 2fpdcin*, repeat * to * around, sl st in first fpdc. (8 increases after each round)

Repeat Rnd 4 until your piece has a diameter (or as close as possible to) as below in the chart, but make sure to end with an even number of rows.

0-6 months ——————— 4.13 in (10.5 cm)
6-12 months ——————— 5 in (12.5 cm)
1-3 years ——————— 5.5 in (14 cm)
4 years-teen ——————— 5.75 in (14.6 cm)
Medium ——————— 6.25 in (16 cm)
Large ——————— 6.75 in (17 cm)

START CABLE

RND 5: Ch2, *fpdc1, bpdc1, fpdc8, bpdc1, fpdc5*, repeat * to * to end, sl st in first fpdc. (no increases)

RND 6: Ch2 *bpdc2, skip 2, fptr2, fptr2 in the skipped stitches behind the previous stitches, skip 2, fptr2, fptr2 in the skipped stitches in front of the previous stitches, bpdc2, fpdc4*, repeat * to * to end, sl st in first bpdc. (no increases)

RNDS 7 AND 8: Ch2, *bpdc2, fpdc8, bpdc2, fpdc4*, repeat * to * to end, sl st in first bpdc. (no increases)

Repeat Rnds 6-8 until your piece has a length of (or as close as possible to) as below in the chart, but make sure to end with Rnd 7.

0-6 months ——————— 4.25 in (10.8 cm)
6-12 months ——————— 5.5 in (14 cm)
1-3 years ——————— 6.25 in (16 cm)
4 years-teen ——————— 6.75 in (17 cm)
Medium ——————— 7.5 in (19.1 cm)
Large ——————— 7.5 in (19.1 cm)

BRIM OPTIONS (Choose one)

Single Brim

RND 9: Ch2, *fpdc1, bpdc1*, repeat around, sl st in first dc. (no increases)

Repeat Rnd 9 until your piece has a length of (or as close as possible to):

0-6 months ———— 5.25 in (13.3 cm)
6-12 months ———— 6.5 in (16.5 cm)
1-3 years ———— 7.25 in (18.5 cm)
4 years-teen ———— 7.75 in (19.5 cm)
Medium ———— 8.5 in (21.6 cm)
Large ———— 8.75 in (22.2 cm)

Cut yarn and weave in ends.

Folded Brim

Work as for the Single Brim to length indicated for size (do not cut yarn).

RND 10: Working all sts in front loop only, ch2, dc1 in each stitch around, sl st in first dc. (no increases)

RND 11: Ch2, *bpdc1, fpdc1*, repeat from * to * around, sl st in first bpdc. (no increases)

Repeat Rnd 11 until the fold-over part is the same length as the first part of the brim.

Cut yarn and weave in ends.

Skill Level: 4 of 5

CELTIC CABLE HEADBAND

MATERIALS

Yarn
Fingering weight sock yarn. Samples shown in:

Brown
Lang Yarns Jawoll; 75% wool, 25% nylon; 1.7 oz/230 yd (50 g/210 m); #83.0339

Yellow
Durable Soqs; 75% superwash wool, 25% polyamide; 1.7 oz/230 yd (50 g/210 m); #411 Mimosa

Blue
Scheepjes Metropolis; 75% extra fine Merino wool, 25% nylon; 1.7 oz/437.5 yd (100g/400 m); #012 Manila

Crochet Hook
US size G-6 (4 mm)

Estimate of Yarn Required

0–6 months	230 yd (210 m)
6–12 months	230 yd (210 m)
1–3 years	460 yd (420 m)
4 years–teen	460 yd (420 m)
Medium	460 yd (420 m)
Large	460 yd (420 m)

Size and Gauge
For help choosing a size and matching gauge, refer to Size and Gauge on pages 12–13.

ABBREVIATIONS

⬯	**ch**	chain
✕	**sc**	single crochet
⬤	**sl st**	slip stitch
⊢	**dc**	double crochet
	hdc	half double crochet
⌐	**fpdc**	front post double crochet
⌐	**bpdc**	back post double crochet
⋋	**fpdc2tog**	fpdc 2 together
⋉	**2fpdcin**	2 fpdc in next stitch

RND 1: Ch37, close the ring by making a
slip stitch in the first chain and
make sure that your chains aren't
twisted, ch2 (first ch2 doesn't
count as first dc throughout the
pattern), dc20, hdc1, dc16, sl st in
first dc. (37)

RND 2: Ch2, *fpdc3, bpdc3, fpdc8, bpdc3,
fpdc3, hdc1, fpdc16, sl st in first
fpdc. (37)

RND 3: Ch2, *fpdc3, bpdc3, skip 2, fptr2,
fptr2 in the skipped stitches behind
the previous stitches, skip 2,
fptr2, fptr2 in the skipped stitches
in front of the previous stitches,
bpdc3, fpdc3, hdc1, fpdc16, sl st in
first fpdc. (37)

RNDS 4 AND 5: Repeat Rnd 2.

Repeat Rnds 3-5 until your piece has a
length (or as close as possible to) as
below in the chart, but make sure to end
with Rnd 4 or 5.

0-6 months ———————— 12 in (30.5 cm)
6-12 months ——————— 16 in (40.5 cm)
1-3 years ————————— 17 in (43 cm)

Bind off and cut a long tail. Fold
the headband in half and sew the ends
together through both layers at once.
Keep in mind that the front and back of
the headband do not have the same number
of stitches. Make sure that the ch2, the
hdc, and the cable are aligned. You can
use stitch markers to pin these stitches
together, on both ends, while sewing.

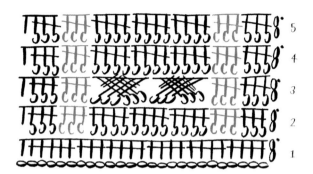

SIZES: 4 YEARS-TEEN, MEDIUM, LARGE

· ·

RND 1: Ch45, close the ring by making a slip stitch in the first chain and make sure that your chains aren't twisted, ch2 (first ch2 doesn't count as first dc throughout the pattern), dc24, hdc1, dc20, sl st in first dc. (45)

RND 2: Ch2, *fpdc3, bpdc3, fpdc12, bpdc3, fpdc3, hdc1, fpdc20, sl st in first fpdc. (45)

RND 3: Ch2, *fpdc3, bpdc3, skip 3, fptr3, fptr3 in the skipped stitches behind the previous stitches, skip 3, fptr3, fptr3 in the skipped stitches in front of the previous stitches, bpdc3, fpdc3, hdc1, fpdc20, sl st in first fpdc. (45)

RNDS 4-5: Repeat Rnd 2.

Repeat Rnds 3-5 until your piece has a length (or as close as possible to) as below in the chart, but make sure to end with Rnd 4 or 5.

4 years-teen ———— 18 in (45.5 cm)
Medium ———— 20 in (50.5 cm)
Large ———— 21 in (53 cm)

Bind off and cut a long tail. Fold the headband in half and sew the ends together through both layers at once. Keep in mind that the front and back of the headband do not have the same number of stitches. Make sure that the ch2, the hdc, and the cable are aligned. You can use stitch markers to pin these stitches together, on both ends, while sewing.

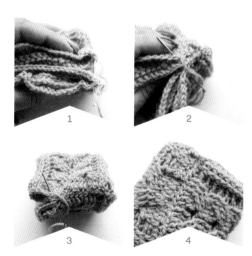

DOUBLE TWIST HEADBAND

MATERIALS

Yarn
Fingering weight sock yarn. Samples shown in:

Yellow/Rose
Lang Yarns Jawoll; 75% wool, 25% nylon; 1.7 oz/230 yd (50 g/210 m); #150 Medallion and #248 Rouge

Light Gray
Scheepjes Metropolis; 75% extra fine Merino wool, 25% nylon; 1.7 oz/437.5 yd (100g/400 m); #73 Izmir

Crochet Hook
US size G-6 (4 mm)

Estimate of Yarn Required

0–6 months	230 yd (210 m)
6–12 months	230 yd (210 m)
1–3 years	460 yd (420 m)
4 years–teen	460 yd (420 m)
Medium	460 yd (420 m)
Large	460 yd (420 m)

Size and Gauge
For help choosing a size and matching gauge, refer to Size and Gauge on pages 12–13.

ABBREVIATIONS

⬯	**ch**	chain
⬤	**sl st**	slip stitch
⊣	**dc**	double crochet
⊤	**hdc**	half double crochet
⌐⊢	**fpdc**	front post double crochet

SIZES: 0-6 MONTHS, 6-12 MONTHS,
1-3 YEARS

SIZES:
4 YEARS-TEEN, MEDIUM, LARGE

.

RND 1: Ch37, close the ring by making a
slip stitch in the first chain and
make sure that your chains aren't
twisted, ch2 (first ch2 doesn't
count as first dc throughout the
pattern), dc18, hdc1, dc18, sl st in
first dc. (37)

RND 2: Ch2, fpdc18, hdc1, fpdc18, sl st
in first fpdc. (37)

RND 1: Ch45, close the ring by making a
slip stitch in the first chain and
make sure that your chains aren't
twisted, ch2 (first ch2 doesn't
count as first dc throughout the
pattern), dc22, hdc1, dc22, sl st in
first dc. (45)

RND 2: Ch2, fpdc22, hdc1, fpdc22, sl st
in first fpdc. (45)

All Sizes

RND 3: Ch2, fpdc1 on each fpdc until the
hdc, hdc1, fpdc1 in each fpdc to
end, sl st in first fpdc.

Repeat Rnd 3 until your piece has a
length (or as close as possible to) as
below in the chart. If you want to make
a headband with two different colors,
switch colors when you reach the exact
half of the measurement below.

0-6 months ——————— 12.5 in (32 cm)
6-12 months ——————— 16.5 in (42 cm)
1-3 years ——————— 17.5 in (44.5 cm)
4 years-teen ——————— 18.5 in (47 cm)
Medium ——————— 20.5 in (52 cm)
Large ——————— 21.5 in (54.5 cm)

RND 4: Fold the end of your headband
nice and neatly with the ch2 and
hdc aligned. Work 1 sc through the
stitch after the ch2 and the stitch
before the ch2 of the previous
round. Continue working this way

and make 1 sc through each of the
opposite stitches until you reach
the hdc; you'll skip the hdc. Bind
off and cut an extra-long tail. You
will use this later to close the
headband.

RND 5: Close the other side of the head-
band in the same way as described
in Rnd 4 with a new piece of yarn in
the matching color (I used approxi-
mately 47.2 in/120 cm). Bind off and
weave in ends.

RND 4

RND 4

Finishing

1 Start by threading the remaining end through yarn needle. Fold the headband together lengthwise.

2 Now fold both ends toward the center. Twist one of the ends so they aren't facing the same direction.

3 Put the ends together and then fold them around each other.

4 Take the needle and sew the ends together like this; you will be working through all four layers at the same time. Bind off and weave in ends when you are done.

5 And now comes the best part: Turn the headband to the other side and admire your double twist!

Skill Level: 5 of 5

GRAPHIC HAT

✕ ✕ ✕ ✕ ✕

MATERIALS

Yarn
Fingering weight sock yarn. Samples shown in:

Beige
Lang Yarns Jawoll; 75% wool, 25% nylon; 1.7 oz/230 yd (50 g/210 m); #226 Bone

Green/Lilac
Durable Soqs; 75% superwash wool, 25% polyamide; 1.7 oz/230 yd (50 g/210 m); #268 Pastel Lilac and #2157 Cadmium Green

Crochet Hook
US size G-6 (4 mm)

Estimate of Yarn Required

0–6 months	230 yd (210 m)
6–12 months	230 yd (210 m)
1–3 years	460 yd (420 m)
4 years–teen	460 yd (420 m)
Medium	460 yd (420 m)
Large	690 yd (630 m)

Size and Gauge
For help choosing a size and matching gauge, refer to Size and Gauge on pages 12–13.

ABBREVIATIONS

⬯	**ch**	chain
✕	**sc**	single crochet
⬮	**sl st**	slip stitch
⊢	**dc**	double crochet
⊣	**hdc**	half double crochet
⌐⊣	**fpdc**	front post double crochet
⌐⊣	**bpdc**	back post double crochet
⋌	**2fpdcin**	2 fpdc in next stitch

PATTERN

RND 1: Start with a magic loop, ch2
(first ch2 doesn't count as first dc
throughout the pattern), 9dc in the
loop, sl st in first dc. (9)

RND 2: Ch2, 2fpdcin for each of the
first 4 stitches, hdc1, 2fpdcin for
each of the next 4 stitches, sl st
in first fpdc. (17)

RND 3: Ch2, *2fpdcin, bpdc2, 2fpdcin*,
repeat * to * once more, hdc1,
repeat * to * twice more, sl st in
first fpdc. (25)

RND 4: Ch2, *2fpdcin, fpdc1, bpdc2,
fpdc1, 2fpdcin*, repeat * to * once
more, hdc1, repeat * to * twice
more, sl st in first fpdc. (33)

RND 5: Ch2, *2fpdcin, fpdc2, bpdc2,
fpdc2, 2fpdcin*, repeat * to * once
more, hdc1, repeat * to * twice
more, sl st in first fpdc. (41)

RND 6: Ch2, *2fpdcin, bpdc1, work all
stitches as they appear (a fpdc on
each fpdc and a bpdc on each bpdc)
until 1 stitch before the next
2fpdcin of previous round, bpdc1,
2fpdcin*, repeat * to * once more,
hdc1, repeat * to * twice more, sl
st in first fpdc. (8 increases)

RND 7: Ch2, *2fpdcin, bpdc2, work all
stitches as they appear (a fpdc on
each fpdc and a bpdc on each bpdc)
until 2 stitches before the next
2fpdcin of previous round, bpdc2,
2fpdcin*, repeat * to * once more,
hdc1, repeat * to * twice more, sl
st in first fpdc. (8 increases)

RND 8: Ch2, *2fpdcin, fpdc1, work all
stitches as they appear (a fpdc on
each fpdc and a bpdc on each bpdc)
until 1 stitch before the next
2fpdcin of previous round, fpdc1,
2fpdcin*, repeat * to * once more,
hdc1, repeat * to * twice more, sl
st in first fpdc. (8 increases)

RND 9: Ch2, *2fpdcin, fpdc2, work all
stitches as they appear (a fpdc on
each fpdc and a bpdc on each bpdc)
until 2 stitches before the next
2fpdcin of previous round, fpdc2,
2fpdcin*, repeat * to * once more,
hdc1, repeat * to * twice more, sl
st in first fpdc. (8 increases)

1

2

Repeat Rnds 6-9 until your piece has a diagonal (or as close as possible to) as below in the chart, but make sure to end with Rnd 6 or Rnd 9. You can see how to measure in photo 1 on page 118.

0-6 months ———————— 5.3 in (13.5 cm)
6-12 months ——————— 6.1 in (15.5 cm)
1-3 years —————————— 6.7 in (17 cm)
4 years-teen ——————— 6.9 in (17.5 cm)
Medium ————————————— 7.5 in (19 cm)
Large —————————————— 7.8 in (20 cm)

RND 10: Ch2, *fpdc1, bpdc1, work all stitches as they appear (so a fpdc on each fpdc and a bpdc on each bpdc) until the next 2fpdcin of the previous round, bpdc1, fpdc2, bpdc1*, work all stitches as they appear to 2 stitches before the hdc of the previous round, bpdc1, fpdc1, hdc1, repeat from * to * to the 2 last stitches, bpdc1, fpdc1, sl st in first fpdc. (no increases)

RND 11: Ch2, work all stitches as they appear (a fpdc on each fpdc, a bpdc on each bpdc and a hdc on a hdc), sl st in first fpdc. (no increases)

Repeat Rnd 11 until your piece has a length (or as close as possible to) as below in the chart.

0-6 months ———————— 5 in (12.8 cm)
6-12 months ——————— 6.3 in (16 cm)
1-3 years —————————— 7.1 in (18 cm)
4 years-teen ——————— 7.5 in (19 cm)
Medium ————————————— 8.3 in (21 cm)
Large —————————————— 8.3 in (21 cm)

BRIM

Turn your hat inside out; this will make the brim look the same as the hat when folded. Change colors if making the two-color version.

RND 12: Ch2, dc1 in each stitch to the hdc, hdc1, dc1 in each stitch to end, sl st in first dc. (no increases)

RND 13: Ch2, work all post stitches exactly opposite from Rnd 11 (fpdc above each bpdc and a bpdc above each fpdc, you'll still make a hdc on the hdc), sl st in first fpdc. (no increases)

RND 14: Ch2, work all stitches as they appear (a fpdc on each fpdc, a bpdc on each bpdc and a hdc on a hdc), sl st in first fpdc. (no increases)

Repeat Rnd 14 until your piece has a length of (or as close as possible to):

0-6 months ———————— 6.2 in (15.8 cm)
6-12 months ——————— 7.8 in (19.8 cm)
1-3 years —————————— 8.8 in (22.3 cm)
4 years-teen ——————— 9.25 in (23.5 cm)
Medium ————————————— 10.2 in (26 cm)
Large —————————————— 10.4 in (26.5 cm)

Cut yarn and weave in ends. Turn the right side of the hat back out and fold the brim.

Chapter 7

TIPS AND VARIATIONS

MAKING A CORD TO CONNECT MITTENS

Step 1 Take two long threads (for the example I used two threads of approximately 3.3 yd/3 m each).

Step 2 Make a slipknot with both threads held together and put your hook in the loop.

Step 3 Take the right thread over the hook from front to back and hold it in the back.

Step 4 Now take the hook and pull the left thread through both loops on your hook.

Repeat steps 3 and 4 until the cord is long enough and sew the ends to the inside of the cuffs.

MAKING A BOW

Rnd 1: Ch16, sl st in first ch to form a circle and make sure it's not twisted, ch2 (first ch2 doesn't count as first dc throughout the pattern), dc1 in each stitch around, sl st in first dc. (16)

Rnds 2 and 3: Ch2, fpdc1 in each stitch around, sl st in first fpdc. (16)

Fasten off and cut a very long tail, fold the bow flat, wrap the thread tightly around the center (approximately 15 times) until you like how it looks. On the back of the bow, fasten off by going around the center threads with a needle. Sew the bow on the hat or mittens with the remaining thread.

— — — — — — — — — — — — — — — — —

ADDING A LABEL

I gave these hats the finishing touch by adding a leather label from Mez11. My friend Joyce customized these special "A la Sascha" labels. Leather labels are available from many online sources in various colors and with different prints (even your own design).

MAKING A POM-POM

Pom-poms are so fun and easy to make. I like to use the Clover Pom-Pom Maker for this. They are available in different sizes, but for the example I used the 65 mm from the "Large" set.

Open one side of the pom-pom maker (this means both layers on one side) and wrap the yarn around it until one side is full. Repeat this for the other side. Take a pair of scissors and cut the yarn in the opening between the two layers, make sure to keep the pom-pom maker closed shut.

Take a long piece of thread and wrap it around the opening where you just cut. Tie the yarn securely a few times. Separate the two layers and remove the pom-pom from between them. You can now trim the pom-pom into a nice shape, but make sure not to cut the closing thread. You can use it to sew the pom-pom to your hat.

1 2 3 4

5 6 7 8

9 10 11

#CROCHETHATSANDMITTENSFOREVERYONE

Many beautiful projects have already been crocheted with
the patterns from this book. It's so exciting to see all the
different variations and colors! Inspire others as well and
share your work with **#crochethatsandmittensforeveryone**
on Instagram. Join discussions at A la Sascha on Facebook
and follow @alasascha on Instagram.

@minkesthuis

@sosanne85

@creating_by_aria

@sosanne85

@sofiehaaktenmaakt

@studiowoordendraad

@dehaakzolder

@studiowoordendraad

@dehaakzolder

ACKNOWLEDGMENTS

Dear Josse, Mijntje, Julia, and Olivier, thank you so much for all your kind support. This book has turned out so beautifully thanks to your incredible modeling and enthusiasm.

Ans Baart, thank you so much for all of the hours testing and checking, and for crocheting some of the beautiful samples in this book.

Dennis de Gussem, thank you so much for all the behind-the-scenes help and for making some of the beautiful samples in this book.

Thank you so much for all your hard work and support, to all the testers: Emanuelle Overeem, Lisa van de Graaf-Slootman, Tine Oetzman, Eveline Koeleman, Karin Frenzen, Mathilde van der Waal, Linn Torfs, Sofie De Zutter, Diane van Lier-Noordenbos, Chantal Put-Schoutene, Angelique Jonkman van Welderen, Corina van Krieken, Monique Schut, Sabrina Jansen, Joke Stuurman, Bianca van de Maarel, Colette Hendriks, Susan Higbe, Annie Shelton, Morea Petersen, Yee Wong, Debbie Allen Richardson, Leslie Mansfield, Mandy Jo Steil, Jo-anne Chater, Jessica Williams, Grace Dunlap, and Lanie Brown.

Furthermore I would love to thank my father, mother, brother, and sister-in-law for all of your support and guidance. Also to my mother-in-law, one of my biggest fans and promoters, it's so wonderful to see the things you make with my patterns.

Thank you for the moral support from my in-laws, brothers-in-law, sisters-in-law, nephews, nieces, uncles, and all other family members.

Thank you, dear Sigrid! Thanks to you I dared to take the task of taking the photos for this book myself. It's such a joy to make a new edition together, adding another gem to the collection.

Of course, a big thank you to Kosmos Publishers and in particular Marieke Woortman and Sabine Meekel. It's always a pleasure to create books together, and I feel so honored with this tremendous privilege.

Dear Bregje Verhoef, thank you so much for the beautiful mitten blockers and your infectious enthusiasm!

Dear Joyce, thank you so much for the amazing labels and your delightful conversations.

Thank you, Jeanet Jaffari-Schroevers, Allan Marshal, Dico Sprokkereef, Linsey de Leeuw, Francis Notten, and Sara Veng.

Lovely colleagues, thank you so much for the support, enthusiasm, and inspiration: Alexa Boonstra, Laura Borgers, Pleun van Hoeckel, Manon Zwerver, and Wim "Mr. Knitbear."

Additionally, there are many companies and their employees who have contributed to the materials for this book. Thank you so much!

SPONSORS

Yarns
Onion through Breishop.nl
Scheepjes through De Bondt bv
Groothandel in Fournituren
Durable through G Brouwer & Zn
Fournituren Groothandel
Lana Grossa through Knottenwol
Lang Yarns

Handmade crochet hooks
Bowltech Crochet Hooks

Mitten Blockers
Bregje Verhoef from Studio Spintol

Bags MUUD

Leather Labels Mez11